The Survivor's Guide

WHAT YOU NEED

TO KNOW & WHAT YOU NEED

TO DO WHEN SOMEONE

CLOSE TO YOU DIES

V.K. THORNTON

SILVER LAKE PUBLISHING
LOS ANGELES, CALIFORNIA

The Survivor's Guide

What You Need to Know & What You Need to Do When Someone
Close to You Dies

First edition, 2004
Copyright © 2004 by Silver Lake Publishing

Silver Lake Publishing
3501 W. Sunset Blvd.
Los Angeles, CA 90026

For a list of other publications or for more information, please call
1.888.638.3091. Outside the United States and in Alaska and Hawaii,
please call 1.323.663.3082. Find our Web site at **www.silverlakepub.com**.

Library of Congress Catalogue Number: Pending

Thornton, V.K.
The Survivor's Guide
What You Need to Know and What You Need to Do When Someone
Close to You Dies
Includes index.
Pages: 324

ISBN: 1-56343-776-7
Printed in the United States of America.

Acknowledgments

I'd like to thank the Silver Lake Editors, especially Megan Thorpe Rust for all her time and great effort in shaping this text. There are many individuals and organizations I'd like to recognize for their contributions.

In particular, I'd like to thank the following people for their help in my research and for sharing their personal knowledge and experience with me: Lisa Carlson of the Funeral Ethics Organization; Joshua Slocum from the Funeral Consumers Alliance; Dr. Michael V. Herman of St. Vincent's Medical Center; Lori Lasak and Katie Monfre of the National Funeral Directors Association; Colleen Murphy Klein of Funeral Services Consumer Assistance Program; William Holt, funeral director; Jack Springer of the Cremation Association of North America; Ron Rothacher of Forest Lawn Memorial Park and Mortuaries; Victoria Watts of the Los Angeles *Times*; Donald C. Dimond II, funeral director of Dimond and Sons; Jim Olsen of State Farm Insurance; Jerri Lyons of Final Passages; Gus Hald of Sea Services; Father Gary of Our Mother of Good Counsel Church; Peter Hartman of Jarvis & Mandell; Glen Bower of Cypress College Mortuary Science Department; Dr. and Mrs. Thornton; Wendy Abrams; Allison Joyce; Kim Turner; Angela Ferragamo; Peter Hujanen; Karin Kuhn; Karen Avrashow; Beth Austin; Peggy Sue Davis; Amy Engelhardt; Susan LaTempa; Marguerite Topping; Devin O'Brien; Greg and Kerry Herman; Michelle Kane; Christine Herman; Karen Chretien; Penelope Senecal; James D'Amour; Maria Burns; Kristen McGary; Lyn Wyche; Jamie Walsh and Kristin Loberg.

Dedication

To my Mom and Dad, my husband, Spencer, and son, Hunter, without whose support and patience this book would not have been possible.

November 2003
V.K. Thornton

Contents

A Tradition
of Greed

When I first set out to write this book, my goal was to create a simple and practical guide for people facing one of life's most difficult tasks—planning the funeral of a family member or close friend. This emotionally stressful task is something that each of us, at one time or another, has to face. Death, after all, is a part of life.

A novice in the area of funeral arrangements, I thought it would be a good idea to develop a step-by-step guide for planning a funeral. *I'll make a few calls to a couple of funeral homes, talk to a few funeral directors and a few friends who've been down this road before and I'll be all set.*

Wrong. What I hadn't realized, in my naiveté, is that there exist two distinct camps when it comes to funeral planning: 1) Those that are in the death care business to make money (and in some cases we're talking *big* money); and 2) Those that want to memorialize respectfully the dead and circumvent the "traditional" big-business funeral.

The average American funeral costs roughly $6,265.35 according to a August 2003 survey of price lists by the National Association of Funeral Directors. A full-service funeral with a viewing (a funeral service that allows survivors to see the embalmed body of the deceased, usually in an open-casket) can cost upwards of $20,000. This does not include burial or cremation. This is what the industry wants you to believe is fair and reasonable. It's what the market will bear because the consumer doesn't know any better. But, there are much less expensive (and more personal) ways to go, which this book will address.

Calling a funeral home for advice on planning and purchasing a funeral, I learned, is like calling a car dealer and asking him what kind of car you should buy. If you call a Mercedes dealer, he's not going to send you to a Nissan dealer. He's going to try his best to convince you that a Mercedes is the *only* way to go. And, if you should show up at his lot, he'll take one look at the car you drove up in and the clothes that you're wearing and assess which car you can afford—and then he'll show you the one priced just above that.

Add to this scenario the fact that you *need* this car right away (as is the case when purchasing an "at need" funeral) and that he knows you're about to come into some cash. He's going to do his best to insist that, under the circumstances, you deserve the best and should buy the top of the line S-Class, because, after all, "You only live once."

Well, we only *die* once, too. And, if you don't shop around and decide to go with the first funeral director you visit, you may find your loved one in a casket more expensive than any car he ever owned and his body the center piece at a funeral more lavish than any party he ever threw. Fine, but ask yourself, *is this what he would have wanted? Does that represent the person he was? His values?*

My personal feeling is I want the S-Class, I want the big party—but I want it *now*, when I can enjoy it. When I'm gone, put me in a plain pine box—or better yet, no box, just a simple cremation (which does not, by law, require a casket), and cast me to the wind (but not in California since it's the only state where scattering of remains is highly regulated.)

When asked, most people feel the same way about a simple send-off. However, given our cultural desire to avoid death altogether, we rarely discuss it, much less share with friends and family our wants and desires regarding our own funeral. This is an oversight that can cost family and friends both emotionally and financially. Friends and family, out of love, guilt, stress, exhaustion, grief and a tumult of other emotions plan lavish send-offs, swayed in large part by what the

"professionals" in the death industry would like us to believe is the "traditional" hence appropriate (and often costly) thing to do.

Grief and the Hard-Sell

People overspend on funerals because the sales tactics of the funeral director influence them. Some are overcome with grief and simply hand over the planning to the funeral director (basically giving him a blank check). Others are driven by guilt at having not done enough for the person in life, are concerned with what people will think or are ill-informed or misled about legal requirements and actual costs of funeral goods and services.

To go back to the car dealer/funeral director analogy for a moment—or rather to show where the analogy breaks off—the car dealer is competing for your business with many other dealers. He knows that you have the time to shop around and in all likelihood, you will. You'll go online, you'll study *Consumer Reports* and you'll come back to buy—or not—with a better understanding of the market and the products he has to offer in relationship to your needs. You more or less know your rights as a consumer.

Here's where the car dealer/funeral director analogy breaks down.

The funeral director knows that when a loved one dies you are in little position to shop around and compare prices (although you can and most definitely should). You are unfamiliar with your rights as a consumer and the laws governing the disposition of the dead. You wouldn't know where to go with a complaint, should you have one and, well, once the casket has been buried, it's hard to make any claims against the warranty.

Time seems to be short (though, in most instances, you have more time than you think) and you need to make many decisions regarding your loved one and the funeral arrangements in a relatively short period of time. The funeral director knows that, regardless of what you're

driving or wearing, the deceased will in all likelihood have a life insurance policy, pension, Social Security or veterans benefits that become payable upon death.

In some cases, the funeral home may be a named beneficiary in some of these benefits (not the best idea, but older people are often persuaded to do this). In which case, the funeral director knows, or can guess from some basic questions (e.g., "So, what occupation did your dearly departed father have?") how much he can expect you to have available to spend on the funeral. With experience and savvy questions, the funeral director is in the driver's seat of more than a hearse.

"Come into My Parlor," Said the Spider to the Fly

When you sit down to plan the funeral with the funeral director, know that the meter is running. You will have to pay him for "planning" the funeral. This is part of what is called the non-declinable fee for "basic services and facilities." It's essentially the same as paying the car dealer to fill out the paperwork once you agree to buy the car (i.e., "document and dealer prep fees").

One California mortuary explains the fee this way:

...[it] includes discussion with you and implementation of desired arrangements; preparing, securing signatures and death certificate; obtaining necessary releases and burial permit; clerical and staff personnel to prepare necessary documents; use of the mortuary building, vehicles, etc.

Use of the mortuary building? Where else do they suggest you bring the body? That's like the dealership charging you for parking the new car on their lot. And, the *vehicles* listed under the Basic Services and Facilities category do not refer to the use of a limousine, hearse or chauffeur. Those items are listed separately, and of course, cost extra.

Essentially, what I discovered is the same old *caveat emptor*—buyer beware—that applies in all business dealings. However, it applies in

spades to the funeral industry. This is not to say that all funeral directors, mortuaries and funeral homes are out to cheat you. Many of them work well within the letter of the law. However, they know the law and you don't. This gives them an opportunity to allow you to be misled without actually misleading you. They are a well-organized big business with a slew of lawyers and lobbyists at the ready to defend their practices and uphold the "traditions" they have put in place.

They know the market and they know that you don't. You'll probably buy a car every five years or so in your life. You'll likely only buy one or two funerals (one every 15 years or more at the most) in that same span of time. You will be making your purchase under duress; the death of a loved one is one of the most traumatic things that can happen in anyone's life. And, you may easily fall prey to the open arms of the funeral director who so generously offers to "take care of everything." Just remember *everything* comes at a price.

The funeral business is a *business* and a very profitable one. The General Accounting Office (GAO) estimates that over $9.3 billion is spent each year on funeral costs alone in the United States. And, that doesn't include the cost of burial or cremation. Huge conglomerates are feverishly buying up smaller mom-and-pop neighborhood funeral homes and grossing billions every year. Let's face it, no matter how good our health care gets people will die (on average 2.4 million deaths a year in the U.S.). Death care will always be a service we need. However, we shouldn't have to put our families into debt when it happens. It should be a legal right that every person be allowed a simple and affordable funeral and a respectable death.

The Costs of Funerals in Other Countries	
England	$1,650
France	$2,200
Australia	$2,100
United States	$4,700

Information Sources

The only defense against this imbalance of power in this particular sales equation is to be as educated a consumer as possible at your given time of need. To know your rights and know as much ahead of time about what your loved one really wants or would have wanted, will put you ahead of the merchants in the temple. If you are unprepared when purchasing a funeral, your loved one may wind up in a very pricey casket with an elaborate send-off—one that he or she may not have wanted and that you may not be able to afford.

There is a lot of information available on the Internet, at your local library, funeral home or memorial society about how to handle the final arrangements for you or your loved one. Be advised to consider the source of your information. Much of what is out there appears to be consumer-oriented but is, in fact, advertising for the funeral industry sponsored by the National Funeral Directors Association and the Cremation Association of North America. Even the AARP (formerly known as the American Association of Retired Persons) and other more reliable resources for information have fallen into step with the funeral industry and its imposed standards.

Another valuable resource for consumer education are the many consumers' groups and non-profit memorial societies that approach death from the opposite end of the spectrum. These societies were formed—in response to the unchecked greed of a growing number of those in the funeral industry—in order to return death to the simple, personal, spiritual family experience that it once was. Use them to your and your family's advantage.

> *Caveat emptor*: There are several direct disposition companies that refer to themselves as "memorial societies," such as the Neptune Society. They are *for-profit* businesses that charge for membership (and can be expensive) and usually take care of the cremation and disposition of the remains for a fee prepaid by the deceased. If you are talking with a memorial society, ask if it is a non-profit or for-profit enterprise.

Societies like the Funeral Consumers Alliance (FCA), formerly the Funeral and Memorial Societies of America (FAMSA), have volunteers who do regular price surveys of funeral homes and cemeteries and help keep a close eye on members of these industries to be sure they are operating within the letter of the law. There are more than 115 non-profit societies in the U.S. Many negotiate discounts for members with cooperating, ethical mortuaries.

Some organizations help families who wish to handle their own arrangements for the disposition of a loved one to do so without the costly assistance of a funeral director.

One such organization, Final Passages, offers education about personal and legal rights concerning home or family-directed funerals and final disposition (burial and cremation). "A home funeral trend is emerging," said Jerri Lyons who heads the organization. Caring for your own dead is completely legal in most states. Lyons adds:

> It is our intention to reintroduce the concept of funerals in the home as a part of family life and as a way to de-institutionalize death. We are dedicated to a dignified and compassionate alternative to current funeral practices.

Some Basic Ground Rules

Although the FCA has no legal authority, they can provide advice to consumers about legal rights—by state—and can help you to report any misdealing to the Federal Trade Commission (FTC) or other regulating bodies.

In the 1980s, these consumer-oriented societies were responsible for getting the FTC to enact the **Funeral Rule**. In essence, the rule states:

- Prices must be provided to you over the telephone when you inquire.

- A **General Price List (GPL)** must be presented to you when you visit a funeral home in person at the beginning of any discussion for funeral arrangements.

- The GPL must contain a disclosure that embalming is not (usually) required by law.

- As the purchaser, you have the right to choose an alternative container (other than a casket) for cremation.

- A funeral provider may not claim that embalming or caskets preserve the body or lie about state laws.

- You must be given an itemized **Statement of Funeral Goods and Services Selected** before any services are provided. You do not have to purchase any goods or services you don't want.

- There must be a disclosure on your statement if the funeral home takes a fee when paying for "cash advance" items on your behalf.

There have been a few setbacks to the Funeral Rule over the years (thanks to millions spent on lobbying efforts by organizations like the International Cemetery and Funeral Association among others)—such as the allowance by the FTC of the non-declinable fee. This fee includes "unallocated overhead"—essentially everything else that is not itemized on your bill from the funeral home's downtime as employees wait for a body to come to its parking lot. Although the FTC rarely enforces these regulations, the consumer groups continue to fight for consumers' rights and to prompt the FTC to make and enforce much needed changes such as bringing cemeteries and crematories under the Funeral Rule.

In September 2003, responding to a request from Senators Chris Dodd and Mark Foley, the General Accounting Office (GAO) conducted a study showing that a broad disparity exists in both the way states regulate various segments of the funeral industry and the mecha-

nism in place to enforce such regulations. Dodd and Foley's request came after news of the desecration of graves and human remains surfaced in several states, including Connecticut, Florida, Hawaii and Georgia. The report also reveals a lack of a means and place of collection for consumer complaints.

Senators Dodd and Foley introduced legislation in 2002 (and plan to reintroduce similar legislation to this Congress) to expand the Funeral Rule to include every business that sells funeral goods or services directly to consumers. This would mean a federal law rather than a unenforceable regulation. While funeral homes themselves are generally regulated and licensed, other businesses in the death care industry, such as crematories, cemeteries and funeral goods salesman are not. The legislation, which Dodd and Foley would like to see enforceable by the end of 2003, also aims to provide grants to states to hire and train inspectors, require states receiving these funds to adopt clear standards and license requirements for funeral service providers, and provide additional information to consumers.

There are many funeral homes that are family-owned businesses run by funeral directors who truly want to help their neighbors in a time of need. The International Association of the Golden Rule is a worldwide professional organization of independently owned and operated funeral homes (*www.ogr.org*) that provides a forum for interaction and information exchange and strives to educate its members on providing the best products and services related to the death care profession as well as how to handle preparation, care, disposition and other death care issues with compassion and understanding.

Even so, they are little fish being devoured by giant industry sharks, like Stewart Enterprises and Service Corporation International (SCI). These funeral franchise operations buy up the small-fries, keep the funeral homes the same and keep mom and pop on as management. The only perceptible difference to the consumer is the price...a big difference. As one consumer experienced, her grandfather's funeral

cost around $4,000 at the local funeral home. A year later, the same exact funeral for her grandmother at the same home (under new ownership unbeknownst to her) cost more than $6,000.

The chain-owned funeral homes (called in industry slang, *McMortuaries*) follow the 1980s business model of "rolling up" local firms and then charging more for their funerals. But this model has always been problematic. There are more complaints filed with the FCA against chain-owned funeral homes than family or independently owned mortuaries.

Protecting Yourself

So, what can you do to make sure you don't get taken? The best thing you can do is prepare yourself. Know your rights, know your options and know what you are willing to pay for what you want. Don't let anyone talk you into buying more or into handling things in a way that seems inappropriate for you and your family.

At times in this book, my tone may seem irreverent (born of anger and frustration) but I believe it is far less so than the actions of those I encountered taking financial advantage of grieving families (more often senior citizens) at a time of personal crisis.

This is not a book on grieving. Nor will it tell you how to cope with a loved one's death. This book is designed to be a practical guide that will help you make important and informed decisions that affect you and your family, at a time when you may be overwhelmed with emotion and most vulnerable to costly advice. This book outlines—in chronological order—the decisions you will face and the steps you will need to take immediately following the death in order to fulfill your loved one's wishes and to put him or her to rest.

Although the circumstances of each death, just as in each life, are unique, most require a certain amount of medical, legal and financial paperwork. This book is designed to make you familiar with many of the terms and forms you will be need to be familiar with in the days

and months following the death of your loved one. It will also help you help your loved ones make your final arrangements when the time comes.

When an industry offers neither justice nor equity, the frustrated consumer's first reaction is to expect someone else to fix things—state or federal government agencies. Don't imagine that these people, swayed by the wealthy lobbyists from the funeral industry, want to help the common man. But you have the power to bring about change. As the consumer, you fuel the system with your dollars and only you have the power to say how those dollars are spent. You have the power to change a tradition of greed by becoming an educated consumer and spending your money wisely.

1 When You Get the Call

The death of a loved one is always sudden.

As unfair as it may seem, you will be expected—while numb—to make many major decisions regarding his or her final affairs. Decisions that include not only flowers and funeral arrangements, but also those that may affect you and your family financially for the rest of your lives. You will have hundreds of questions to answer, arrangements to make and urgent details to work through.

If the deceased has died leaving a **letter of instruction**—with details of his or her preferences for final disposition and distribution of assets—this will be a great help to you. However, most people don't like to think about their own mortality and therefore leave no instructions for their loved ones to follow after their passing.

> Or, as often happens, such information is included in a will that is found in a safe deposit box or other location after the final arrangements have already been made.

Such was the case with Franklin Roosevelt, who died while President and who left very detailed instructions, insisting on the utmost simplicity for his funeral and disposition: no lying in state; no hearse; no embalming; no lining the grave with cement or brick or stone; and no hermetically sealed casket, just a simple wooden box. No one in the family knew of these instructions or of this detailed document until a few days after his burial. As a result, the only one of his re-

quests that was met was that his body was not put on display for viewing, as Mrs. Roosevelt found the practice distasteful.[1]

> Letters of instruction, the will and other such documents should be kept where they can be found easily. Family members should know where to find them. Even though it's difficult, try to discuss this beforehand. If you, as the next-of-kin, don't have a copy, check with your loved one's executor—the person responsible for settling your loved one's estate.

There is some urgency in locating the letter of instruction; it may contain not only information about funeral arrangements but also time-sensitive provisions such as the deceased's desire to bequeath anatomical gifts, which can only be done at the time of death.

The Funeral Consumers Alliance (FCA) recommends storing such documentation in your refrigerator with a note on the outside of the door. That way it can be easily accessed, updated and applied when the time arises.

> The FCA offers a booklet for outlining your final wishes and includes a magnet for the refrigerator that states: "Important Documents Inside." It can be found or ordered at 33 Patchen Road, South Burlington, VT 05403.

If your loved one has been ill for a long time, take the opportunity to discuss some details regarding his or her final arrangements. Write everything down to help you remember. Perhaps it's little details that mean the most to him or her, such as a certain type of flower at the funeral or maybe he or she wants to be clear about certain financial arrangements.

Dr. Elisabeth Kübler-Ross, psychiatrist and world renowned expert on grief, best known for her books dealing with the natural phe-

[1] Mitford, Jessica; *The American Way of Death*; 1963, Vintage Books, New York, NY (page 182). For more information see Mitford's book *The American Way of Death Revisited*.

nomenon of dying—including *On Death and Dying*—points out the importance of encouraging and assisting the dying with the completion of unfinished business. Talking about final arrangements, resolving relationships and disposing of possessions can give the person some peace and acceptance of death. It also helps the dying individual to know that the family accepts the death and that they will be all right on their own once he or she is gone. By helping a loved one get his or her things in order, you are showing him or her that everything is going to be all right. And this will put him or her at ease.

But, even if you talk over final arrangements with your loved one, the impact of his or her death can be tough. Even if you've been through it before.

This chapter deals with the situations and circumstances you can expect to face within the first few hours following a death.

Dying in a Hospital

Most deaths occur in medical care facilities like a hospital, emergency room or nursing home where there are professionals trained in caring for the dying and their families. If you are the next-of-kin and you are not present, you will be called by a doctor, nurse, chaplain or trained volunteer at or near the time of death. If you leave the hospital after your loved one has been admitted, be sure the hospital has all the numbers they need in order to reach you. Provide them with the following:

- your work phone;

- your home phone;

- your cell phone; and

- the number of a co-worker, friend or relative who may know how to reach you otherwise.

If your loved one is elderly or coping with a terminal illness he or she may have been asked at the time of admittance to the medical

facility about "advanced care" considerations—what measures should or should not be taken in order to prolong life. Your loved one may have signed a **living will,** sometimes called a **health care declaration** or **advanced health care directive.** This document states his or her wishes regarding end-of-life medical treatment—such as the use of ventilators and breathing and feeding tubes—in the event of a serious or irreversible illness when he or she can no longer communicate.

Every state has laws that permit individuals to sign documents stating their wishes about health care decisions when they can no longer speak for themselves. A living will usually goes into effect when a patient is not expected to regain consciousness.[2]

The hospital or hospice may have asked if your loved one signed a **Do Not Resuscitate (DNR) order** upon admittance, which provides medical staff with clear instructions not to perform any extreme life saving measures. As long as the patient is aware of the risk, he has the right, unless mentally incompetent, to refuse treatment even when the refusal means certain death. This is not to say that no medical treatment will be provided. The patient will be made as comfortable as possible, given pain control medication and allowed to die as peacefully as possible.

If you are aware that your loved one signed such a document or you know his or her wishes regarding end-of-life treatment, you should make them known to the hospital staff and provide copies of the documents to be included in the hospital chart. Having clear—preferably written—directives allows the doctors to follow your loved one's wishes for end-of-life treatment. If there is any doubt—or family disagreement—doctors will use every means possible to keep a patient alive for as long as possible in order to avoid any liability.

[2] For more on living wills, see Silver Lake Publishing's *Taking Care of Mom and Dad* by Mike Rust (2003, ISBN: 1-56343-740-6).

In lieu of or, as a back up to, a living will, your loved one may have assigned an agent, such as yourself, with **medical power of attorney** to make health care decisions on his or her behalf when he or she can no longer communicate. Having a **health care proxy** is important, since not every possible health care crisis contingency is covered by a living will. Written documents are subject to interpretation whereas a human being can make critical decisions in minutes if necessary. The designated person, sometimes called the **patient advocate**, should have a clear understanding of the wishes of the loved one and be willing to see them carried out in spite of any opposition from family or doctors. Most states do not allow the patient's doctor or health care provider to be the patient advocate. Other states do not allow a beneficiary to have medical power of attorney.

Although legal requirements differ from state to state for medical power of attorney and living wills, you usually don't need a lawyer to draw up these documents and for them to be legally binding. The living will must be signed in front of two qualified witnesses (no relatives, heirs or doctors). The documents must be specific and make clear that the signer does not want doctors to use any extreme means—such as artificial nutrition, hydration or ventilation—to sustain life if the condition is terminal, incurable or if they are in a vegetative state.

Information about obtaining forms for each state is available from the American Bar Association at 740 Fifteenth Street, NW, Washington D.C. 20005-1022. You can call them at (202) 662-8690, or visit their Web site at *www.abanet.org*.

In the absence of anyone being granted the power of attorney, medical professionals will consult in order of importance with the spouse, adult children, parents, adult siblings or other close relatives or friends.

Making Tough Decisions

Although you may clearly understand your loved one's wishes, they may not always be easily applied. It may be uncertain if his or her condition is actually terminal or irreversible. Also: you may have concerns that a desire to die has been brought on by depression, pain that is not being adequately managed or fear of treatments such as surgery or chemotherapy.

Stay calm.

Consult with the doctors and let them know your concerns. Do your best to make the decisions that you feel are most in line with what your loved one genuinely wants. You may be up against family opposition. Remind them of what your loved one's wishes are, let them know that their concerns are being heard and that you are doing what you feel is best for the loved one. Letting go is always hard, even if it has been anticipated.

You may even have a doctor who is at odds with your loved one's request regarding end-of-life treatment. If you feel this is the case, you may ask him or her to transfer the case to another doctor who is more willing to comply with the wishes of your family.

The organization, Partnership for Caring, Inc. (1035 30th Street NW Washington D.C.; (800) 989-9455; *www.choices.org*) may be a valuable resource for you if you are facing opposition to getting your loved one's wishes carried out.

The American Medical Association's Council on Ethical and Judicial Affairs declared that artificially supplied respiration, nutrition and hydration may be withheld from a patient in an irreversible coma, even if death is not imminent. In treating the terminally ill or irreversibly comatose patient, the council ruled that the physician should determine whether the benefits of treatment outweigh the burdens.

As one adult child of a terminally ill patient described it, "My father suffered for a long time, hooked up to tubes and respirators. He really just wanted us to let him go and end his suffering."

Immediately After

If you were not at the hospital or nursing home at the time of death, you will be called by staff at the facility, informed about the death and asked to make arrangements to have the body removed. In the case of an accident when your loved one was rushed to emergency care, you may be asked to identify the body.

Although there will seem to be a sense of urgency about matters, there really isn't.

The only urgency is if your loved one chose to leave his or her body/organs as an anatomical donation/gift, or if you are making the gift on his or her behalf. In such instances, time is of the essence since the donated organs must be collected within a few hours of death.

If organ donation is not in the plan, there really is no need for haste. The hospital or nursing home may have its own agenda and want to have your loved one's bed vacated as soon as possible to make room for others. Don't allow yourself to feel pressured. There is no need to make quick decisions in an attempt to appease others.

Even after the body has been removed, you may want to take time to go to the facility and talk with your loved one's doctor or the nurse who was present when your loved one died. It may help for you to know what the last few moments were like or to share your feelings with those who cared for him or her while ill.

Organ and Tissue Donation

If the deceased expressed a desire to donate all or part of his or her body to medicine, he or she may have filled out a **Uniform Donor Card (UDC)** or a donor card issued by a specific medical school. The

UDC allows the donor to specify the type of donation as:

- any needed organ;

- only specific organs (the donor can list); or

- the donation of the entire body.

The options of donating one's organs or one's body are mutually exclusive in that if organs are removed from the body for transplant purposes the body then becomes unacceptable for medical research. If, however, the body is donated for medical research, organs cannot be removed for transplantation.

Under the **Uniform Anatomical Gift Act** (applicable in all states), any anatomical gifts by a deceased person designated in a will or other gift document, (i.e., a donor card) must be honored by the survivors. The person in possession of the gift document is legally obligated to carry out the instructions it contains. However, as is too often the case, the deceased's intentions may be foiled if the gifts are refused, not harvested in time, are too expensive or impractical to transport or for a number of other reasons. If you have made an effort to comply with the deceased's wishes but are unable to do so, you will then have to choose a method of **disposition** instead of donation.

The Uniform Anatomical Gift Act

There are a number of detailed laws affecting donation, but in brief what you need to know is:

- Anyone over the age of 18 can choose to make an anatomical gift.

- Unless the deceased specifically stated that they did not want to make an anatomical gift at the time of death, the next-of-kin, in the following order can authorize the donation of all or part of the deceased's body (spouse, adult children, parent, adult siblings, grandparent, guardian).

- Some states have laws requiring medical personnel to ask next-of-kin at the time of death if organs or tissues may be removed and transplanted to those who need them.

Even if you plan to donate the body to a medical school you can still have a funeral with the body present prior to shipping the body. The funeral director can make arrangements with the school and embalm the body in a manner required by the school (embalming for medial study requires stronger chemicals to keep the body longer). He could arrange for the death certificate and prepare forms for anatomical gifts.

If you live in a state with no medical school (Alaska, Delaware, Idaho, Montana and Wyoming), or in a state where all medical schools require prior enrollment (Arizona, Nebraska, Nevada, South Carolina and Wisconsin), the New York-based National Anatomical Service may be of some help. Since 1975, this organization has been in the business of procuring and transporting cadavers to medical schools. The best part: They know which schools are in the greatest need and offer a 24-hour phone service to those looking for assistance. For more information on anatomical gifts and medical schools, contact the National Anatomical Service at (800) 727-0700.

Types of Donation

There are three types of donation: tissue donation; organ donation to the living; and donation of the body to medical science (i.e., a medical school, dental school, chiropractic school, etc.).

> Cornea and skin tissue, even of elderly people, can be donated separately even if a body donation is planned.

Organs that can be donated include the following:
- heart;

- lungs;

- liver;

- kidneys;

- pancreas; and

- small intestine.

These organs can be taken *only* while the heart is still beating, when the donor is **brain dead**. A brain dead person is maintained on a ventilator, and because the machine breathes for him, the donor's heart continues to beat and the organs continue to receive a blood supply.

Tissues (skin, bone, corneas and heart valves) can be recovered up to 24 hours after the heart has stopped beating.

Federal law requires that all families of brain dead patients be offered the option of organ and tissue donation. Your loved one's doctor may bring up the subject of organ donation if your loved one is a viable candidate. *Brain death* is defined as the irreversible loss of all functions of the brain. According to the Coalition on Donation, it can be determined in several ways, including:

- No electrical activity in the brain, as determined by an EEG.

- No blood flow to the brain, as determined by blood flow studies.

- Absence of function of all parts of the brain, as determined by clinical assessment (no movement, no response to stimulation, no breathing, no brain reflexes).

When a person is brain dead, the brain is no longer functioning in any capacity and never will again. The person no longer feels pain. Since he or she is already dead, the removal of respiratory support is not the cause of death. The respiratory support equipment only keeps the heart beating, which gives the appearance that the person is living.

The failure of many organs begins to occur soon after brain death, although a brain dead person on a ventilator can have organs that continue to function via a ventilator for a few days. Unless damaged by injury or disease, another individual may use these organs through an organ transplant.

A person who is declared brain dead is dead medically and legally. In most states, two physicians must declare a person brain dead before organ donation can proceed.

Patients who are in a deep coma or vegetative state have slight brain activity and are not brain dead. They are not dead medically or legally dead.

The decision to donate your loved one's organs may be a difficult one especially if your loss was sudden and unexpected, as in the case of an accident. Keep in mind that organ/tissue transplantation offers life or a better quality of life to another person. It gives you and your family the opportunity to help others at a time of tragedy and loss. It may seem insensitive for attending medical staff to broach the subject at such a difficult time. However, in the case of most live organ donations, the decision needs to be made rather quickly in order to allow organs to be harvested while tissue is alive.

According to the Coalition on Donation, organ and tissue donations can help a wide variety of patients. Kidneys, hearts, livers, lungs, corneas and more can be transplanted to replace damaged or diseased organs and tissues. One donor often helps several patients regain normal lives. If you or a family member wishes to donate organs and tissues, share this with other family members and obtain and sign organ donor cards.

People of all ages and medical histories are potential donors. A person's medical condition at the time of death will determine what organs and tissue can be donated.

A common concern of families regarding organ donation is whether or not their religion will approve of the donation. Most religions support organ/tissue donation as a charitable humanitarian act. If you have any doubts that your religion will approve, discuss your concerns with your minister, priest, rabbi or hospital chaplain.

The New York Regional Transplant Program has published the views of most major religions on the subject. For a brief summary of their findings visit the Coalition on Donation Web site at *coalition@shareyourlife.org*; or, write or call them at: Coalition on Donation, 700 North 4th Street Richmond, VA 23219; (804) 782-4920.

Once you and your family have given permission for organ or tissue donation, the organ procurement team will evaluate the deceased as a donor. Blood samples are taken for the matching process. When recipients are located, a team of surgeons and specialists trained in organ recovery will remove organs and tissues. After the organs and tissues are removed, the body is prepared for the funeral home of your choice or for you to take home (See page 34 for securing written permission/documents to remove the body yourself). Donation of organs and/or tissues should not cause a delay of final arrangements. An open casket funeral may be planned and no one, except those directly involved, need to know about the donation.

There is no cost to the donor's family or estate for organ and tissue donation. All costs related to donation are paid for by the organ procurement program or transplant center. However, hospital expenses incurred before the donation of organs/tissues and funeral costs remain the responsibility of the donor family. There is also no monetary compensation for families making organ/tissue donations.

For additional information on organ and tissue donation contact the following organizations:

- Department of Health and Human Services donation Web site: *www.organdonor.gov*;

- TransWeb, a non-profit educational Web site directory and collection of transplantation and donation related information: *www.transweb.org*; and

- The United Network for Organ Sharing (UNOS) maintains the U.S. organ transplant waiting list matching system and brings together members of the transplant community to facilitate organ allocation: *www.unos.org*.

Donating to Science

The deceased may have expressed a desire to have his or her body donated to a medical school, dental school, chiropractic school, teaching hospital or other medical science facility. Or, knowing your loved one as you do, you may decide that this option is what he or she would have wanted. As with organ/tissue donation, this is a noble election at a time of stress and grief. Medical and dental schools across the country, and even more so in other countries, are in great need of cadavers for anatomical study and research.

> Note: Bodies can't be moved internationally for scientific study, although individuals can be shipped for burial in most cases. However, if death occurred abroad you may want to consider donating the organs or body locally.

If the deceased filled out a donor card issued by a specific medical school or made such an indication in his or her will or letter of instruction, the medical school will already have him or her on record as a donor. There should be a number on the card for you to call to have the body picked up at the hospital by the medical school.

Your loved one may have indicated on his or her organ donor card that he or she would prefer to donate needed organs first, and then his or her body if no organs were needed. However, once major organs

(excluding eyes or skin) have been donated the medical school may not want the body for study. In turn, if the body is designated for donation to a school, the organs will not be removed.

He or she may have filed a **bequest** (a gift by will of personal property) for body donation. In some states, the bequest can take precedence over the wishes of the family. Two people (family members) should have witnessed signing the donor card or the bequest.

In spite of a bequest, a body may be rejected by a medical school if any of the following occur:

- major organs have been removed as in the case of transplant donation;

- the body has been autopsied;

- the deceased was too old or too young; or

- the deceased suffered from trauma, underwent surgery or died of a contagious disease.

Alternative plans for disposition should be considered by all donors in the event that the body is rejected.

If the deceased designated a specific medical school, you will need to contact the school directly to make arrangements for transportation of the body. Some schools may be reluctant to accept a body donation without prior enrollment. Policies for donating under such circumstances vary greatly. If the deceased left no letter of intent you may have to call a few schools to check their policies before you find one that will accept the body.

Once a medical school has been contacted they may want to retrieve the body as soon as possible to begin preservation. Once the school has accepted the body they will pay for all or part of the cost for transportation and final disposition and file the death certificate. They may ask you for some information on your loved one's medical history, so be prepared to answer these questions if you're serious about the donation.

You may ask the school to return the remains or **cremains** to you; however, this may not always be possible. In such instances when the body of a loved one has been donated to a medical school, the family usually opts for a memorial service without the body present.

> Donation of the body to a medical school is the least expensive means of disposing of the body.

Removing the Body

Once you and your family have decided whether or not to donate the deceased's organs/tissues in accordance with his or her wishes or those of your family, you will need to "make arrangements" to remove the body from the hospital or medical facility for **disposition**. As difficult as this task may be, it is an important part of a final tribute to the one you love—and should be handled respectfully and responsibly. There are essentially a few ways to dispose of the body—earth burial, entombment, cremation or donation to science. If the means and manner in which your loved one wanted to rest have not been planned out in a letter of instruction or whispered to you in his or her final hours, you don't need to rush to a decision.

Depending on the hospital and its need for beds, the staff may allow you some time alone with the body. You and other close family and friends may want to use this time to say goodbye. Ask the nursing staff to remove all life support apparatus so that you can view your loved one in a more natural state. It may be your last opportunity to cradle him or her in your arms (you can't do so once the body has been embalmed and is in a casket at a more formal viewing). Take advantage of this time alone with him or her while you can.

Some nursing homes or other medical facilities might make this alone time more difficult. If they try to rush you out, you might want to remind them that you have paid for this room (probably until the end of the month) and there should be no rush to fill the empty bed as

there may be in a busy hospital emergency room. If the room is semi-private, the nursing home may ask for and expect a relatively quick removal of the body out of courtesy for other residents.

If you have a loved one in a nursing home, it is a good idea to discuss the facilities expectations at the time of death as well as your own. A good deal of frustration and disappointment can be avoided at a stressful time if you know what to expect.

The staff at the hospital or nursing home may ask you if you have a **funeral home** you'd like them to call. If you don't have a home in mind, they will probably offer a suggestion for you. Don't feel pressured to go with the funeral home suggested at the hospital or to have the body removed promptly.

> Take time to discuss the matter with other family members and friends, know what your options are and read through the loved one's letters of instruction to make meaningful decisions with the help of all concerned. Let your family and close friends help with the planning. Not only will they feel more useful, but it'll take some of the burden off you.

Shop around for a funeral home. In fact, call several and ask for prices over the phone before heading out to visit one. If they won't quote you prices over the phone, don't bother considering their establishment. They're not being straight with you. Funeral homes are *required by the FTC's Funeral Rule* to give you prices over the phone if asked. And, if you don't ask, you may wind up paying a great deal more than you expected for funeral arrangements. (See Chapter 2 for more information on funeral homes).

> It pays to shop around. I called two mortuaries within 10 miles of my home and was quoted prices that varied by almost $1,000 for the same service. At the time of death, few people are concerned with price, they are more concerned with their loss. The funeral home knows this, too. And, it may even be giving the staff of the hospital or nursing home gifts for recommending their facility.

The point here: Be assertive. You can ask the hospital to store the body of your loved one for a few hours while you call relatives and friends to help you with your decision regarding what to do with the body.

Not all hospitals and few nursing homes have the capacity to keep the body for long. You may have to pay to have the body taken to a nearby funeral home and stored there until you make your decision about final disposition. This will, of course, cost you.

Finally, on the saddest note, disposition of an infant or fetal death may be handled entirely by the hospital if you so choose. A special death certificate is required in most states. In such instances, a funeral home or crematory will charge little for an infant death, depending on the arrangements you make.

Taking the Body Home

If you do not use the services of a funeral director or a funeral home, you can make arrangements to take the body home—for a family-directed home funeral—directly to a crematory or to the site for direct burial. Although this may seem unusual, and hospital staff may be unaware of this option, it is your right and completely legal in most states. A growing number of people are opting for this more personal involvement in the disposition of loved ones. Just as more mothers are opting for natural childbirth at home surrounded by family, more families are choosing to care for their dead at home, just as we used to do before our reliance on funeral homes.

Final Passages is an organization in Northern California devoted to educating people on how to conduct more meaningful home funerals and how to prepare bodies for burial, or cremation—bypassing the need for a funeral director.

> If you are considering this option, discuss it with your loved one's physician and medical staff as soon as possible. If you meet resistance, you may want to get in touch with Final Passages at P.O. Box 1721, Sebastopol, CA 95473, (707) 824-0268 (*finalpassages.org*), the Funeral Consumers Alliance at (800) 765-0107 (*www.funerals.org*) or one of the consumer groups or memorial societies in your area (see Appendix A at the back of this book for a list) for guidelines in dealing with such issues.

If you know your rights and are determined to handle the final arrangements yourself, you may have to have your lawyer call the hospital to let them know. You will need to acquire the appropriate documentation before moving the body. At the very least, the documents you will need are the death certificate and a transit permit. Each state and local authority has a unique set of regulations and requirements for transporting a body and final disposition. Check with the authorities in the area where your loved one has died and in the area where the final remains will be placed before acting on your own.

According to the Funeral Consumers Alliance (FCA), caring for your own dead is permitted in *all* states with the following conditions or exceptions:

- **Colorado.** Statutes in Colorado specifically refer to the rights of religious groups and their members to care for their own dead. In practice, the "religious conviction" of any family is likely to be honored. Funeral directors are not licensed in Colorado, so anyone can be a "funeral director."

- **Connecticut.** The laws in Connecticut are in conflict with each other. The laws specifically provide that the custody and control of remains...shall belong to the surviving spouse...or...next-of-kin...[Sec. 45-253]. On the other hand, a funeral director's signature is required on the death certificate, and only a funeral director or embalmer may "remove the body of a deceased person from one town to

another" when a person dies in Connecticut, but towns and ecclesiastical societies may provide a hearse and pall bearers for burial of the dead. A licensed embalmer must be in charge when death is from a communicable disease. Because the laws are conflicting, a family wishing to care for their own dead should seek the help of legal counsel. The FCA office may be able to help.

- **Indiana**. Statutes in Indiana are also in conflict. In the business statutes, it dictates that a disposition permit may be given only to a funeral director. None of the health statutes, however, have such restrictions and refer to the "person in charge," defined as *next-of-kin*. Families that wish to care for their own dead may be able to find a local mortician who will cooperate in getting permits. Otherwise, they should be prepared for a court challenge to get their rights.

- **Louisiana**. Again, in this state, laws are in conflict with a family's rights and should be challenged in court. A family in Louisiana may transport a body once all permits are acquired. A mortician, however, is needed for all other aspects such as obtaining permits and at final disposition.

- **Nebraska**. Statutes regarding family rights (and obligations to pay the bill) are in conflict with statutes requiring a funeral director to be in charge of all deaths.

- **New York**. As in Louisiana, a family may transport a body once all permits are acquired. A mortician, however, is needed for all other aspects such as obtaining those permits and at final disposition, so this information is primarily helpful only to those taking the body to another state.

When Autopsy Is Necessary

If the deceased died as the result of a violent, accidental, unexpected, suspicious or unusual death, including a suicide, an **autopsy** will be required by the **medical examiner/coroner**. An autopsy **determines the cause of death**.

In some instances, an attending physician may ask the family for permission to have an autopsy performed in order to gather more information on the cause of death—information that may help others as in the case of genetic or contagious disease. The family has the right to object unless law mandates the autopsy due to the circumstances surrounding the death.

In certain instances, the family may request an autopsy. If you feel unsure about the cause of death or question the care your loved one may have received at the hospital where he or she died, you may hire an independent pathologist and arrange for an autopsy. A family may want to request an autopsy when:

- the loved one was in good health;

- there may be a chance of genetic disease;

- there may be a work-related cause;

- there may have been a misdiagnosis; or

- there may have been malpractice at a care facility.

Before requesting an autopsy you may want to discuss the procedure with your family, the deceased's doctor, your lawyer and your clergy. There may be benefits for your family or others with a similar medical condition as the deceased. Or you may have greater peace of mind regarding the cause of death. There are various religious philosophies regarding elective autopsy.

No autopsy should be requested if you plan to donate the body to a medical school or education facility.

If your family requests an autopsy, you will have to pay for the cost of the exam and transporting the body to the funeral home or place of final disposition. When it's requested by the doctor or required by law there should be no extra cost to you.

State and law enforcement involvement in the autopsy may delay release of the body, which may add to your frustration and grief. The body can be released to the funeral director you select or you may choose to handle arrangements yourself. In several states, the state is obligated to cover all costs for returning the body to the family if asked to do so. If you choose to receive the body yourself, be warned: After the medical examiner's exam, the body may not be returned intact or cleaned up in anyway. This may be traumatic for the family, and you may prefer to use a funeral director's services.

> The coroner may have a relationship with a funeral home, or may even be a funeral director—but that does not mean that you have to use that particular home if you don't want to.

Following an autopsy, a funeral director may prepare the body for an open-casket service, if that's what your family wants. However, you may not wish to have a viewing of the body after the coroner has completed a thorough *medicolegal* autopsy, which includes examination of the head. If you do wish to see the body after the coroner's exam, discuss this with him or her in order to prepare yourself for what you will be seeing.

When Death Occurs Under Hospice Care

If your loved one was terminally ill, he or she may have been receiving care under the hospice program. **Hospice** is not a place but a care concept designed to provide comfort and support to patients and their families facing a life-ending illness. Hospice is usually avail-

able upon referral from a patient's doctor if the patient has a life expectancy of approximately six months or less. Patients and their families who elect hospice understand that care is **palliative**—aimed at pain relief and symptom control—not curative.

Participants in the program sign forms that clearly define their wishes, which include a **Do Not Resuscitate (DNR) form** or other advance directives. According to the Hospice Foundation of America (HFA), patients do not need to have a DNR order signed at the time of their enrollment into hospice. Often, physicians rely on hospice to get a DNR order because they are reluctant to hold the discussion with patients themselves.

Hospice staff work with the families of the dying to prepare them as much as possible for the inevitable. They also provide a list of instructions to follow in the event of the death. Bereavement services and counseling are typically available to survivors up to a year after the loved one's death.

If your loved one has been receiving hospice care a hospice worker should be called at the time of death. The hospice worker will confirm the death and call the doctor and the funeral home (if you choose to use one for final disposition.)

Since your loved one will likely be receiving hospice care in his or her home, or yours, there's no rush to remove the body. You may keep the body at home for several hours or even a few days, if you would like the time to say goodbye and to obtain the necessary permits and make arrangements for final disposition. (Turn off the heat and put on the air conditioning to help contain the body for up to 72 hours depending on the weather).

If you want to handle the final arrangements, yourself you are free to do so as long as you obtain the proper documents required by your state and local authorities. As with hospital staff you may have to let the hospice staff know of your plans to handle final disposition yourself. Make them aware of your plans and inform them of your rights

well in advance in order to avoid any conflict or additional stress at the actual time of death.

For more information on Hospice Care contact: Hospice Foundation of America, 2001 S St. NW #300, Washington D.C. 20009, phone: (800) 854-3402, fax: (202) 638-5312.

When Death Occurs at Home

Whether your loved one suffered from a prolonged illness or experienced a sudden accident—unless he or she is under hospice care—if he or she dies at home, you should call 911. If you live in an area without 911 service, call the police or other emergency number. (If he or she died under hospice care, call your hospice nurse.)

Emergency personnel will immediately be dispatched to your home. Be sure to state your name, address and type of emergency—whether there's been an accident, the person has stopped breathing or you've found a body that's been dead for some time. Stay on the line and even if you don't know the exact address or are too flustered to convey information coherently, the 911 dispatcher should be able to find your location and pass it on to responding emergency personnel.

Sadly, since so many elderly persons in the U.S. live alone, they also die alone. Concerned neighbors find their bodies. In such cases, the police will seal the house or apartment to protect its contents until the next-of-kin can be located. Once the appropriate individuals are located, the seal will be broken and the family will be allowed to enter the home.

If medical personnel respond before the police and the person is assessed to have been dead prior to their arrival, the police will still need to be called. Police must investigate all deaths that occur without medical personnel in attendance.

The paramedics or responding personnel may call the police for you. They may also call the **coroner**. The coroner's job is to investigate facts that will help to determine the cause of death. It's not his or her job to pursue criminal prosecution or to look for someone to blame for the death. Don't be alarmed by the ensuing investigation—the police and the coroner may take pictures of the body and of the house and ask you several questions. They are not trying to implicate you in any wrongdoing. It is merely standard procedure to help determine the details surrounding the exact cause of death. If you are uncomfortable or need emotional support you may call family or friends to be with you while the police are in your home.

The coroner may ask you questions about your loved one's medical condition—illnesses or diseases and if he or she was under a doctor's care. The coroner may ask for the name and number of the doctor for help in confirming the cause of death. Even though medical records may be provided from your loved one's doctor to the medical examiner, there still may be a need for an **autopsy**.

> A medical examiner usually has some medical training, and is appointed by the department of health. A coroner, however, is an elected official. In most states, anyone can run for the office of coroner without medical training.

If an autopsy is not necessary, you may ask for the death certificate and to keep the body at home if you'd like to prepare the body yourself (or with family or friends) for a home funeral and final disposition. If the death occurred on the weekend, getting all the permits you need may be more difficult and you may have to work through a funeral director to get them.

If the deceased dies anywhere other than a medical facility, it is unlikely that organ or tissue donation will be possible because harvesting needs to be done immediately and in a sterile environment. However, an eye bank may be able to arrive in time to quickly remove

much-needed corneas. Body donations may be possible unless an autopsy is performed or the body has been severely damaged.

When Someone Dies at Work

If someone dies at work, his or her employer will immediately notify the person listed as the emergency contact. If you also work and are listed as the emergency contact and his or her company only has your home phone number, it may be difficult to track you down. This is why it's important to provide employers with your work and cell phone numbers as well as your home number. In addition to the emergency contact information, an employer should know if its employees have heart disease, asthma, diabetes or other serious medical condition.

When called, you should be told at least some of the circumstances of the death and to which medical facility the body has been taken. Ask a friend to drive you to the hospital or wherever you are told to go. Do not drive if you are upset.

If it is a sudden death, 911 will be called and Emergency Medical Technicians will be dispatched in an attempt to resuscitate the body.

It is the employer's responsibility to be sure that prompt medical attention is called for a sick or injured employee at the workplace, regardless of the cause of the distress (even if it was not a work related injury). In most instances, if a death occurs the body will be removed to a hospital, the coroner may be called to investigate and an autopsy may performed in order to determine the cause of death.

According to the Occupational Safety and Health Administration (OSHA), there were 5,900 worker deaths in the U.S. in 2001 — and this figure does not include fatalities related to the 9/11 terrorist attacks.

If the death was work related the employer is required to file a report with the local OSHA office. If working conditions caused the death you may want to file a complaint and report the workplace violation to OSHA, which may investigate your claim (*www.osha.gov*). If the employer is found to be in willful violation of OSHA standards penalties may be imposed and changes will be made to protect other workers.

You may also be able to file a **wrongful death claim** against the employer. Consult with your attorney or a skilled personal injury lawyer about the possibility of pursuing a claim for monetary damages.

Medical expenses incurred prior to death that were the result of a workplace injury or disease may be paid through a **workers' compensation claim**. As the surviving spouse, you and your children may be entitled to death benefits such as a pension or other benefits, whether your loved one died at work or elsewhere. Contact your state's Workers' Compensation Board or Department of Workers' Compensation to file a claim.

Check with the employer's human resources representative. He or she can help you file a claim and find out what benefits you are entitled to. If you are the surviving spouse, your may also be due back pay as well as vacation benefits, stock options and other benefits.

When Someone Dies Away from Home

Just as when someone dies at home or at work, if he or she dies while traveling, emergency personnel should be called. If you are unfamiliar with the local emergency numbers, ask management of the place where you are staying to call emergency personnel for you. An unexpected death may require an investigation into the cause of death by local law enforcement, including a coroner. You may be asked a number of questions regarding your loved one's state of health at the time of death, or what may have happened in the case of an accident.

This doesn't mean you are under suspicion; the investigators are merely trying to determine the cause of death.

Once death has been pronounced, call home to notify family and close friends, especially since you are in unfamiliar surroundings. Leave a number where you can be reached.

It will be your responsibility to have the loved one's personal belongings shipped home.

> If the body is to be shipped back home—within the Untied States—make arrangements through the funeral director near your home. You may want to ask family or friends back home for the name or names of funeral homes near home. Be sure to provide the funeral director with the full name of the deceased, the place of death, the location of the body and where and how you can be reached.

The funeral director may work with a funeral home in your location to secure transportation permits and copies of the death certificate as well as preparation of the body for shipping. He is required to provide you with a price list prior to shipping that includes the cost of shipping the body and any other services he will provide—such as meeting the body at the airport and, if necessary, arranging for a translation of the death certificate and other documents. If you don't see such a price list, ask for one.

If the deceased was traveling alone and is found dead, and if he or she was carrying identification, the police will use that information to seek out the next-of-kin. They may call law enforcement in the area of the deceased's home and send them to the address listed on the driver's license or I.D. If family is not home they may meet with neighbors to try to find the family.

If the deceased wasn't carrying any I.D., then the police may have to use finger prints or dental records for identification. They will then use that information to track down the next-of-kin.

> If you were not traveling with the person at the time of death, and have decided to travel to the country where death occurred, you may be eligible for **bereavement airfares** (available on both domestic and international airlines). They may however, be expensive and you may want to check for lower fares first.

Prior to being shipped via common carrier, (i.e., air, rail or sea) the body may need to be embalmed. If you object due to religious beliefs, the carrier may allow you to refrigerate the body or use dry ice in order to help preserve it while traveling. No one needs to accompany the body, but if you choose to do so, tell the ticket agent upon booking your ticket.

Cremains—cremated remains—can usually be shipped via registered mail. In some states, Federal Express will accept cremains for shipment; UPS however, will not. Needless to say, cremains are less expensive to ship than a body.

You may want to have the body buried or **cremains** dispersed in the area where death occurred. (In the U.S., cremains may be scattered in all states except California.) Consult with a funeral home or crematory in the area, as well. You may want to contact the Funeral Consumers Alliance for a list of ethical and affordable facilities in the area. (If the deceased was a member of one of the FCA affiliates, he or she would be entitled to the discount offered to local members. Call the local affiliate to see what services are available.)

When Death Occurs Abroad

When a U.S. citizen dies abroad, making arrangements for disposition can become very involved and expensive. The **Citizens Emergency Center** assists with the return of the remains of citizens who have died abroad. The **Bureau of Consular Affairs** in conjunction with the U.S. State Department is responsible for locating and informing the next-of-kin.

Between 6,000 and 8,000 Americans die abroad each year.

If your traveling companion has been pronounced dead while traveling abroad, the Bureau of Consular Affairs will function as the liaison between the family back home and the local officials in the country where the death took place. If you are faced with this situation while traveling, the Department of State recommends that you call the U.S. Embassy or consulate before calling the person's family. The Bureau of Consular Affairs will send a cablegram to the next-of-kin back home with official notification of the death, including an explanation of circumstances surrounding the death. They will also send an outline of available options for disposition to the family, along with costs.

An officer from the Bureau may be assigned to work with the family to discuss the cost of shipping the remains. The family will need to relay its decision for disposition immediately to the consulate or embassy. This can be done directly by the family through the assigned officer or through the Department of State's Overseas Citizens Services, which can be reached 24 hours a day at (202) 647-5226.

The cost to return a body to the U.S. for disposition can be expensive. Arrangements will need to be financed with private funds. In most cases, the U.S. government will not pay for the repatriation of a deceased U.S. citizen. The fastest way to access needed funds will be to wire them to the Department of State (there's a $20 processing fee), which will then wire the money to you at the embassy.

An officer from the consulate will prepare an official Foreign Services Report of Death of an American Citizen, based on the local death certificate. You will need to use this report—just as you would a death certificate—to verify the death, settle the estate, file life insurance claims and apply for survivors benefits.

If you were not with the deceased when he or she was abroad, it is the responsibility of the Bureau officer to:

- Report the death to the State Department, who will relay the information to the next-of-kin;

- File a Consular Report of Death;

- Help identify the body;

- Carry out the wishes of the deceased or next-of-kin regarding the disposition, including taking care of documents required (which may include Consular Mortuary Certificate, transit permits and death certificate) in both the host and home countries for shipping the remains; and

- Inventory the deceased's personal effects—clothes, money, jewelry—and return them to the next-of-kin if that is what the family wants.

> The Department of State Office of Overseas Citizen's Services can be reached at 202-647-5225 between 8 a.m. and 10 p.m. Eastern Standard Time on weekdays, 9 a.m. to 3 p.m. on Saturdays and at (202) 647-1512 or (202) 647-4000 after hours or on Sundays. (You can write them at U.S. Department of State, 2201 C Street NW Washington, D.C. 20520.)

If you wish to have the body returned to the United States, it will be prepared and shipped according to local laws, customs and facilities. It may cost a great deal and may take a week to 10 days or more to complete. If you are planning to use a funeral home for arrangements once the body is returned to the U.S., you should notify the funeral director as soon as possible so that he may assist you with arrangements.

Embalming is not widely practiced in countries outside the U.S. and Canada. Other methods of preparation are used, which may pre-

clude an open casket viewing. For example, the body may be wrapped in a chemically-saturated shroud. In other countries, particularly in predominantly Catholic or Muslim countries, cremation may be prohibited. Some countries have only one crematory, causing greater cost and delay in returning the cremated remains.

If you elect to have the body disposed of in the country where the death took place, the U.S. Consulate will inform you of your options. Some countries do not allow the burial of foreigners.

There is an urgent need of organ and body donors in many countries and great international good will could be born out of such a generous gesture. Again, the Consul's office can help you with this.

Options When a Loved One Dies Abroad

- Bury body in host country. (Keep in mind: Some countries do not allow the burial of foreign nationals);

- Return body to U.S. Will require preparation and "packaging" of the body, embalming may not be available in all counties;

- Cremate body. May not be available in all countries, in some countries it is forbidden;

- Return cremated remains to U.S. The consuls office can help with making these arrangements and having them sent to the family;

- Donate the body to a medical school. The consul's office can help with making these arrangements, too.

Conclusion

No one's completely prepared for the call, mail or visit that says a loved one has died. But most of us will receive this message at least once in our lives. When this happens, sadness is usually mixed with confusion about what needs to be done. This chapter has outlined the

basic answers to that question. But more questions keep coming in the hours and days after. The following chapters will deal with those.

2 In the Hours Afterward

Following the pronouncement of death by a physician, medical examiner or nurse—and in spite of your exhaustion and grief—you will be expected to make a number of decisions, contact a great many people and agencies and do a number of other things in a relatively short amount of time. Some decisions, such as whether to donate organs or tissues, will need to be made immediately (if the deceased had not expressed his wishes prior to death). Others, such as the type of funeral or memorial, need not be rushed.

When someone dies, there tends to be a feeling of urgency about matters, which adds to the stress of an already difficult situation and causes people who are having a hard time thinking clearly to make decisions that are costly. Try to remain calm, take your time, ask questions, and whenever possible, ask for help. Close family, friends and clergy—can help you with the many tasks and decisions you have ahead—can also lend you much needed support.

Although you may feel that all the responsibility falls to you as the spouse, next-of-kin or partner of the one who has died, you do not need to make all of the pressing decisions and do all of the immediate tasks alone. Friends and family really do want to help at a time like this. Take the pressure off yourself by delegating as much as you can to others—including neighbors. Having something to do can help them work through their grief and pay tribute to the deceased. By

including others, you can avoid making hasty emotional decisions and alienating family members who want a say in the planning of the arrangements.

This chapter addresses the things you will need to do immediately following the death of your loved one. Below is a checklist to help you prioritize and keep track of the many things you will have to do.

What to Do First

☐ **Call 911 or emergency services** (if necessary, as discussed in Chapter 1).

☐ **Call hospice caregiver** (if deceased was under hospice care).

☐ **Call deceased's doctor** (if not in attendance at the time of death).

☐ **Call immediate family members**.

☐ **Call close friends**.

☐ **Call clergy** (Priest, Rabbi, Minister or other spiritual counselor).

☐ **Call executor**. (He may have a copy of the letters of instruction and the will, which may contain time-sensitive information.)

☐ **Locate letter of instruction and/or will** (specifically regarding organ donation, guardianship of minor children and final disposition).

☐ **Carry out organ, tissue or body donation arrangements**.

☐ **Decide whether an autopsy is necessary**. (If law enforcement makes such a pronouncement, you can not object. Otherwise it's your decision at your expense.)

☐ **Make arrangements if death occurs far from home**.

☐ **Call memorial society, funeral director or persons to assist with funeral and final disposition.**

911 or Emergency Services or Hospice Caregiver

If the death occurs at home, your first call should be to 911 or emergency personnel. However, if he or she has been under hospice care, you should call the hospice nurse. If the deceased dies in a hospital or nursing home, staff there should be able to provide you with support and guide you through some of the initial decisions you'll need to make.

Calling the Doctor

If the deceased was under a doctor's care at the time of death, the hospital may inform the physician of the death. If death was sudden and unexpected, the coroner or attending emergency room (ER) physician may have consulted with the doctor in an attempt to determine his or her medical history and the underlying cause of death.

> If you are considering donation, discuss any concerns you may have with the doctor. He should be able to tell you if the deceased is a good candidate for organ donation given his or her age and overall health at the time of death. He may also be able to help put you in touch with a transplant team and a needy recipient.

Consult with the doctor regarding the cause of death and discuss any need for an autopsy. There may be reasons for requesting an autopsy, particularly if the deceased seemed in good health at the time of death, or if he or she suffered from a genetic disease and an autopsy will reveal important information for other family members and *their* health.

If you think an autopsy should be performed, discuss this with the doctor. If you think the death may have been the result of a misdiagnosis or a workplace or environmental hazard, then you may want to request an autopsy in order to file a wrongful death claim. If an

autopsy is performed at the request of the next-of-kin and not the coroner or deceased's doctor, the family will assume responsibility for the bill.

If the person had more than one doctor, including a psychologist, psychiatrist or therapist, you may want to inform them of the death. If you are not sure how to reach the person's doctor you might be able to find his or her name and number on medication or prescription bottles.

The doctor or the physician attending your loved one in the hospital will sign the death certificate—which will include the cause of death, including the underlying cause of death.

Death Certificate

A **death certificate** includes details such as the time and date of death, sex, occupation, date of birth, place of birth, residence, citizenship, Social Security number, marital status, name of spouse and names and place of birth of parents. The certificate may also require the name of the person providing this information.

Whether you fill out the form or leave it to the funeral director, make sure that all the information is accurate and that the appropriate medical professionals sign it. If there is a mistake, the process may be held up for weeks, which will interfere with your funeral plans, probate proceedings and filing for death benefits. Hospital or hospice staff can also help prepare the form. However, either you or the funeral director will need to file it with the **registrar's office**.

Each state has different regulations and filing rules regarding death certificates. If you are doing the filing yourself, you may want to check with your local registrar's office. You will need several official copies of the death certificate for probate filing, preparing tax returns, gaining access to the deceased's bank accounts and safe deposit boxes and for filing claims for any death benefits due to the family. A funeral director can get these copies for a service fee or you can get them yourself from the registrar's office for less.

Ordering Copies of the Death Certificate

You and the executor (if you're not the executor) will need several certified copies of the death certificate for probate filing, preparing the deceased's tax returns, gaining access to his or her bank accounts and safe deposit box and for filing claims for any death benefits due to the family. You'll need a death certificate to change the title on investments, mutual funds, brokerage accounts, property, real estate and vehicles—even jointly held assets will require a certified copy of the death certificate.

Your funeral director can get copies for you for a service fee or you can get them yourself for less from the registrar's office in the county where the deceased lived at the time of death (or in the county where he or she died, if different). Look in the phone book under registrar of vital statistics, registrar of deeds or similar listing. You will be asked to provide the following:

- the name of the deceased;

- date of death; and

- city where death occurred.

> It may take two weeks to get copies by mail or (if the death was within 60 days) you may go to the registrars office to pick up copies. It may cost you between $5 and $10 for each certificate, however, there may be a discount on the additional copies ordered.

Family and Close Friends

It's never easy to tell family and friends about the death of a loved one. Even if the death was expected. Don't feel that you have to call *everyone* right away, or that you have to call everyone yourself to deliver the news. Call the loved one's core family and close friends first. Then ask your close friends to call other friends outside of your immediate

circle to inform them of the death and any arrangements such as the time and location of any funeral or memorial service, once that has been decided.

Let close family members help by contacting extended family members and sharing the same information. Have those who live far away contacted as soon as possible to allow them time to make any necessary travel arrangements should they decide to attend the funeral or memorial. Ask one or two friends or relatives to serve as secretaries—keeping a log of who has called and who should be called.

You and your family may feel that things are out of control. By including everyone in the decision making and giving each person a responsibility, a part in planning the service and helping with the details you will be taking some of the stress off your shoulders and giving them a sense of some control over the situation at hand.

Delegate, delegate, delegate. Assign family and friends various responsibilities for which you may not have the time, inclination or ability to handle on your own. They will appreciate having a useful part to play at your time of need.

The following is a checklist of just a few of the many things you can assign to family and friends.

What Others Can Do to Help

☐ Secure the home or apartment and belongings of the deceased if he or she lived alone;

☐ Collect the personal effects from the hospital, nursing home or police;

☐ Arrange childcare or elder care for the deceased's dependents;

☐ Make sure the deceased's pets are taken care of;

☐ Answer the phone and the door bell;

☐ Keep track of phone calls (make a list of who calls);

- ☐ Pick others up from the airport;

- ☐ Prepare and supply food;

- ☐ Clean the house;

- ☐ Arrange hospitality for out-of-town guests; or

- ☐ Water plants.

These things will need to be taken care of almost immediately following the death.

If the deceased lived alone, you will need to be sure that you secure his or her home and its belongings—immediately. Thieves notoriously take advantage of such a situation. They often break in because they know that no one will be home. Some thieves even go so far as to read obituaries, looking for people to prey on. They read the obits to find out when a service is taking place and then break in when everyone is out attending the service.

The solution? Ask a neighbor to stay in the house or keep an eye on the house during the service. If no one will be living at the deceased's home for a while, hire someone to stop by as if he or she were out of town. Keep the lawn mowed, take in the mail and water any plants. Cancel any newspaper delivery as soon as possible. Piled papers and an unkempt yard are the first signs that a house is empty.

Another suggestion: Ask a neighbor to watch the children who will not be in attendance—at your home. This way, the house won't be empty. If a neighbor is not available or attending the service, get a baby-sitter. If the deceased did not live with you, ask one of his or her neighbor's to keep an eye on the deceased's residence, as well.

When the post office learns of the death, law says, it will hold the mail for 15 days and then return it to the sender. Be sure to have someone contact the post office and have the loved one's mail forwarded by filing a change-of-address form.

If you are not the one designated by the will or the probate court to settle the estate, you may need to have the mail forwarded to the deceased's **executor**. The executor is legally responsible for handling the estate's assets and liabilities. (See Chapter 7 for more on the executor's duties.)

The executor can have the mail rerouted to his or her address and by providing the postmaster with a copy of the letters of authority or instruction (see Chapter 7 for more on this). Family can do the same by providing the postmaster with proper identification and a copy of the death certificate. However, if the postmaster gets two change-of-address forms, the executor will have final authority.

You will also have to notify the utilities companies, the gardener, housekeeper, landlord and others that the deceased might have employed or be indebted to. You may want to ask a family member or friend to be in charge of organizing any incoming bills and contacting the companies that send them to find out what their policies are when someone dies. They may or may not need a copy of the death certificate to close an account. If a person other than you is the executor this will be one of his or her responsibilities. Make sure you contact the executor immediately after the death.

Social correspondence should be answered by family members or by means of a death announcement. (More on this later.)

Magazines can be donated to a library or canceled with a request for a refund for the remaining portion of the subscription.

Calling Clergy

Contacting your priest, rabbi or other religious counselor may help you spiritually and pragmatically with the decisions you have to make regarding organ donation, body donation, final disposition and funeral or memorial arrangements. Most churches or synagogues have a number you can call day or night in order to reach someone for assistance and guidance. If you don't know the number, look in your local Yellow Pages.

If the deceased had been sick for some time you may have already called your priest or rabbi and had them visit with your loved one at home or in the hospital. Most clerics prefer to be called as soon as someone is sick or hurt so that prayers for healing can be offered on behalf of that person and spiritual counseling can be administered.

So what happens if the deceased wasn't a member of a church or congregation? Our generation is much less likely to have these relationships than our grandparents did only a few generations ago. However, just as weddings and births have a way of bringing people back to their roots, the impact of a death in the family is so profound it has a way of bringing us back to our cultural traditions and religion. Even if you—and the deceased—did not have an affiliation with a particular church you are still welcome to call for council and advice.

However, the break from tradition may allow you greater freedom to plan the type of personal, meaningful memorial that you know your loved one may have wanted.

If you feel it would be important to the deceased to follow the traditions of his or her faith, the rabbi, priest, minister or religious leader can council you on what these guidelines are and the significance of certain rituals. If you want the cleric to preside over the services, it is always best to confirm their availability before making arrangements with the funeral home, church or other location where the service will be held. If you want to have a funeral mass or service in the church, you need to schedule this time with the church. If you use a funeral director, he can do this for you.

Likewise, your cleric or church may be able to recommend a funeral home, if you choose to use one, that meets your family's particular needs. Some funeral homes cater to particular religious groups as well as different cultural groups. In Los Angeles, for example, there are more than four pages of churches listed in the phone book representing a number of different ethnic, religious and cultural groups that each have their own houses of worship and connection to particu-

lar funeral establishments that understand and specialize in their needs (the African Methodist Episcopal Church, the Armenian Evangelical Church, the Korean Baptist Church, the Greek Catholic Church, the Hungarian Reformed Church, the Russian Orthodox Church and the Polish National Catholic Church, just to name a few).

> Throughout history, funerals were a major responsibility of religious leaders and the religious community. Over the years, however, many have been willing to advocate involvement and let the funeral directors take over.

Funeral directors are not religious leaders. They are secular businessmen. Although some may have an affinity with a particular religious group or establishment, they are in no way part of a church, temple or synagogue. (Although there may be a *few* who are also ministers or rabbis.) The "chapels" that some funeral homes or crematories operate are "for-profit" establishments and should not be confused with a church or house of worship. You shouldn't be charged for the use of your church or synagogue or other place of worship for a funeral service. (There will be an honorarium for the cleric and maybe an offering for the mass.) However, you will be charged for the use of the funeral home's chapel or other facility.

You may want to work with a funeral home that your clergy is comfortable with, since in some instances funeral directors may clash with the clergy when it comes to counseling the bereaved on funeral purchases. The clergy may stand in the way of the funeral director by essentially "directing" the funeral and counseling their flock toward humble religious ceremonies with simple caskets and burial in the local church yard. If the clergy accompanies the family to the funeral home, the funeral director may try to get the family alone so that they are not be influenced by the clergy to choose a simple, humble (less expensive) casket.

Many churches, synagogues and other religious establishments, and in some cases particular clergy, have "relationships" with for-profit funeral homes. Many funeral homes furnish gifts including vacations, cell phones, cash or even sides of beef (yep, that's what I said) to the clergy, parish or congregation for recommending their funeral establishments to their parishioners.

Some funeral homes even take the liberty of including an inflated price of an "expected" honorarium in their general prices lists to insure that the clergy get top dollar for their services and keep sending business to their funeral home.

One funeral home I visited told me that the $200 honorarium for a priest was a non-negotiable part of my contract. The money was to be given to the funeral home and then given it to the priest. When I spoke with my priest he told me he has never received a $200 honorarium for a funeral. I wonder how much he would have gotten of the $200 I was asked to give the mortuary on his behalf. I walked out of that funeral home before I had a chance to find out after several other slightly less than ethical negotiations were tacked on to my bill, including a $400 handling fee for a casket I bought elsewhere (illegal) and $260 for a motorcycle escort for a four-car motorcade, which I was told was "required by law" (wrong).

> These gifts to clergy make it harder for Church officials to maintain an unbiased opinion when it comes to funeral home selection.

The separation of "church and state" gets fuzzier yet. Certain communities have formal arrangements with funeral conglomerates such as the one between the Los Angeles Catholic Archdiocese and Stewart Enterprises. Stewart contracted to build five mortuaries on the tax-exempt cemetery property owned by the dioceses. There are six more Catholic cemeteries owned by the diocese and plans are in the works

for Stewart to capitalize on them in the future as well. There is, of course, some financial benefit to the diocese since Stewart leases the land. In exchange, Catholic funerals are funneled to the Stewart mortuaries.

According to a spokeswoman in Archdiocese Department of Cemeteries, priests "in good standing" in the diocese are encouraged to send parishioners to the Stewart mortuaries since they are conveniently located on Catholic cemetery grounds. The independent funeral homes (on taxable land) suffer and the cost for a traditional Catholic funeral and burial in the area is top dollar. Why? In part, because of a lack of competition.

> Stewart has become well versed in the Catholic funeral traditions, however because it has been given the blessing by the Church to allow mourners to believe that other elements of the funeral are also part and parcel of the Catholic tradition—such as the viewing.

Stewart runs the mortuaries for the Church and the Church collects from Stewart. Everyone benefits from the situation—except maybe the bereaving parishioners, many of whom are low-income minority families.

> If you ask your clergy for a recommendation, you may want to ask why he recommends that funeral home over another. It may be the answer he's been told to give or he may have had a better experience with one than with another. Or he may think that a certain mortuary understands your particular funeral traditions better than another.

My priest recommended that I go to the one closest to my home or the Church—in order to save me driving time. This was a sensible idea from that standpoint—but I found that the prices near my home were substantially more than those in a community or two over.

Take your clergy's recommendation merely as a suggestion, don't feel pressured to go with his recommendations. You will still need to comparison shop.

Many faiths stress humility in death, the return of "ashes to ashes and dust to dust." However, you may recall, as I do, a more lavish funeral for your grandmother or grandfather. The "full funerals" were born from traditions the funeral industry has perpetuated throughout the last half century. The open casket, embalmed body, satin-lined bronze casket, lavish flower displays and limousine motorcade, have nothing to do with a religious or spiritual tradition. The more you buy as a tribute to your loved one, the more money the funeral director will collect.

Remember, your loved one knew how much you cared during his or her life, lavish displays of affection after death won't change that. Your rabbi or minister may help you make practical decisions that will result in a more spiritual, rather than financial, tribute to your loved one.

The Executor

Also known as a **personal representative** or **administrator**, the executor, is a friend, relative, attorney, bank or trust company appointed by the deceased in his or her will or by the probate court to carry out the terms of the will or, if there was no will, in accordance with the state's **intestacy laws**. (See Chapter 7 for more details on the responsibilities of the executor and settling the estate.)

The executor is responsible for the initiation and administration of the probate process—if it is necessary—inventorying the deceased's assets, paying final taxes and debts and distributing the rest of the estate to the designated beneficiaries. This process can take only a few days but, depending on the size of the estate, typically takes between six months to a year and a half.

If you are not the executor, you will want to inform the executor of the death as soon as possible. This individual should have copies of the will and the letter of instruction, which may contain time-sensitive instructions such as the deceased's desire to bequeath anatomical gifts.

Also, if there are children orphaned by the death, these documents will indicate the person designated as guardian. This should also be addressed as soon as possible.

A letter of instruction, if one exists, should tell you what the deceased wanted for his or her final arrangements. Although less than half of Americans write some kind of will, even fewer die with a letter of instruction for their loved ones. A letter of instruction will help you in planning the funeral and final disposition. It will also help with advice on funeral funding since funds may be coming from the estate.

If you are the spouse or next-of-kin you may have a copy of the will or a letter of instruction naming the executor chosen to handle the deceased's affairs after death. If you are not the named executor, contact the executor as soon as possible after the death. If you are not sure who the executor is, check with your family and friends and with the deceased's attorney. The attorney who drafted the will should have a copy and be able to identify the nominated executor. You can also check with the probate court to see if the deceased filed the original will there.

If your loved one died without a will, the probate court will appoint a personal representative to handle administration and settlement of the estate in accordance with the state's intestacy laws. The court usually appoints a relative—the surviving spouse, adult child or family friend. In some cases, it may appoint a stranger. If you wish to be the appointed executor, you can include such a request when you file the petition for commencement of proceedings in the probate court. You can be a beneficiary of the deceased and be the executor.

Letter of Instruction

A **letter of instruction** will tell you whether the deceased made a bequest of anatomical gifts and what his or her preferences were regarding final disposition and funeral arrangements. A letter of instruction lists the deceased's assets and liabilities in detail, specifies their location and identifies their form of ownership (solely, jointly, in a trust or payable to a beneficiary). The executor will need this information in order to settle the deceased's estate. (A will should not contain this information, as access to the will usually takes more time and this time-sensitive information may be found too late.)

Oftentimes, the letter of instruction will include all types of other information that will be helpful to survivors, such as computer passwords, where keys and important papers are hidden, the contact information for the gardener, the plumber, the mechanic, etc.

The letter may also contain any personal messages that are not appropriate to include in a will. (The will, once filed in probate court, becomes a public document, accessible to anyone.) In addition to funeral arrangements, the letter sometimes expresses wishes, such as how to divide personal property—clothes, plants, photos, odds and ends—that are not included in the will. Big-ticket items—such as real estate, jewelry, stocks and bonds—are part of the estate and subject to probate if not held jointly.

If the death was expected, you may have discussed these arrangements or know where to find the letter of instruction. But, if the death was unexpected or final arrangements where not discussed, you may have to locate the letter, if one exists.

> The deceased's attorney or executor should have copies of the letter of instruction, if one exists.

If no executor has been appointed prior to death, you may need to enlist the help of family or friends in looking for the letter and any

other important documentation. Look in drawers, closets, desks, the garage, the attic, etc.

Unlike a will, a letter of instruction is not a legally enforceable document. It can be in almost any format from an informal letter to a computer disk. It should be immediately accessible to the executor after the death. Even if you find a letter of instruction, you may or may not be able to follow the deceased's wishes "to the letter" for financial or practical reasons. Don't stress over this. Do your best to honor your loved one's wishes, but consider what is best for you and your family. Do what feels right and what you can afford. Keep in mind that one of the main purposes of the funeral or memorial service is to comfort *you*—the grieving family and friends—and that's really what your loved one would have wanted.

If a letter of instruction can't be found (or you're putting stuff together for your own letter of instruction) the list on the following pages may help you organize the important information you will need in order to plan the funeral service, contact loved ones and file claims.

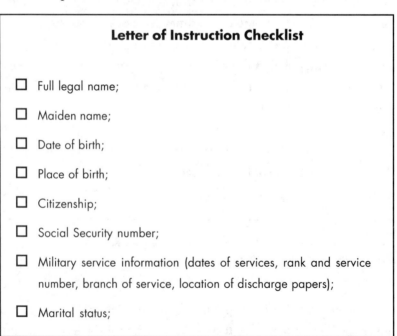

Letter of Instruction Checklist

- ☐ Full legal name;
- ☐ Maiden name;
- ☐ Date of birth;
- ☐ Place of birth;
- ☐ Citizenship;
- ☐ Social Security number;
- ☐ Military service information (dates of services, rank and service number, branch of service, location of discharge papers);
- ☐ Marital status;

☐ Name of spouse/partner, address and phone number;

☐ Names, addresses and phone numbers of children and dependents;

☐ Names (including father's legal name and mother's maiden name) and birthplaces of parents, if living, their addresses and phone numbers;

☐ Names, addresses and phone numbers of brothers and sisters;

☐ Names, addresses and phone numbers of former spouses;

☐ Names, addresses and phone numbers of friends, employers and others to be contacted;

☐ Advanced directives: health care proxy or medical power of attorney, living will;

☐ Organ/tissue or body donation information;

☐ Names, addresses and phone numbers of doctors;

☐ Religious affiliation;

☐ Designated agent for body disposition (funeral home or other);

☐ Type of disposition desired (body donation, cremation, burial);

☐ Type of funeral or memorial service (if any);

☐ Hymns/readings for service;

☐ Where to make donations in his or her name;

☐ Names of pall bearers (if any);

☐ Location of will;

☐ Name and phone number of attorney and/or executor;

☐ Location of keys to any safe deposit boxes and address of bank;

☐ Location and account numbers for all checking and savings accounts;

☐ Location of checkbooks, stock certificates, bonds, trusts;

☐ Location of all credit cards;

☐ Location of all insurance policies, policy numbers;

☐ Location of property titles, deeds, leases, real estate;

☐ Location of tax returns;

☐ Name and phone number of accountant;

☐ Debts owed to others;

☐ Debts owed to deceased;

☐ Memberships in professional/fraternal/social/volunteer organizations;

☐ High schools/colleges attended (dates and location); and

☐ Where to run obituary.

Other useful contacts to include in the letter of instruction:

• Therapist;

• Electric company;

• Heating fuel company;

• Telephone company/cell phone service;

• Gardener;

• Housekeeper; and

• Veterinarian.

Getting the Body Home

If the deceased died while traveling and you have to contend with having their remains transported home, you may want to enlist the help of a local funeral director. Ask others for references or check the local Yellow Pages for funeral director listings.

If the body has not yet been picked up by a funeral home in the area where the death occurred, and you don't intend on having any service in that area, ask your local funeral director to use a **body shipping service** such as Inman Nationwide Shipping.

According to the Funeral Consumers Alliance, Inman charges about $695 for the following:

- picking up a body;

- getting permits and the death certificate;

- embalming; and

- delivery to the airport.

There may be an additional mileage charge if the agent must travel a great distance. By comparison, a funeral home may charge anywhere from $750 to $2,000 or more for this service. Inman may also be able to arrange for a simple cremation.

If the body has already been taken to a funeral home in the town where the death occurred, your local funeral director can work in concert with that funeral home to have the body or cremated remains transported back home.

Ask about the cost of "forwarding remains." This option is offered by funeral homes as required by the FTC and usually includes pick-up of the body, the basic service fee, embalming, a shipping container and transportation to the nearest airport. The price of this option is often much less than the individual items listed separately.

Sometimes the shipping container is not included. There are two types of containers—one carries the body, the other protects the casket. According to the Funeral Consumer's Alliance, the wholesale costs for these items are approximately $68 and $49 respectively. The FCA advises that if the funeral home is going to charge you more than $100 for one of these, ask if there is a used carrier that can be recycled for a reduced rate.

If you're not planning a funeral with the body present once the body returns home, ask your local funeral director about "receiving remains"—another FTC-required option. According to the FCA, it may cost as little as $450 and should include picking up the body at the airport, filing permits and transportation to the cemetery where you can have a graveside service (which will be an additional cost but much less than a funeral.) And/or you can plan a memorial service anytime and anywhere after the burial.

If you do use the services of a funeral home on either end of the transaction, you should not receive a separate bill from each funeral home. Your local funeral director should work with the out-of-town director to coordinate billing.

Be sure to check your bills to be sure you have not been charged twice for the same service.

> In most areas, it is legal for a family to transport the body. Even if the family were to rent a van, it might be considerably less expensive than airfare, and such a journey may have some very therapeutic value. —Funeral Consumers Alliance

A local funeral director can also handle arrangements for returning the body if the deceased died while **traveling abroad**. He will contact the U.S. Consulate in the country where the death occurred and will arrange to have the body or cremains shipped to a local funeral home or he can help with arrangements for disposition on foreign soil.

Repatriation of the deceased's remains may take some time and be relatively expensive. If you can work directly with the consulate, I suggest doing so. The consulate probably knows more about these matters, will provide you with a list of options and save you the expense of involving a funeral director.

> Contact the U.S. State Department's Overseas Citizens Services for more information on handling a death outside of the U.S. at (888) 407-4747, (317) 472-2328 (from overseas) or visit their Web site at *http://travel.state.gov/medical.html*.

Prior to travel, some people purchase a **travel assistance** or **travel insurance policy** that includes the cost of medical evacuation and the return of mortal remains. Be sure to check through any travel documents the deceased may have left with you for this information. Plans that offer "assistance" may help with arrangements but any transportation will come at an additional cost to you. For example, some credit cards and travel programs offer assistance with "coordination" of medical or emergency travel. However, you will bare the cost of any transportation arrangements. Other programs are for medical evacuation only and do not include the repatriation of remains.

> If the deceased used a credit card to purchase his or her transportation, he or she might have been covered under a **free automatic life insurance plan**. You may have a short window in which to file such a claim. Check with the credit card company and or the travel agent who booked the itinerary for more information.

If the deceased purchased a prearranged funeral package from a funeral home, the plan may have included coverage for returning his or her remains from outside the local area to the designated funeral home. If you are aware of any pre-arrangement with a funeral home,

you may check the agreement for any such previsions. Additional details on the transportation of remains is covered in Chapter 1.

Memorial Societies

If the deceased was a member of a **memorial society**, such as the Neptune Society—a nondenominational, *for-profit* organization that specializes in **direct disposition**—the society may pick up the body, cremate the remains and scatter them by air or sea as directed. A memorial service is usually planned by the family separately, or sometimes the society will help with that aspect of the arrangements as well—for an extra charge.

Members of a for-profit memorial society pay a membership fee and pre-pay the society to take care of their final arrangements. Many societies provide a "package" that they pre-sell to members. These societies promote their services as less expensive than the "traditional funeral"—but this isn't always the case.

There are also *non-profit* **memorial societies** or consumer organizations run by volunteers who help members plan economic and meaningful funerals. They *do not provide funeral services* but contract with ethical funeral homes in local areas to insure that their members receive low rates for *only* the funeral services they want.

These societies conduct surveys of funeral service providers to find out which are serving consumers appropriately, within the guidelines of Federal Trade Commission regulations and at a fair price. Most charge a one-time membership fee of less than $30, but save members from 50 to 75 percent on funeral costs. Most of these societies will allow immediate "at need" membership so, if you or your loved one are not a member of such an organization and would like to take advantage of their member benefits call the society nearest you. (See Appendix A for list.)

If a member moves, he or she may transfer his or her membership. If death occurs away from home, you can enlist the help of the nearest society.

There are more than 150 societies in the U.S. united as Funeral and Memorial Societies of America (FAMSA). The organization changed its name to the **Funeral Consumers Alliance** because *for-profit* funeral organizations, like the Neptune Society, were using "society" in their names in an effort to confuse consumers.

> A non-profit funeral consumers' organization—sometimes known as a society—will never try to sell you anything. If you are in doubt about whether you are dealing with a genuine consumer organization contact the FCA—all legitimate consumer organizations are members of the FCA.

If you are calling a "memorial society" for help with disposition ask if they are a non-profit group that can give you the name of ethical funeral directors and crematories or if they are a for profit organization that handles direct disposition. Either way, know which it is you are looking for when you make the call.

If your loved one has already died it may be too late to join a chapter of the FCA, but you can call your local consumers' organization for information that may help you find an affordable death care provider in your area.

> If there is not a funeral consumer organization in your area, or if you are not sure where to find one, you can contact the Funeral Consumers Alliance central office in Burlington, Vermont at (800) 765-0107.

If the deceased was a member of a memorial society, you should contact the society immediately after death so they can begin to help you fulfill the deceased's wishes for final disposition. The letter of instruction, will or documentation in the deceased's wallet may indicate if he or she was a member of such a society and how they can be reached. You may want to look for these items before you call.

Finding a Funeral Home

If the death is unexpected, you probably won't have a funeral home in mind. Most people ask family, friends, hospital or nursing home staff or clergy for a reference to a funeral home. Ask for a few suggestions and call or visit several before making a decision. This may not feel like the right time to be shopping. But, like any major purchase, you don't want to go with the first and only recommendation you get.

You can save thousands of dollars by calling around to even a few homes in your area.

The Federal Trade Commission requires that all funeral homes quote prices over the phone when asked. By law, they don't have to offer to do so until you ask. By calling around to at least a few homes, you will get a better sense of each and what they have to offer. Not to mention a better idea of which may be the more affordable for you. To be sure you are comparing apples to apples, it helps to have some idea of the type of services you are looking for. Are you looking for an open-casket funeral? A direct burial? Or, a cremation with memorial? (For a full list of options, see Chapter 4).

Other factors to consider in the search for a funeral home: the funeral home's religious affiliation, familiarity with your cultural traditions and the size of the facility. If, for example, you plan a large funeral, you will want a funeral home that can accommodate one. Or, if you want something simple you may not need access to a high-end full-service funeral home that may charge you more for facilities you won't be fully utilizing.

You can call a funeral home day or night and ask to speak to a funeral director. Most directors will be appropriately compassionate and respectful. If you feel he or she is not being so, hang up and call another funeral home. There are plenty of them out there and they all want your business.

There are approximately 22,000 funeral homes in the U.S. that handle 2.4 million deaths per year—an average of 90 funerals each. In reality however, only a small number of homes handle the majority of the business. That means most of the homes that have only one funeral a week must charge inflated prices for their downtime and overhead. Funeral providers must keep a full staff on hand and their facilities ready for a call day or night.

How can they support this down time and overhead? By passing the cost on to the consumer through giant mark-ups of service and merchandise. This "stiff" (pardon the expression) competition has forced many funeral directors to become more aggressive salesmen.

> It's not the funeral director's job to console you but to sell to you as many goods and services as you can possibly use and/or afford. With that in mind, don't let a seemingly well-meaning funeral director influence you into spending more then you want to. Remember, everything he offers to do for you will in all likelihood cost you.

You may also want to be sure the funeral home you think you are calling is indeed the funeral home you call. In other words, many independently-owned, family-run funeral homes have been bought up by one of the big funeral conglomerates—like Service Corporation International (SCI), Alderwoods Group and Stewart Enterprises. The new owners don't change a thing on the outside and they may even keep the family on to run the business. But, they tend to hike up the prices—considerably.

Bodies may be prepared at one central location and then brought back to the funeral home for the service. By consolidating certain types of services like embalming, body preparation, cosmetology and restoration they save on overhead but instead of passing that savings on to the consumer, they keep more of the profit.

> This is worth mentioning simply because some families—like mine—have used the same family-owned funeral parlor for generations. Your family may trust and have a relationship with a funeral home in your area. And although you may meet with the same funeral director your family has used for decades, he may be representing a completely different business—with a different set of ethics and standards.

Ask who owns the funeral home. In certain states, like Massachusetts, the funeral home must clearly display the emblem of the company that owns them on all signs and business materials. If asked whether the establishment is owner operated, some conglomerates have told their employees to say "yes" because employees hold stock in the company. Ask who owns the funeral home and if it is independently-owned or owned by a conglomerate. It may make a difference to you personally in the quality of service you receive and the amount that you'll pay.

> If using an independent funeral home is important to you, contact the International Association of Independent Funeral Homes at the International Order of the Golden Rule 13523 Lakefront Drive, St. Louis, MO 63045, (800) 637-8030 or (314) 209-7142, www.ogr.org. Ask for an independently-owned funeral home in your area that meets your religious, cultural and personal needs and compare prices with those owned by the conglomerate. You will likely find a difference.

Here's the rub. You may actually find the prices of the conglomerate-owned homes in your area cheaper than the independent homes. This may be because they are trying to undercut the independents in the area and put them out of business. The chains can afford to do this because they make up the difference at one of their many other high-priced establishments. And, once the competition is driven out, the prices in the area will go up in keeping with the chain's standard pricing.

For example: The FCA recently reported that a Mr. and Mrs. Gragg filed suit against an SCI mortuary in Phoenix after the woman's mother was cremated (against her wishes and religion) and her cremains were sent to another family. Another woman was dressed in the clothes she had made for her mother and was mistakenly presented for viewing.

In another incident, the California Department of Consumer Affairs demanded license suspension for a San Francisco mortuary owned by SCI. Its former managing funeral director picked up a body from a hospital and embalmed it without authorization, then held it in storage, and failed to file the death certificate, for nearly four years. He reportedly stored the cremated remains of six other people at the funeral home instead of delivering them to survivors or cemeteries, or scattering them at sea, as he had contracted to do.

Before selecting a funeral home, be sure the funeral director is licensed by the state and in good standing with your state's Cemetery and Funeral Bureau. (Again, funeral directors are licensed—except in Colorado where there is no state run funeral regulating body.) You may also want to check with the Better Business Bureau, the FCA and your local memorial society to find out if any complaints have been filed against the funeral home or its management.

More on the Funeral Director

The funeral director, in affiliation with a funeral home, helps families plan for the final disposition and funeral of a loved one. He or she can inform you of the many options available and although he or she can't make the decisions for you, he or she can help you through the decision-making process. He or she may offer to assist you with some of the administrative tasks you will have to handle as well, including:

- obtaining copies of the death certificate;

- contacting the Veteran's Administration (if the deceased was a vet); and

- calling the insurance company.

A funeral director can be very reassuring at this time. He has, after all, been down this road before and can advise you of your options and responsibilities.

Some funeral directors even offer grief counseling, although for most their training in this area is minimal and only serves to complement the list of death related services tacked on to your bill. If you need grief counseling, seek a specialist in that area, not one associated with a funeral home—particularly if you don't want half-rate advice that'll only end up costing you more in the long-run.

The funeral director has a difficult job, dealing day in and day out with loss, surrounded by sadness and sorrow. Since culturally we do not deal well with death—our collective thinking tends to believe that if we ignore it, it will go away. But, our individual reactions to it vary greatly. Your reaction to the death may be one of profound sorrow or anger or fear.

For many of us, death forces us into an unfamiliar environment (the funeral home) and often (purposely) intimidating surroundings where we are confronted by a person who wants to sell us things we really don't know anything about and don't want to be buying. The funeral director bears the brunt of this resentment.

One funeral director with 50 years in the business told me several stories about individuals who responded violently to the deaths of their loved ones.

Funeral directors work in an over-saturated industry and over the years, due to outrageous abuses by some members of the industry, have had a speculative shadow cast over their reputation putting them on a par with used car dealers. In spite of all this they carry on in an attempt to make a living and provide a service to the community.

According to Donald C. Dimond II of the Nichols funeral home in Haleyville, Alabama:

Dealing with death every day is like dealing with life every day. You just find your way, find the joy in helping people,

find the peace that comes with all of that and don't let it get to you. Sounds easy. It ain't. Babies, abused children, kids killed when they fly out of pickup truck beds, kids killed unnecessarily because they're not belted in properly, people who commit suicide and leave hopelessly wrecked survivors asking themselves why for years thereafter. If you let it get to you, it will drive you nuts. You do what you can and find peace in the realization that you have really listened and done your best.

Although the funeral director you select may serve as counselor and advisor, and help your family through a time of great crisis, you must not forget that he is above all a businessman. He will help you but he is also out to make a living for his family. He is a salesman. Therefore, you need to do your part as a consumer to be informed about your rights and options.

> Call the funeral home and ask whatever questions you may have about service, merchandise and price. Be clear about what you want and what you don't want. If you aren't sure, discuss your options with the funeral director. Let him or her know what your concerns are.

Under stress, we remember even less of a conversation than under normal circumstances. It's a good idea to have a friend listen in to help you remember and take notes.

The funeral director you speak with will have a number of questions for you in order to assist you and assess your needs. You will want to be prepared for these questions. In most cases, the funeral director will want know any or all of the following:

- The name, address and phone number of the next-of-kin or person in charge of making the arrangements;

- Name of the deceased;

- Location of the body;

- Name and phone number of the person who pronounced the death;

- Name and phone number of the doctor who can sign the death certificate;

- The type of disposition you are considering—burial or cremation;

- Whether a burial plot or niche has been pre-purchased;

- The type of service you are considering—funeral, memorial, or other;

- You and your loved one's religious affiliation;

- Whether you want an open casket or closed;

- The size, time and location—church, funeral home, grave site or other—of the service you are considering; and of course,

- Your budget and how your plan to pay—with insurance, workers' compensation, Social Security, etc.

He will make arrangements to pick up the body from the place of death and store it for you until you can decide about final disposition and service arrangements. It may be helpful for you to tell the funeral director if the body needs to be moved downstairs or if the deceased was a large person. That way, he will know how many staff members to bring with him to move the body. You should also tell him if you do not want the body to be embalmed for religious or other reasons. Some funeral homes assume you will want this service by virtue of the fact that you have handed the body over to them. They will, of course, charge you for this service.

> The funeral home is required by law to show the cost for embalming on the itemized list of charges presented to you for consent before any services are to be rendered.

The funeral director will also want to set up a time to meet with you at the funeral home to show you the facility and the merchandise available.

He may ask you to bring:

- Clothes, jewelry, shoes that you'd like your loved one to wear.

- A recent photo of your loved one, for help in restoration, if there is to be a viewing.

- Important documents such as your loved one's Social Security card, military discharge papers, insurance documents, marriage and birth certificates, etc. He will need these in order to help you file for Social Security, veterans and insurance benefits and to include in the obituary.

Remember: The documents above are highly personal information. Although Social Security and veterans benefits are fairly standard, you may not want the funeral director to know how much you and your family will be receiving in insurance benefits or other compensation. If you are expecting a windfall, he may see no reason why you shouldn't spend more on your loved one's casket and funeral. He may humbly ask, "How much can you afford?" That's not the point and none of his business. The only other profession to ask you something so innocuous would be a used car salesman. Funny how that analogy just won't go away. Why not ask something equally as personal like your weight or waist size? Only the IRS needs to know what you can afford.

He may be more than happy to help you with your probate filing as well, for by law, the first debt to be paid is that to the funeral home.

As I've cautioned before, whatever you let the funeral director/funeral home handle for you will cost you. You or a family member or friend can write the obituary for no more than what the newspaper will charge you to run it. Ask a friend to help you file for benefits, or do it yourself, that way you'll know what you are getting and how much you want to spend.

Going to the Funeral Home for the First Time

When you go to the funeral home take someone with you—a family member or close friend. Have in mind the type of funeral or memorial service you want, the method of disposition and how much you want to spend, *before* you get to the funeral home. Let your friend help you to stay within those perimeters and not allow you to be swayed by emotion or the funeral director's subtle selling techniques to buy more than you wanted or need.

Once at the funeral home the funeral director will show you his merchandise—caskets, memorial books, etc.—and the facility. He will go through a long list of items and options (probably more than you could ever imagine) that you may want to include in your loved one's funeral. Try not to be overwhelmed. Most people are exhausted by the death and want no more than to get this part over and done with. Don't let your haste cause you to make costly decisions. This may be what the funeral director is hoping for. The funeral director may try to sell you a "package" of goods and services. This may include things that you don't want and you don't need. Be assertive; tell the funeral director exactly what you want and don't want. However, if you want all that is included in the package then it might be cheaper then buying each item and service á la carte.

> The **cost of burial**—plot, headstone, vault, opening and closing the grave—is not included in the cost of the "funeral."

"Basic Services and Facilities"

Regardless of which funeral home you choose, or the type of service you elect—elaborate or simple—you will be charged a **non-declinable basic service fee**. These fees vary greatly and range roughly between $400 and $3,000. But can cost much more. Ask up front what the funeral home's fee is and what it includes. **You must pay this fee, as well as the cost of the specific funeral goods and services you select**. This fee usually covers such services as the funeral director's time spent:

- helping you plan the funeral;

- making arrangements with a cemetery or crematory (or other funeral establishment if the body will be shipped out of the area);

- obtaining the death certificate and other required permits;

- submitting the obituary;

- clerical and staff personnel to prepare necessary documents;

- use of the mortuary building and vehicles; and

- "unallocated overhead," including taxes, insurance, advertising and other business expenses.

General Price List

By law, the funeral director must show you in writing the price of every item and service he offers. This list is yours to keep. This is called the **General Price List (GPL)**. He must also (if not part of the services GPL) show you a price list including descriptions of caskets, vaults and grave liners before he shows these items to you. The GPL will also list any "required" purchases. For example, the law does not require embalming but the funeral home might in the case of a sched-

uled viewing. Again, vaults may not be a legal requirement but the cemetery you've chosen may require them.

Use the GPL to help you decide just what you want, need and can afford.

Remember: Do what feels right to you but don't let a funeral director influence what you think is best for your loved one or for your pocket book. You mother may deserve the best, but no matter how much you spend on the funeral it will never reflect your true feelings for her.

Be practical in your purchases and be extravagant in more personal ways of expressing your love and emotion. Instead of doling out a fortune on the casket and flowers, show your feelings in a more personal—and reasonably-priced way. Write a beautiful eulogy, plant a tree on her behalf or have a family member or friend of the family sing a song at the memorial service that she loved.

Once you have made your selections the funeral director must provide you with an itemized statement of the total cost of the funeral goods and services you've selected. You are not committed to these items at this time. In addition, he must provide in writing a "good faith" estimate of the goods and services that he will purchase from outside vendors on your behalf—such as flowers, obituaries and gratuities and honorariums for clergy. This estimate must also disclose if there will be a mark-up or additional service fee for securing these items through the funeral home.

The FTC requires those who charge an extra fee to disclose that in writing, although they are not required to specify the amount of the mark-up. They are also required to make you aware of any refunds, discounts or rebates from the suppliers. Again, you can save money buy handling these things yourself or by delegating the responsibility for them to family and friends.

Don't be surprised if your meeting at the funeral home takes several hours.

Options to Using a Funeral Home

It may come as a surprise to know that you don't have to call a funeral director to handle the funeral of your loved one. In only a handful of states is any involvement of a funeral director in the disposition of remains required by law—Nebraska, New York, Louisiana, Connecticut and Indiana. If you are the next-of-kin, the body of your loved one legally belongs to you, and in some states that makes you financially responsible for the disposition of the body. This should empower you to do with it as you see fit (within reason) when it comes to providing an appropriate and loving final tribute.

> You can handle the disposition and/or the memorialization by yourself with the help of family and friends. By doing so you may find more ways to excise your grief, accept the death, pay a more personal tribute to your loved one as well as save a great deal of money in the process.

The service can be any type of gathering or ceremony that you want. It can be a religious mass or an informal gathering of friends sharing memories of a loved one. You can have it wherever you want from a church to a meadow to your loved one's front parlor. You can have the body present, as in a traditional funeral, or you can have a memorial after the body has been buried or cremated.

Not too long ago, it was standard practice to handle the death of a loved one at home with the help of family and close friends. The body was washed and dressed and placed in the front parlor for a wake or vigil. Essentially, the body was watched day and night for a few days to be sure the person was actually dead. Crowded urban housing made home funerals more difficult and lead to the development of funeral parlors and the subsequent transformation of undertakers as

part-time tradesmen to full-time professional funeral directors. Some communities, mostly religious ones, still take an active role in the care of their dead. But for the most part, we as a culture, have handed this honor over to the secular stranger—the funeral director—as if preparing a loved one for eternal rest were a chore and a burden to be put on hired help.

We fear death in our culture. We don't like to talk about it. We want to distance ourselves from it as much as possible as if by doing so we can keep it from happening to us. The funeral industry has catered to us in a way by sanitizing death and keeping the whole unpleasant business at a distance. The bodies of our loved ones are prepped and packaged in an unnatural way, through embalming, restoration, casketing, in order that we may keep a false "memory picture"—a term the industry likes to use—of how he or she once was. For this we can't fault the funeral industry for giving us what we may have asked for through our quiet acquiescence.

But all this pretty packaging and distancing of death has cost us something, not only monetarily, but spiritually. Lisa Carlson, in her book *Caring for the Dead: Your Final Act of Love*, writes:

> Almost everything the funeral industry sells interferes with our natural return to the earth, and few know what that involves. By understanding what happens to the body after death and demystifying funeral options, our end-of-life decisions prior to death may be less fearful to face.

Carlson is part of a growing number of advocates who, through organizations like the FCA are trying to educate the public on alternative, more personalized, less costly ways to handle the disposition of the dead than through the use of funeral homes. Some speculate that this trend toward more personal involvement comes from the same hands-on Baby Boomer spirit that brought back natural childbirth. The other driving factor is that the cost of a traditional funeral has become outrageous.

It may help to think of a funeral director like a wedding planner. You don't really need one, but if you can afford one they will take a great deal of the planning burden from your shoulders.

"I'm a wedding coordinator with a three day turn around," admitted one funeral director. He added:

I encourage families to participate—it makes separation easier. It also helps because the waiting (while the funeral director does everything) can be the hardest part. Families should customize the service to make it what they want. I'm there to serve.

The services of a funeral director could be quite comforting at a time when the family least feels like dealing with permits, certificates, insurance documents and other paperwork. And let's face it, for some, moving, washing and casketing the body of a loved one may be too much to bear.

Using a funeral home does not have to be an all or nothing situation.

You may want to use the service of a funeral director for the disposition of your loved one's remains (burial or cremation) but take a more active role in handling a lot of the other details, like the funeral or memorial service yourself with the help of family, friends and your community.

There are many ways you can save by doing things yourself. You may want to build a casket or purchase one from a wholesaler or on the Internet, for much less than the funeral home will charge. The funeral home (if you use one) has to accept the casket you want to use and cannot charge you a handling fee for a casket that is not their own. You may want to contact the cemetery or crematory directly and make arrangements to deliver the body yourself. Write the obituary yourself and contact the newspaper directly.

Conclusion

Little by little funeral directors are recognizing that they need to make a shift from the "traditional" in order to appeal to a generation

of "do it yourselfers." Katie Monfre spokesperson for National Funeral Director's Association (NFDA) admits, "Funeral directors are becoming more accommodating. They want to be sure they can continue to provide a meaningful funeral experience for families."

It's up to you how best and most affordably you can use the funeral director. Find one that you can work with and who is willing to give you the options you need to have a uniquely personal memorial and stay within your budget. You may find that rolling up your sleeves and doing a lot of the physical work helps you better deal with your grief and gives you a great opportunity to participate in the final tribute to your loved one.

There are a number of funeral consumers groups and memorial societies, under the Funeral Consumers Alliance, that provide information on affordable funeral service providers and on handling the disposition and memorialization of your love one yourself. For a state by state list of memorial societies see Appendix A.

3 Keeping Perspective

At this point you may feel overwhelmed by the number of decisions and calls you've had to make immediately following the death of your loved one. You are probably exhausted and haven't eaten properly. You need to take care of yourself and let others take care of you. Take time for a walk and fresh air. Breathe. Although you may feel pressured—by friends, family and the funeral director—to make many decisions all at once, thank them for their concern but let them know you need some breathing room and that all decisions will be made in their own good time.

Don't let your current condition make you susceptible to a seemingly well-meaning funeral director who may try to sell you more than you need or want under the guise of traditional or legal requirements. Even the savviest of shoppers, under normal circumstances, would be taken in by some of the tricks of the funeral trade. The funeral director is there to help you through uncharted waters, but you need to make sure he is not steering you in the wrong direction. Shopping around, at least by phone, and knowing what you want and don't want is a start to staying on course. However, the more you know about your rights as a funeral consumer, the actual cost of funeral goods and services, what your options are and the type of smoke and mirrors selling you'll be up against, the less likely you will be taken advantage of.

In this chapter, I'll discuss funeral prices, paying for a funeral, consumer information and some of the manipulative tactics you may face along the way.

A Little Background

It used to be that the first call a family made after a loved one died was to the local undertaker. The **undertaker** was someone in the community who, in addition to his carpentry, livery or other business, assisted neighbors by providing a coffin and transportation of the body to the cemetery for a nominal fee. As urban centers developed and people were crowded into tenement homes, the concept of home funerals—laying the deceased out in the front parlor—became more difficult and the professional **funeral parlor** came into being. Most funeral establishments had an affiliation with a particular religion and or ethnic group whose traditions they catered to.

The role that the clergy and community played in the funeral got smaller and smaller as the role of the funeral director grew until we came to believe that we couldn't have a funeral without a funeral director. With the development of the funeral parlor and the growing popularity of embalming, undertakers evolved from tradesmen into professional funeral directors. Their side job became a major source of income as they were able to sell to consumers various goods and services that they deemed necessary for a "traditional" American funeral. These elements no longer consisted of a simple pine box and a vehicle long enough to transport it and its contents to the gravesite. They grew to include, among other things:

- Metal caskets of copper and bronze with satin linings, mattresses and seals to keep out the natural elements (or so they claim);

- embalming, dressing, restoring and cosmetically retouching the body to make it "life-like";

- services at the funeral home instead of the church or place of worship;

- lavish flower arrangements;

- motorcades of limousines with motorcycle escorts;

- memory books, acknowledgment and mass cards; and

- obituaries and video tributes.

None of these items is required by law. None of these things is part of any religious, national or cultural tradition. They do little or nothing to assuage the grief of the survivors, but they do however, hike up the cost of a funeral considerably and help the professional funeral director to cover his overhead and maximize profit.

There is a lot of down time at most funeral homes—in some parts of the country people don't die every day. There are approximately 22,000 funeral homes in the U.S. There are approximately 2.4 million deaths a year. That's about 90 funerals for each funeral home, or about two a week. But when you consider that not everyone can afford a funeral, that some are disposed of by the state and others elect direct cremation through a memorial society, then there are even fewer bodies to go around. Yet the funeral industry is a multi-billion dollar (roughly 9.3 billion) a year industry and it keeps growing.

It's easy to see why parsimonious entrepreneurs would be interested in capitalizing on this gold mine. And so they have.

The Conglomerates

Another reason funeral costs have been increasing at a rate greater than inflation, is that funeral chains like Service Corporation International (SCI) and Stewart Enterprises are buying up smaller, independently owned or family run funeral homes at break-neck speed. They often keep mom and pop on to run the business, and keep the physical facility pretty much intact so that the community thinks they are

still dealing with the same family business that they have been for years, but the price goes up and the service goes down.

The high-priced conglomerates handle nearly 30 percent of the funerals nationwide.

And if mom and pop don't sell out fast enough, the chains have been known to undersell them and drive them out of business.

Because these large mortuaries handle all of the body preparation at a central location, their overhead is low. They have the buying power to get goods at 25 percent less than independents, yet instead of passing this savings on to the consumer, they have raised prices nearly 35 to 40 percent more than the independents and keep the margin of profit for themselves.

If competing with a retail casket seller, the chain will lower the casket price to match, but increase their basic non-declinable fee to make up the difference. They'll always attempt to make up the difference. If you're saving in one place, you're probably spending more in another.

In addition to the independent, family-run funeral homes, the giants have bought up cemeteries, florists and other funeral related services throughout communities and virtually done away with competition in some areas. They double the prices of the original vendors and do nothing to improve the service. You pay more but get nothing more for your money.

The conglomerates claim that having everything—the mortuary, the cemetery, the florist and headstone maker—in one place is more convenient for the consumer, therefore the consumer should pay for that convenience. Okay, but what about when the customer has little or no choice but to use these on-site vendors at the chain's outrageous mark-ups? That just isn't fair—and it's called a monopoly.

The large mortuaries even make it a practice to provide trips and gifts to clergy in order to persuade them to recommend their mortuar-

ies to parishioners, in spite of the high prices, and keep other family-run funeral homes from providing comparative price lists to parishioners. They have made deals with various religious organizations to take over and run their cemeteries in exchange for being allowed to build the chain-owned mortuaries on site—purely for convenience of the parishioners—I'm sure.

Conglomerates threaten competition. And that is *not* an American tradition.

The funeral directors at these establishments, many of whom initially went into the business to help people in their time of need and to make a modest living, have been forced to become salesmen, who pressure customers into buying services and products they don't need or want. In fact, many of the chain-owned mortuaries have sales quotas that average $10,000 per funeral.

Don't ever go to the funeral home alone. Take someone with you who won't let you be taken advantage of. Don't feel that you have to take the "deal" that you are being offered. You wouldn't go buy a car by yourself, either.

I went to three funeral homes in one day and was not able to get what I wanted for poor Aunt Rhonda —a simple wooden casket and a graveside service. I was told that I would have to pay for motorcycle escorts—even though there would be no funeral and fewer than two cars meeting at the cemetery. I was told that embalming was required as was cosmetology and dressing the body—even though this was to be a direct burial. I was told that I would have to pay for the transportation of the body to and from the off-site "preparation facility"—even though there was not going to be any service at the funeral home. I was told I would have to pay for someone to direct traffic to the gravesite for the service if there was no motorcycle escort (for just two cars in the motorcade). I was told that I'd have to pay a $400 handling fee for a casket I bought elsewhere. All of these things, among

others, I was told are blatant violations of the Federal Trade Commission's Funeral Rule (see below).

I don't believe that all of the funeral personnel I spoke with were aware that they were breaking the law. I think many of them were following instructions given by a higher authority. For when I delved deeper and asked "why" I had to purchase a package or pay for a motorcycle escort or embalming, the response I got was something along the line of that's just the way "they" do it here. Or, "they" want it that way.

The point here being that these funeral directors/sales associates should know better. They are getting away with lying to consumers simply because most of these consumers don't know their rights.

At one funeral home I was given a contract that listed one price ($2,895) and was told that "everything was included" except the casket—oh, and the burial (which includes the opening and closing, vault, headstone, etc., that I would have to get at the cemetery). So, if I'm buying a direct burial that doesn't include the casket or the burial what was the $2,895 getting me? When I asked, a rather annoyed sales girl told me that itemization of my bill would cost extra. Itemization, FYI, is a requirement by the FTC. I exited post haste.

> Don't be surprised if what you are told is contrary to what is in the contract. Don't sign it or agree to it if you have any doubts. If the funeral director wants you to sign something to get the "ball rolling" and promises to amend the contract later, don't sign it. Once you sign it the funeral home is not legally obligated to make any changes and the written contract will outweigh any verbal understanding you had with the funeral director/salesman in a court of law.

The powerhouse mortuaries have used their clout to take over the state funeral boards—governing bodies intended to protect *consumers* rights, not the rights of funeral directors. They use their governing power to make regulations that destroy smaller family-owned funeral

homes and force them out of business. They have millions of dollars to spend on lobbyists in Washington to make sure that the ostentatious traditional *American way of death* (coincidentally the name of Jessica Mitford's exposé) continues with little or no threat from consumers groups like the FCA or regulators like the FTC.

Why Are Funerals so Expensive?

When you read figures estimating the average cost of a funeral between $4,000 and $6,000, you may *think* paying $5,000 doesn't seem so bad. But, keep in mind that the funeral these figures are estimated for doesn't include the cost of the disposition—burial or cremation. It refers *only* to the actual funeral service—which legally, ethically and morally you can handle yourself for free. These estimates do not include the costs associated with the burial plot, the opening and closing of the grave, the vault or the headstone or marker—all of which can easily cost another $5,000 on top of that initial $4,000 to $6,000. According to the FTC:

> Funerals rank among the most expensive purchases many con-
> sumers will ever make. A traditional funeral, including a cas-
> ket and vault, costs about $6,000, although "extras" like flow-
> ers, obituary notices, acknowledgment cards or limousines can
> add thousands to the bottom line. Many funerals run well
> over $10,000.

Prior the mid-1980s, the price of the funeral was essentially the price of the casket. Everything else—the funeral director's time, pick-up of the body, embalming, the hearse, use of the funeral home for services, etc.—was included in the price. Of course, the price of the casket was marked up accordingly by 500 to 700 percent. If you paid $1,809 in 1980 (average per National Funeral Director's Association survey for that year) for a casket, all the "services" were thrown in. And, whether you had a big funeral or a small one didn't matter.

Services remained the same in number and quality regardless of the casket price. If you wanted to pay less, you got a cheaper casket. This "unit pricing" is still practiced by some funeral homes. Others use a "two unit" pricing system—quoting one price for professional services and another for the casket. Under this system, the services are specified but not priced individually.

Following the passage of the Funeral Rule in 1982, FTC regulations require item pricing—the itemization of all the goods and services a funeral home makes available to you. Each component should be priced separately and the price list should be provided to the customer before any arrangements are made. Funeral homes, which historically have not used price advertising, don't like this requirement because it allows consumers to compare prices among funeral homes. (Armed with a list of itemized prices, you may be able to negotiate both services and prices with other funeral homes offering the unit price.)

The intention of the *unbundling* was to let the consumer know exactly what he or she was paying for instead of everything being lumped under the "unit" price of the casket. However, this backfired because the price of the caskets, which was inflated to cover the cost of all the services, never went down once the package was unbundled. Instead, the costs for services, facilities and vehicles were tacked on to the price of the casket. So, the result was that prices went up for consumers and not down.

> Funeral directors were able to take advantage of the new ruling by lumping "extras" like the acknowledgment cards, the registry book, flowers and music on to the cost of the casket to make the "traditional" funeral package, which by its name implies that anything less would be substandard.

Some funeral homes offer an itemized list but insert prices only after discussion with the customer. You don't know if the prices are

standard, whether the funeral director has adjusted them to what he perceives to be your income level or whether he has raised them to compensate for the choice of a low-priced casket. Or, if you reject one of the items, like embalming, you may be forced to accept another item, like refrigeration, which oddly enough is priced exactly the same at some mortuaries.

One former funeral director told me that he believes that his peers have made the price of funerals too high, and as a result, are forcing people out of economic necessity toward cremation. As a counter-attack, more funeral directors are trying to sell cremation with all the bells and whistles—open casket service and viewing—as the tradi-tional full funeral, including a burial plot (or niche) for the cremains.

More funeral homes are building crematoriums, which one fu-neral director told me cost about the same as a hearse (less the mainte-nance costs), and which allow the mortuary to keep more of the money without having to send the body out for cremation to a separate facil-ity. One funeral director even told me, his peers were against his build-ing a crematory. "My philosophy was if you can't beat 'em join 'em. My peers soon followed suit."

According to the National Funeral Directors Association 2001 General Price List Survey, the national ranges for common funeral services and merchandise are as follows:

- **Professional services charges**—$392 to $2,890;

- **Embalming**—$185 to $990;

- **Other preparations (cosmetology, hair, etc.)**—$25 to $500;

- **Visitation/Viewing**—$50 to $1,085;

- **Funeral and funeral home**—$75 to $3,075;

- **Memorial service**—$75 to $2,625;

- **Graveside service**—$50 to $3,440;

- Transfer of remains to funeral home—$50 to $1,850;

- Hearse (local)—$65 to $458;

- Limousine—$12 to $775;

- Service Car/Van—$25 to $375;

- Forwarding remains to another funeral home—$85 to $3,245;

- Receiving remains from another funeral home—$85 to $2,620;

- Direct cremation (container provided by funeral home)—$300 to $3,000;

- Immediate burial—(container provided by funeral home) $270 to $5,000;

- Acknowledgment cards—$3 to $150;

- Wooden caskets—$394 to $8,000;

- Metal caskets—$299 to $4,000; and

- Vaults—$252 to $17,800.

The complete price list survey can be purchased through the NFDA's Web site at *www.nfda.org* for $150.

Although the funeral industry does not use price advertising, the industry is very competitive and every funeral director knows that an inexpensive funeral may be better than no funeral at all. Some may forego profit merely to pay their continuing overhead costs. Keep that in mind when negotiating your arrangements.

Things to Look Out For

You might say that the funeral director faces an ethical conundrum of sorts—having to advise the customer about which goods and

services to choose and at the same time trying to sell them to the customer.

In dealing with a funeral director, the consumer who does not know exactly what he or she wants is likely to be taken advantage of. Under no circumstances should you surrender yourself to the will of the funeral director and let him call the shots. He is, after all, a salesman required to maximize profits. Funeral consumers are usually easy prey due to grief, ignorance, lack of experience and inability to make immediate decisions. You may not even realize that you are being subtly swayed into buying more than you bargained for.

Here are a few tricks to watch out for when dealing with funeral directors. As you do your funeral shopping, if the person you are dealing with resorts to one of these tactics, you should question his or her integrity and walk out the door. You can always spend your money elsewhere.

Watch out for **manipulative language or gestures.** This may be subtle but persuasive language that plays upon your guilt for not doing enough for the deceased during his or her life, your desire to do what is expected by your family and community and your fear of appearing cheap. If the funeral director lets loose any of the following, stand firm:

- "Your mother deserved the best. Didn't she?"

- "You want to do right by your Uncle Tom, don't you?"

- "Your Aunt had excellent taste."

- "You father was always so generous to others."

- "This is the last thing you can do for your father."

If you hear any of the above, know that these are sure signs of an attempt by the funeral director to manipulate you into spending more. Don't let the funeral director presume to know you, your loved one or the relationship you had with him or her. How much you cared for your loved one could not possibly be reflected in material goods like a casket or even flowers.

Some funeral directors may imply that the casket is an indicator of social status. A "quality" casket illustrates the socioeconomic level of the deceased and his or her family as well as the love and respect they had for him or her. What price can you put on your feelings for someone? None. Don't let the funeral director tell you what you want, or what the deceased might deserve. It's up to you.

> You are the consumer and no one will look askance at you for asking well informed questions about the goods and service involved in your loved one's funeral and disposition.

Some funeral directors will also deceive you by **not presenting less expensive options**. This is wrong. The FTC Funeral Rule requires that a funeral home display a certain number of lower priced caskets. Although you may not see anything for under $1,500, ask. They could have them hiding in the back...just ready to be put on display. There are plenty of perfectly fine caskets out there for less. Some funeral directors hide the less expensive models in poorly lighted corners of the display room or even in the basement or storage room. They may refer to them as new arrivals that haven't hit the floor— even though they've been collecting dust for months or maybe even years. This helps with the deception that "no one ever buys these." He may refer to these models as "welfare" caskets or even "morgue boxes" in an attempt to steer you away from these models. There is absolutely nothing wrong with them except that he makes less money from these. Don't misunderstand, the mark-up is still great—more than 10 times what you could find it for elsewhere—but the overall price is much less then the well-lit models. He may make gestures, facial expressions or even remarks of disapproval when you show interest in the less expensive models.

Some caskets are covered in felt or plain cloth, on which family and friends could write a final message to the deceased. You may find

that the simpler caskets are in hideous colors to make them seem even more undesirable. If you don't like any of the models on display, ask to see the manufacturer's catalogues. Any model they list can usually be delivered promptly in any color you want.

> If the style of the casket doesn't matter, inquire about the Orthodox Jewish casket. Religious law requires that this be a plain wooden box devoid of ornamentation, it is likely to be less expensive and is available almost anywhere. Many people like its simplicity.

Another thing to look for: Marked up merchandise far beyond the wholesale price. As I've already mentioned, with caskets, the mark-up can be an outrageous (as much as 300 to 500 percent or more). For example, a casket that is listed for $2,100 at the funeral home might wholesale for only $400. That same casket is probably available from a casket retailer for $700.

The casket is usually the most expensive component of the funeral—it can account for 50 percent—and the most profitable for the funeral director. You can easily find caskets at casket stores, wholesalers or on the Internet for much less than the same caskets would be priced at a funeral home. Reportedly, a few casket manufactures have refused to sell to anyone but funeral homes. However, you can usually find the same or similar models at a retailer and save between 25 to 75 percent. The funeral director may warn you about the quality and delivery of a casket bought elsewhere, but this is often a ploy to scare you into buying a casket from him. It is illegal for the funeral home to charge you a handling fee for a casket you a buy from outside their facility.

Deceptive Language

Funeral directors may try to **mislead you with deceptive statements**—subtly suggesting that it is better to pay a little extra for a

"sealer" casket with a protective gasket that will prevent the penetration of water and preserve the remains indefinitely. Nothing can prevent the decay of the body. The casket manufacturers only guarantee their products for up to 25 years. If the funeral director explicitly states that a casket postpones decay, he is breaking regulations spelled out in the FTC's Funeral Rule.

He may not say anything but allow you to be misled by names like "Protector Vault" or "Duravault," which many people assume protect the casket and its contents indefinitely. This is assumption is wrong. Nothing can. These products are designed to protect the gardener from falling into holes created when the graves settle as the contents decompose. These outer burial containers can be as fancy as caskets, with some prices going as high as $7,000 or more. They may offer the casket some protection from ground water, but if you live in a flood zone know that "sealer" vaults have been known to come out of the ground and float away. No state has a law requiring an outer burial container.

A funeral director will also attempt to **judge your financial status by your physical appearance.** Some funeral directors have been taught to study the clothes and accessories of people to assess how much they can spend on a funeral. If he sees a Chanel bag or a pair of Gucci shoes, he won't waste his time discussing direct disposition. A car salesman might do the same. He isn't going to point you toward the Hyundai if he thinks you can afford the Lexus. A funeral director might argue that this is because he doesn't want to insult those with higher taste and expectations. Likewise you may find the interior of a funeral home very intimidating and formal. You may feel you need to impress the funeral director, let him know that you are worthy of this fine establishment with the chandeliers and bonsai trees, and that you can afford to pay for a funeral. It's up to you to be the judge and to tell the funeral director what you want and what you think is reasonable.

The funeral director may put off the funeral a day or more if they have another funeral taking place or for some other fictitious reason

and then charge you for storage of the body. If he does this, he is attempting to **prolong the process and services** for his benefit. The funeral director should not charge you for "shelter of remains" or for storing the body during the normal course of planning and producing the funeral. In accordance with the Funeral Rule, only after four or five days can you be levied this charge.

Many funeral directors also try to **collect more for cash advance items than what was paid out**. According to the Funeral Rule, if the funeral director collects a fee for ordering cash advance items like flowers or a soloist, he is required to say so up front when making the good faith estimate on such purchases. But how would you know unless you checked with the florist and singer yourself. One way to avoid this possible quagmire is to make these arrangements yourself or ask friends and family to handle them for you. They will likely be more than happy to play an active and important roll in the final arrangements.

> Most funeral directors will push for a traditional full service funeral rather than a less expensive option. Again, the funeral is for those who mourn and can take any form that you and your family feel comfortable with. You need not feel bound by any industry imposed "traditions."

If a funeral director attempts to **charge you for and/or provide unnecessary and unauthorized services**, report him. This is also against the Funeral Rule. If he suggests that "it's time to pick out" the urn, guest book, the soloist, the limo, etc., and the manner in which these things are presented makes them seem like a part of the "package" or necessary items that you *have* to buy, ask questions. They probably aren't part of a package at all, and they will cost you. It will cost you more to have the funeral director arrange them for you.

Ask yourself the following: Do you need a $260 motorcycle escort for a motorcade of two cars? Do you need to have the body em-

balmed for a direct burial? Do you need a flower van to take two sprays of flowers to the graveside? Do you need 150 mass cards, and a registry book with a linen cover? No. No. No. No. And, no. If you want them fine. Tell the funeral director, check the itemized list of agreed upon items and how much he will charge you for his service for arranging these items. If you don't want them, say so. If they appear on your final bill without your say so, say something.

Be sure to look over the list of itemized services—carefully. Many funeral directors **substitute what was paid for with lower priced items**. Why would they do this? Because they can. Would you really know if you got the expensive grave liner or the least expensive one? Probably not. If you paid extra for a sealer casket to keep out the elements, or for one with a 25-year warranty, are you really going to check in the grave to be sure it's in good condition in 20 years? Probably not. If you order flowers for a funeral, would you call to find out if they arrive? Probably not. I have and they weren't. The funeral home knew we were calling from out of town. They took my credit card number and the bill was paid long before I discovered the flowers, which were to be placed in the casket, never arrived.

Not all of these funeral home practices are illegal or unethical, but given the competition in the funeral industry and the vulnerable state most consumers are in when making these buying decisions, it's easy to see how a funeral director might be tempted to take advantage of you.

In 2000 under Senator Charles Grassley's head, the U.S. Committee on Aging held hearings on the abuses of the funeral industry and sited the abuses of the funeral industry among the most prevalent and grievous frauds perpetrated against the elderly.

The Funeral Rule

The FTC passed the Funeral Rule in 1982, which was designed to provide regulations to address some of the less ethical practices perpetrated by the industry.

The Funeral Rule actually went into affect in 1984. Soon after, industry organizations such as the National Funeral Directors Association responded by creating their own code of professional ethics and encouraged their members to find a balance between honesty and good business.

> If asked, a funeral home must provide prices over the phone.

Funeral homes may be reluctant to quote prices over the phone. Some funeral directors argue that misunderstandings are inevitable because customers don't ask specific questions or the right questions. You can't call and ask, "how much for a funeral?" You need to be specific—closed casket service, at the funeral home on a weekday, no embalming, etc. Find out what is "included" in the quoted price. What is the basic services fee?

You may also want to ask about terms and conditions. Three funeral homes I called in my neighborhood quoted me a rounded $5,500 before they even knew what I wanted. As local competitors, I'm sure they were aware of each other's prices. As a seller, the funeral director has a clear advantage over most retailers. Unlike when you are buying a car or house or are planning a wedding or other expensive purchase, you are less likely to have the time or the inclination to shop around for a better deal on a funeral for a loved one who's just died.

Be specific when shopping around. The funeral director's goal is to get you into his establishment. He knows that in your frame of mind, once you are in the door you're not likely to walk out. You'll probably want to get the whole business over with. Don't be afraid to call his bluff. You would do the same to a used car salesman.

If you know precisely what you want, hold your ground, you'll get what you want at a fair price. If this seems too much for you, ask one or two friends to visit several funeral homes to compare prices on the things you want.

> Remember: If you inquire in person about funeral arrangements, the funeral home must give you a General Price List that features the cost of each item and service available. You have the right to choose the goods and services you want, with a few exceptions. The funeral director must disclose this right to you in writing on the General Price List as well as any specific state law that requires you to purchase any particular item on your itemized statement of goods and services selected.

Many funeral homes will try to sell you a package. Prior to the Funeral Rule, many homes required the purchase of a package even if a customer only wanted a few things. One of the major objectives of the Funeral Rule was to outlaw this bundling and allow customers to select only the goods and services they wanted to buy. Everything has to be itemized and cannot be part of an "all or nothing" package.

Most of the funeral homes I went to in my research I was presented with a GPL that featured packages. Some packages featured itemization of all goods and services offered within the package. I was, of course, told that a package was a better deal and it would have been if I wanted everything in the package.

> Ask for what you want. And get an itemized list with prices.

At one funeral home I was told that if I wanted the funeral director to itemize everything I was going to be purchasing instead of buying a package, it would cost me more, because it was more work for the funeral director to itemize my purchases. This was a direct violation of the Funeral Rule.

Embalming Isn't Required

A funeral home's price list must also state clearly that embalming is not required by law, except in one or two special circumstances—

such as when the body is being transported long distances by common carrier. The funeral home must have your authorization before embalming can take place. The funeral director must also disclose in writing that certain funeral arrangements, such as a funeral with viewing, may make embalming a practical necessity and be a required purchase. (Required by the funeral home not the law. However, if you have certain religious objections they will wave that "requirement.") The funeral director may not charge a fee for unauthorized embalming, unless it was required by law. The funeral home must disclose in writing that you have the right to choose a disposition—such as direct cremation and direct burial—that does not require embalming.

A funeral home near my home included embalming in a direct burial package even though I told them there would be no viewing or funeral and the burial was to take place within 24 hours. This was in direct violation of the Funeral Rule and oddly enough contradicted the materials I found in the waiting room of the funeral home, which discussed the legal obligations of a funeral home under the Funeral Rule. When the FTC comes to investigate, the funeral director can point to the materials in the entry in his defense regardless of what he has told his clients.

A Casket Isn't Required for Cremation

According to the Funeral Rule, a funeral director cannot tell you that a casket is required by law for direct cremation. He must disclose in writing your right to buy, or make an unfinished wood box or alternative container and must make an unfinished wood box or alternative available to you.

You may want to note that if you are electing cremation that the price listed on the GPL for a cremation package may not include the actual cremation. It sounds so incredulous that it bares repeating. Yes, the price of a direct cremation may not include the cost of cremation. That's because many funeral homes don't have their own crematories.

They charge you for the funeral home's "services" but will bill you separately for the crematory's service as a "cash advance" item. If you want a cremation ask if the price of cremation, includes the actual act of cremation.

Handling Fees and Other Add-Ons

It is also illegal for a funeral director to refuse to accept or to charge you an extra "handling" fee for a casket you purchase from some other facility and have it delivered to the funeral home. You will find the same caskets the funeral home has available from wholesalers, retailers and even on the Internet for much less.

I went to a funeral home—that clearly was not aware of the Funeral Rule—where I was told that even though the package they were selling me didn't include a casket, I could not buy one from another facility because the funeral home would not be able to guarantee the quality of the casket once it arrived. (It is illegal for them to say such things.) I was also told I would be charged an extra $400 for a casket that came from somewhere else.

> The Funeral Rule prohibits a funeral director from telling you that an item or service can preserve the body indefinitely. Neither embalming, nor any type of casket or vault can preserve the body indefinitely. They may slow down the natural process but nothing can stop nature from taking its course. Eventually "dust will return to dust."

Interestingly enough, one funeral director told me that the purpose of the vault is to preserve the casket. I asked why and was told, "For when you want to exhume the body."

When I asked why again I was told, "Because cemetery plots are very valuable real estate. You can resell a plot you bought for $2,000 for $10,000 today and make a profit."

Evidently, people do this all the time. At least, according to what this funeral director had to say. Though, not everyone agrees with this idea.

> I was also told that once the body and the casket have been exhumed, I can only cremate the body. At that point, I told the funeral director that I'd just assume save the time and money—not to mention hassle—and skip ahead to a direct cremation. She seemed disappointed. The "sale" of the funeral was no longer going the way she had hoped.

Cash Advances

The Funeral Rule also states that a funeral director must disclose in writing if he charges a service fee for buying **advance purchase items**—such as flowers, soloists, obituaries or honoraria for clergy—on your behalf from other vendors or if there are rebates, refunds or discounts from these suppliers. Funeral directors can offer you a beautiful service, music, flowers, memory books, announcements, all sorts of things that you can buy yourself directly at less cost, or you can buy it through the funeral home at a mark-up.

These may be items you want to purchase yourself, or arrangements you want to make in order to remain more involved in the tribute to your loved one—not to mention keep a tighter control over how your money is being spent. Have your niece sing at the service, ask your grandson to write the obituary, pick out the flowers or select a charity to receive the donations in lieu of flowers. These are all more personal—and reasonably priced—tributes than assigning these tasks to a stranger and having to pay for his involvement.

Even if the home provides you with a list of things they have bought from vendors outside of the home on your behalf, and claim that there's been no mark-up, be aware that you are paying for the staff's time for making these arrangements and that the home, in all likelihood, has an "agreement" with the vendors from whom they have purchased merchandise on your behalf. This is a for-profit business.

Again, I went to a funeral home and was told that a $200 honorarium for the clergy would be included on my bill from the funeral home regardless of the service selected or whether I used the clergymen from my own church, or not. When I spoke directly to my church I was told that $75 to $100 was more than adequate.

The funeral director is required to give you an itemized statement of the total cost of all the goods and services you select. And, it should list the individual items and the total price. Cash advance items may be written as good faith estimate. This statement should also disclose any legal, cemetery or crematory requirements that require you to purchase any specific funeral goods or services. The funeral director must give you this statement after you select the things you want to include in the service and *before* any payment is made.

The Non-Declinable Fee

To reiterate, the main objective of the Funeral Rule was to address the issue of "unit pricing" and insure that the consumer does not have to buy goods or services he or she does not want, nor pay any fees as a condition to obtain the products and services he or she wants, except where law requires. The goal was itemization instead of selling all or nothing packages.

However, as a result of the lobbying efforts of the funeral industry, the Federal Trade Commission amended the Funeral Rule to allow the inclusion of a "non-declinable fee" for the basic services of the funeral director and staff. This amount of this fee varies and is charged

regardless of the type and size of funeral you have as long as you use a funeral home. So, whether you have a simple committal service or a full funeral, the cost is the same. You must pay this fee, as well as the cost of the specific funeral goods and services you select.

The allowance of this fee in essence undid the main objective of the Funeral Rule by forcing the consumer to pay for services he or she would not use. The fee may cover such services as the funeral director's time spent:

- **Helping you plan the funeral.** The funeral is the "service" that you may be better off planning with family, friends and clergy, at your place of worship. It does not include the disposition, which is the actual burial or cremation.

- **Making arrangements with a cemetery or crematory or other funeral establishment if the body will be shipped out of the area.** The services of the cemetery, crematory or other funeral home will be charged to you separately in addition to the non-declinable fee. You could save money and be more a part of the decision-making process by cutting out the middleman and dealing with these establishments directly yourself.

- **Obtaining and filing the death certificate and other required permits.** You may be able to obtain these documents yourself from the registrar's office. The funeral director likely has copies on hand; however, he cannot fill them out without the proper information, which you must provide.

- **Submitting the obituary.** You must provide the funeral director with the information for this. The obit will, no doubt, feature a plug for the funeral home and you will have to pay the newspaper for that bit of advertising. You can call, or have someone call for you, to submit a more personal obit to your newspaper.

In addition to these services, the Funeral Rule also allows the funeral home to include the cost of **"unallocated overhead"** in this fee, which includes taxes, insurance, utilities, secretarial and administrative costs, advertising and other business expenses. The Federal Trade Commission allows the basic services fee to include:

> ...overhead from various aspects of [the funeral home's] business operation, such as the parking lot, reception and arrangements rooms and other common areas. It may also include insurance, staff salaries, taxes and fees that [the funeral home] must pay. Alternatively, instead of including all overhead in [its] basic services fee, [a funeral home] can spread the overhead charges across the various individual goods and services [it] offer[s].

The Funeral Rule's amendment was a win for the funeral industry for sure. The rule was intended to drive competition and get prices down. Instead, it has allowed funeral directors to raise prices to even greater levels.

In most cases, non-declinable fees account for more than 20 percent of the funeral cost. At one funeral home in California, a simple cremation costs $1,863—$595 of that is a basic services and facilities fee. At another funeral home in Georgia, the fee for "overhead and professional services" is $,1495—one-third of the total cost of the funeral including the casket.

The International Cemetery and Funeral Association (ICFA), as well as many other industry organizations, have raised millions to send lobbyists and lawyers to Washington to repress any new reforms. It is important to note that the Funeral Rule applies only to funeral homes and doesn't cover cemeteries, casket retailers or monument dealers.

Beware: These industry organizations also have their own methods of bilking you for your money through deceptive practices. They

are often in competition for your money and may practice unethical restraint of trade. You may find a cemetery that requires you to buy the grave marker from them. You may get a great deal on a monument that you don't buy from the cemetery only to find that the cemetery will charge you a fee (one woman reported $500) to have one of its staff "watch" the outside vendor install it. Of course, you have the option of letting the cemetery install it for a hefty fee. In this case, you should observe the installation to be sure the stone is in good condition when the cemetery receives it and that it is indeed installed in the marble base you paid for and not a substitute cement one that you will be charged the same price for. Because they have no FTC regulations, cemeteries don't have to disclose their prices, either.

Where to Go with Complaints

As I've mentioned, the Federal Trade Commission's (FTC) Funeral Rule office in Washington D.C. 202-376-2891 may be of little use to you in resolving an immediate conflict with a funeral establishment. The FTC will not investigate or resolve individual complaints but may take action against habitual offenders. The FTC claims to "work for the consumers to prevent fraudulent, deceptive and unfair business practices in the marketplace and to provide information to help consumers spot, stop and avoid them." To file a complaint with the FTC or to get free information visit *www.ftc.gov* or call toll free at (877) FTC-HELP.

You can try telling uncooperative funeral directors that you are aware of the Funeral Rule and its regulations and let him know that you will call the FTC. Showing a little wisdom and backbone may startle them into compliance.

One woman addressed her concern about her funeral bill with her funeral director and long-time friend, outside of church one Sunday. He was reluctant to discuss it there, but upon her instance he tried to explain why she was charged:

- $140 for "parking," when everyone has to park on the street;

- $150 for "shelter of remains," when the funeral took place within three days;

- $100 for "lounge and supplies," for a kitchenette with no chairs in which only coffee is served. She supplied the coffee (she paid to use the pot); and

- $420 "additional funerary events" (i.e., a viewing).

Her total bill was over $7,000.

Although she understands that he had done nothing illegal, per se, she has since let everyone in her congregation know that her former friend is of questionable integrity and is in a shady business and has changed her will to include an out-of-town cremation.

Discuss any questionable or disputed issues with the funeral director, if possible, before you sign anything or pay the bill. It may have been an error or misunderstanding rather than fraudulent intent.

You can withhold payment of a funeral bill if you regard it as excessive or fraudulent. If you do so, the funeral home will have to file a creditors claim in the probate court. During the proceedings, you will have the opportunity to voice your objections. If the court agrees, it may force the funeral home to amend the bill or it may disallow it entirely and the funeral home will be out of luck.

If the court determines that the funeral director sold too elaborate a funeral to someone of limited means, or that the person was overcharged or defrauded, it can order that the bill be reduced—or not paid at all—even if the contract was co-signed by a survivor.

You can also report the funeral director to your state's mortuary board, if there is one. This is the administrative body that controls the licensing of the funeral directors. Most of these boards, however, consist entirely of funeral directors so it might be hard getting an unbi-

ased judgement there. Many board positions are held by funeral directors from the big chains who want to restrict entry into the profession and limit competition.

If you have no success there, take your complaint up with the National Association of Funeral Directors (13625 Bishops Dr. Brookfield, WI 53005). The NAFD sponsors the Funeral Service Consumer Assistance Program (FSCAP), which arbitrates consumer disputes with funeral directors, whether or not the funeral directors are members of the association.

Other organizations to contact with regards to your grievances:

- Your state's **Department of Consumer Affairs or your State Attorney General** consumer protection division. The attorney general may investigate consumer complaints against chronic offenders.

- The **Cemetery Consumer Service Council (CCSC)** is a non-profit organization funded by the International Cemetery and Funeral Association and the Cremation Association of North America, among others to assist consumers, without charge, in resolving complaints or answering inquiries regarding cemetery services or policies. For more information or to discuss a complaint, contact them at: Cemetery Consumer Service Council, P.O. Box 2028, Reston, VA 20195-0028. Or, call them at (703) 391-8407.

- The **Funeral Consumer's Alliance** a non profit, funeral consumer education organization may be able to give you advice about how best to resolve the issue with your funeral director. (Write them at P.O. Box 10 Hinesburg, VT 05461, or visit their Web site at *www.funerals.org*.)

Reasons People Overspend

No matter how much you spend on the funeral it will never reflect your true feelings for the deceased, so be practical in your pur-

chases and be extravagant in more personal ways of expressing your love and emotion.

The Funeral Consumer's Alliance sites the following as some of the reasons people overspend on funerals. Consumers:

- **Leave all funeral planning to the funeral director**. They essentially hand him a blank check.

- **Think that what they spend is a demonstration of how much they cared**.

- **Worry about what other people think**. They don't want to be perceived as "different" or "cheap."

- **Fail to get or read the price list**. A General Price List is an itemized price disclosure required by the FTC that let's you see what each option will cost before you decide. It also let's you compare prices with competitors.

- **Don't ask enough questions**. If you don't know what something is, ask. If you want to see something less expensive, ask. If you want to know if something is required by law or by the funeral home, ask. The funeral director may be counting on your being too embarrassed or too worn out to speak up if you don't understand something, or if something seems to cost too much. The environment of the funeral home is designed to be a bit intimidating, don't let it get the best of you. You are paying for the environment as part of the non-declinable fee.

The FCA warns: Funeral directors are business folks who deserve to be paid for what they do. However, it is your job, as a funeral consumer, to be well-educated about your funeral choices, to determine the kind of funeral or memorial service that meets the needs of your family, and to locate an ethically-priced facility that will honor your choices with caring and dignity.

Ways to Save

Throughout this book I try to offer suggestions—where appropriate—about ways to save on the cost of a funeral, not so much by cutting back, but by being more involved in the planning (and doing) and leaving less to the funeral director or eliminating the need for him altogether. Being actively involved is very therapeutic and will give you more control over exactly how and where your money is being spent. Many of these ideas have been discussed throughout the book but here is a brief reminder of ways to be more involved and to save money.

- **Donate the body to a medical school.** This should cost you nothing and is a great gesture. However, if arrangements haven't been made in advance, certain medical schools may decline the offer. Also, if the deceased doesn't meet the requirements (age, surgery, etc.) you may have to find an alternative. For more on donation and medical schools, contact the National Anatomical Service at (800) 727-0700.

- **Choose direct disposition.** An option like cremation or immediate burial will eliminate the need for embalming, a casket, a viewing, facilities and transportation to and from the service, among many other costs associated with a funeral. Think about having a memorial service or a visitation later on when and where you choose without the cost or involvement of a funeral director.

- **Have a graveside service.** This alternative is a good compromise between direct disposal and a traditional funeral. The funeral home may charge for the time spent at the gravesite, but you won't have the cost of the chapel, viewing, embalming or restoration.

- **Price shop by phone or in person.** We've made this point many times but it bears repeating. Get help from a

friend or family member, but this step alone can save you hundreds and even thousands of dollars.

- **Determine the type of funeral you want before you call or visit a funeral home.** Know enough about what your options are to call and ask for specific prices for the services you want. If you know what you want, the funeral director will be less likely to talk you into more expensive options. Once you know what you want you will be able to compare apples to apples when price shopping.

- **Find a funeral home with a low basic services fee.** Every home charges a fee. If this fee is low, you will have more to spend on the things that you actually want and need. And the overall cost of the funeral is likely to be less. But compare prices of other items and services with other funeral homes. This fee may be low, but the home may find a way to make up the difference elsewhere.

- **Call your local non-profit memorial society or funeral consumers alliance.** If it's too late to join in order to take advantage of member discounts with local funeral homes, ask for the names or reputable and fairly priced funeral homes in your area.

- **Ask to see the less expensive caskets at the funeral home.** We have already discussed how these may be hidden in a back room. Don't let the funeral director make you feel bad about spending $1,000 on a casket simply because he would rather see you spend $6,000. If you don't like any of the models on display, ask to see the manufacturer's catalogues. Any model they list can usually be delivered promptly. If the style of the casket doesn't matter, inquire about the Orthodox Jewish casket. Religious law requires that this be a plain wooden box devoid

of ornamentation. It is likely to be inexpensive and is available almost anywhere.

- **Buy a casket from a retailer.** You can easily save 75 percent on the same casket you'd find at the funeral home. The retailer can deliver it to the funeral home in a matter of hours. If the state you live in requires that you buy only from a funeral director, you can still purchase one from out of state and have it sent overnight to the funeral home. It is illegal for a mortuary to charge a "handling fee" or to forbid you from using a casket from an other vendor.

- **Make the casket yourself.** If you are at all handy you might find this a very therapeutic and loving gesture on behalf of your loved one. (See Ernest Morgan's book *Dealing Creatively with Death: A Manual of Death Education and Simple Burial* for detailed instructions.) You and your family can decorate it any way that you see appropriate. You may even want to include a final farewell inscription on its surface.

- **Take a levelheaded friend or clergy to go with you to the funeral home.** Walking into a room full of caskets can make even the strongest of us weak in the knees. Remember: Funeral directors are notorious for taking advantage of one's emotions and swaying a person into buying more than he or she needs or wants. Let your friend know what you want and give him or her the authority to speak up if he or she thinks the sales pitch is getting a little out of range.

- **Plan a memorial service.** Following a direct burial, cremation or a committal service you can have a memorial service. Without the body present there is no need for embalming, an expensive casket or transporting of the body

back and forth. Use a church, public park or community center for the memorial service. This will save you from having to hire attending funeral home staff.

- **Have a private family visitation, not a viewing.** Say your goodbyes in the hospital or at home, before you call a funeral director. Or, ask for a viewing that does not require embalming. The funeral director may only allow you 15 minutes...but he's the expert and should know how long it takes to say goodbye to a loved one.

The FCA reminds consumers that there are two tasks at hand when a person dies: 1) the timely disposition of the body; and 2) commemorating the life that was lived. If you can separate those two events, you have many more cost-saving options.

- **Buy a grave liner rather than a coffin vault.** If the cemetery requires an outer burial container, a liner will cost less than a vault. If the funeral director only sells vaults, call the cemetery and see if you can get a grave liner from them, or look around for a dealer on the Internet.

- **Handle all or as much of the arrangements as you can yourself.** I've said repeatedly, you don't need a funeral director at all in most states. If you do, it's only for the disposition. And, you don't need the funeral director for a memorial service.

- **Have the funeral at home.** Families who have done so have found it therapeutic. This is especially feasible if the deceased dies at home after a long illness. You are used to caring for him or her and washing and dressing the body for a final farewell ceremony with family and friends would be a loving last act and a way for you to say goodbye.

- **Handle the disposition yourself**. Each state has different laws regarding the handling of the disposition by the family. Contact your non-profit memorial society for more information and consult Lisa Carlson's book, *Caring for Your Own Dead: Your Final Act of Love,* which list what permits are required in each state and where and when to file them.

- **Have the burial on private land**. You won't have to pay thousands of dollars for a plot. You can dig the grave yourself as long as you comply with local regulations. (Contact the health department for more information on regulations in your area.) Even if you bury the deceased in a church- or town-owned cemetery, you will save more money than if you go to one of the many chain-run cemeteries.

- **Get copies of the death certificate yourself**. You can get them directly from the registrar's office while you wait and avoid the funeral director's surcharge. It is hard to know how many you will need, so don't buy a bunch from the funeral director if you don't think you'll use them.

- **Don't buy clothing from the funeral home**. Bring clothes from home if possible. Or, if need be, go shopping. Regardless of what you buy, it will still be less than what the funeral director would charge you for special funerary wear. Besides, you can probably provide something that leans more toward the deceased's taste.

- **Apply for death benefits yourself**. Although the funeral director may offer to apply for Social Security and veteran's benefits on your behalf, if benefits are applied to the funeral bill, do it yourself. He may present a final bill with these benefits already credited, which will make the bill look reasonably priced when actually it is much higher. You may also be eligible for a tax benefit and able to pay for the funeral entirely with estate funds.

- **Make crematorium or cemetery arrangements your-self.** Select the plot or crematorium where the deceased will be disposed by yourself instead of letting the funeral director do so at an additional cost to you.

- **Handle the honorariums and gratuities for the clergy, soloist, organist, etc., yourself.** If you handle this your-self—or through a family member—the funeral home will be unable to bill you for these fees in advance, charge a service fee on top of that or fail to give the honorarium in full amount to the minister or artist. If you make the check out to a house of worship, versus a person (or a funeral home), it is a **tax-deductible charitable donation.**

Calculating the Cost of a Funeral

The funeral director should provide you with an itemized General Price List of all the goods and service available to you. Once you have made your selections, he should provide you with a breakdown of your costs for each item and service (except the non-declinable, basic services fee, which includes the kitchen sink and let's not forget the parking lot.)

The following is a list of nearly all the services you may need to help you estimate and compare costs for the funeral. Use this as a checklist in your price comparison with various funeral providers.

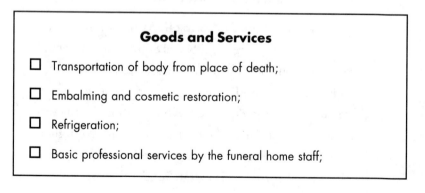

Goods and Services

- ☐ Transportation of body from place of death;

- ☐ Embalming and cosmetic restoration;

- ☐ Refrigeration;

- ☐ Basic professional services by the funeral home staff;

- ☐ Casket;

- ☐ Vault or grave liner;

- ☐ Viewing and/or visitation facilities at funeral home;

- ☐ Chapel facilities at funeral home (or additional transportation; charges to move body to house of worship);

- ☐ Transportation of body to grave or cemetery;

- ☐ Cost of cemetery plot/mausoleum space;

- ☐ Opening and closing of grave;

- ☐ Transportation of mourners and pallbearers by limousine to and from committal;

- ☐ Crematory charge;

- ☐ Urn;

- ☐ Columbarium charge for urn committal;

- ☐ Professional pallbearers fee;

- ☐ Clergy fee;

- ☐ Clothing for body (if not provided by survivors);

- ☐ Fee for music;

- ☐ Flowers;

- ☐ Flower car for transporting flowers from funeral to gravesite;

- ☐ Classified obituary notices;

- ☐ Application for death benefits;

- ☐ Copies of the death certificate;

- ☐ Acknowledgment cards;

- ☐ Visitors' register;

☐ Motorcycle escort;

☐ Grave markers or headstone; and

☐ Perpetual care.

Conclusion: Financing the Funeral

Generally, funeral expenses can be paid over a period of 30 to 90 days; however, more and more funeral homes are **requiring payment in full** up front—via cash, check or credit card. Although probate court usually dictates that the funeral bill be one of the very first bills paid when an estate is settled, funeral homes no longer want to take the chance of not getting paid at all if there is no estate or the deceased's estate is too small.

> If you signed the contract with the funeral home and the estate does not have enough funds to pay for the funeral, you will be responsible for paying the bill.

If the cost of the funeral arrangements is being deducted from the estate, consult with the executor before signing any contract with the funeral director. Payment for the funeral and disposition should come out of the funds of the estate. If you are the executor, carefully review all documents before signing them and authorizing payment. This is part of your responsibility for "managing" the estate effectively to ensure against "unnecessary" depletion of assets.

The deceased may have had a **Totten Trust** or **Pay-on-Death** account—essentially a savings account in his or her name that is payable on death to a pre-determined relative, friend or even a funeral director. The money in the account is designated for his or her funeral and disposition expenses. This may be referred to in the letter of instruction—or will—if either exist. Or, he may have let the beneficiary

know ahead of time. If you are not the one named in the trust, the executor may be. He or she can access the funds and let you know how much money is available for planning the funeral.

If the deceased had a joint account with you or another family member set up for the sole purpose of financing the funeral, you (or the other family member) will have access to these funds immediately and a good idea of what your budget is.

The deceased may have prepaid for his or her funeral through a trust made payable to the funeral home. If he or she pre-paid for the funeral, the funeral director should have put the money into a trust account, naming the funeral home the beneficiary. Although the deceased may have thought he or she was taking care of everything by pre-paying, don't be surprised to find that there are additional charges.

Don't be surprised if you hear something along these lines as well: "The casket your uncle picked out 10 years ago is no longer available." (Casket styles change like cars.) So, the funeral director will show you what you can get for what your uncle paid. Or, you can pay the difference and get a casket that's closer in style to the one he picked out. You'll find that the cost of opening and closing the grave, flowers and other cash advance or services items (rather than merchandise) will not have been included in the original pre-paid plan.

Some states regulate these funeral trust accounts, some don't. Few require that 100 percent of what was received by the funeral home be put in the trust. If the arrangement is ever cancelled, not all the money is returned. And, the funeral home keeps the interest. (For more information on pre-paying for a funeral, see the Conclusion.)

Some funeral homes offer insurance policies.

Be sure to check the deceased's important papers and documents for contracts with funeral homes in the area if you think he or she may have pre-paid for a funeral. With all the major chain mortuaries buying up the smaller funeral homes, the home your loved one may have made arrangements through may have changed ownership, changed its name or gone out of business.

One poor woman (in spite of her meticulous pre-planning and prepaying for her funeral) was buried in a Styrofoam box still wearing her hospital Johnny. She was sent to the wrong funeral home because the owner of the funeral home she'd made her arrangements with had embezzled the trust money and the funeral company that bought them out never let her know of the change. Her family was devastated and sued for damages but that didn't give anyone the closure they were looking for.

The funeral home may accept insurance benefit proceeds as payment for funeral expenses. If you are the named beneficiary you can request that some or all of the proceeds be paid directly to the funeral home. Call your insurance company and find out if this is possible. Your funeral director may offer to call for you (for an extra charge or as part of his "services fee"). You sign a form authorizing the insurance company to pay the funeral home directly. But be warned, a widow who went into a funeral home with a $12,000 insurance policy walked out with a $12,000 funeral. It may be better to play your cards close to your chest in this situation.

It may even be possible that the deceased set up a life insurance policy for the sole purpose of paying for his funeral and made the funeral home the assigned beneficiary. In which case, you will find that the insurance benefit will be equal to the cost of the funeral. There's rarely anything left over.

4 Disposition of the Body

There are essentially two parts to making the final arrangements for a deceased loved one:

- The **service**—funeral or memorial; and

- The **disposition** of the body—burial or cremation.

When a death occurs, most people think about the funeral service first—meeting with a funeral director, the casket, flowers, music, use of the funeral home, transportation, embalming and restoration of the body, etc. This is for the *ceremony alone* and does not include the disposition. When prices are quoted for funerals people tend to think the price includes disposition—in most cases burial—**but it does not**.

Once survivors have spent a good portion of their money on the funeral they're then startled to learn that they need to spend another $5,000 or more to put the casket in the ground. The **final disposition**—how the body will be disposed—is in all instances a separate negotiation made with a cemetery or crematory, although the funeral director can make these arrangements for you for a fee. There are a growing number of one-stop shops popping up that are both mortuaries and cemeteries, mostly monopolized by the chains, but this is a fairly recent development and still the funeral is separate from the disposition. The one-stop shop may be convenient but the convenience can end up costing you a bundle. If you want the deceased

buried at a certain cemetery, you may feel obligated to use their mortuary (flower shop, monument maker, organist, pastor, etc.). More money for them, less choice of services for you. All wrapped in the guise of convenience.

> If the deceased wanted an earth burial and did not pre-purchase a plot, you might want to work backwards when calculating the cost of the funeral arrangements and start with the disposition.

The funeral is merely the ceremony honoring the deceased. It need not be held at great expense in the funeral home, but in a place of worship, a community hall or even your home. You need not have the body present to commemorate the life of the deceased. To save money, have a memorial service without the body present. The service will last an hour or so but he or she will be at the cemetery forever. If you take the time to think about it, you may find that *where* your loved one is buried may be more of a priority than *how* he or she is buried. Think about what is more important to you and your family (or what would have been important to the deceased) and make your purchases accordingly.

> First things first: Consider the cost of the plot in the cemetery you want (or that your loved one may have wanted) and then calculate how much you will have left to reasonably spend on the service. You can select direct burial or cremation, with or without a committal service. The money you save on the funeral can go toward a more scenic burial plot.

If the service is more important than the place of burial, you may want to avoid having to purchase a plot by having the body cremated. Although after a full-service funeral, the cost savings realized by cremation is minimized substantially. The various types of services are discussed in more detail in Chapter 5.

In this chapter, I'll go into some detail on the various types of disposition available, the reasons people tend to elect one option over another, the religious objections to certain types of disposition and the approximate cost for each option.

Making the Right Decision

If the deceased didn't leave a letter of instruction or discuss in advance his or her preferences for final disposition—how his or her body will be disposed—then the next-of-kin will have to make this decision with the help of family, friends and clergy.

If you are the next-of-kin, this may be one of the hardest things that you'll ever have to do in your life. Even if the deceased provided details about his or her wishes for final arrangements, it may be hard to carry them out. Everyone deals with loss differently, but we all go through the same stages as we learn to cope with loss. You may feel that you have done so much to care for this person during his or her life, that you haven't done enough or a little of both. Either way, letting go of the physical body is never easy. (Death educators suggest you think about the disposition of your loved one's body as a final act of love.)

Letting go can be even harder if family members can't agree on what they think the deceased would have wanted. Family members can get into heated debates, which can burn on for years, about what each one thinks the loved one would have wanted with regard to burial or cremation, funeral or memorial, flowers or donations. Funeral directors have to contend with feuding family members and the impossible task of trying to make arrangements that satisfies everyone.

"Many times over the years I've heard things like 'momma always did like you best,' or 'you've been taking money from daddy for years,'" one veteran of the industry told me. "I've often had to send family

members home to sort out their differences. I'm here to help them but I'm not in the family counseling business."

Although seldom enforced, each state has laws dictating who has the right to decide on funeral arrangements. In general, the order is usually as follows: spouse, adult child, parent, adult sibling or guardian.

If you have religious or cultural traditions you would like to adhere to, these may help you come to a decision for final disposition as well as plan a service or ceremony. Ask your clergy to help you plan a service at your place of worship and tell you about the traditions for disposition of the dead within your faith. Be sure to contact clergy at—or near—the time of death for personal guidance as well as advice for making the final arrangements. Remember: Your clergy may be able to recommend a cemetery or crematory that caters to your particular religious and/or cultural beliefs.

Financial limitations also come into play when making decision about final disposition. Some forms of disposition are less expensive than others. Donating the body to medical science, for example, is the least expensive option with direct cremation and direct burial being the second and third least expensive respectively. However, depending on who handles the disposition, your cost for even these simple services will vary greatly.

> Make calls and shop around. It may not seem like you have the time, and you certainly may not feel inclined to do so in your present state of grief, but you can save thousands by simply discussing prices and options over the phone with a few death care providers in your area.

If you don't feel like making the initial inquiries yourself, ask a friend or family member to make calls for you. You will be glad that you did. Be specific about what you want and don't want. Beware of pricey all-inclusive package deals. Like buying a car, the "little extras" will cost you *extra*.

Handling the Arrangements Yourself

Although it is far more common to use a funeral home, in most states you don't have to. If you elect not to use a funeral director and choose to dispose of the deceased's body yourself, with the help of family and friends, you may do so as long as you are careful to follow the regulations of the state and county in which the death occurred and in which you plan to dispose of the body.

In order to begin the legal process of caring for your own dead, you will need to procure a death certificate signed by a physician or coroner, stating the cause of death. The procedure for securing such a document varies by state and situation. Check with the registrar's office in the town where your loved one died. The hospital or your loved one's doctor may also know how to start the process to secure this document. It may be easy to get from your family physician or the physician who attended the death, or you may have to wait a few days to get it from the coroner. (Meanwhile you will have to store the body at the place of death while you await transportation permits. This could cost some money, depending upon the location)

The death certificate must be filed within a state-specified amount of time (usually three to five days) in the county where the death occurs, where the body is found, or—if death occurred in transit—where the body was removed from the train, plane, etc. In a few states, the signature of a licensed funeral director is required. In others, the space on the certificate marked "funeral director" can be signed by you or the person handling the disposition arrangements.

> You may need to specify your relationship to the deceased on the form (spouse, son, daughter). The death certificate must be filed before other necessary forms and permits will be issued. There will be a nominal fee of about $10 for the certificate (any additional copies will cost extra), which you will need for insurance filing and other benefits claims.

You will also need a permit to transport the body to the site of the burial or crematory as well as a permit for disposition. If you plan to cremate the body, a separate permit to cremate as well as authorization from the next-of-kin may be required before a crematory will accept the body.

Depending upon the state—whether on private land or in a cemetery—you may need a permit to inter in order to bury your loved one's body. These permits can be secured from the local registrar's office or health department and will probably cost you around $10 each. If, however, the office is closed—for the weekend or a holiday—you may be able to get these permits from a funeral director, who may function in the capacity of a deputy registrar. He should not charge you anything above what the registrar's office charges for the same services. If he does, you might want to reexamine his fees for other services...because he could be inflating those figures, too.

> Although the trend toward handling the disposition of a loved one is growing, it is still the exception and not the rule. As such, you may meet some resistance from county clerks, doctors, coroners, crematories, cemeteries and others regarding your involvement.

Do your best to follow the regulations and explain your rights to those involved. They should be trying to help you at your time of crises, not setting up road blocks or upsetting you. But, many of these folks are of a mind that—if it's not the way we've always done it, it must be wrong. They don't want to lose their jobs or get sued for breaking any rules. Let them know that you take full responsibility for your actions—a responsibility that you will not take them to task unless they stand in your way. Consult your lawyer if you have to.

Don't move a body without getting a transportation permit. And, before transporting the body, call ahead to where you are taking the body—whether it be a cemetery, crematorium, medical school—so

that they can be prepared for your arrival. Facilities not used to dealing with family members rather than funeral directors might need a little time to adjust. They may also be able to tell you what permits you will need in order for them to take possession of the body.

> Have your papers in order and know your rights and the laws of your state and local area. If you are moving the deceased from one state to another, know that regulations in each state vary. Although each state will honor the permits of another, there may be special regulations regarding disposition for each.

Many death educators believe that taking an active role in the preparation and disposition of a loved one's body can be very therapeutic. It helps survivors accept the death and move more naturally through the grieving process. You also won't feel as helpless. (For more on handling the arrangements yourself and for a list of state restrictions see Chapter 1.)

Types of Disposition

After you have decided whether you will handle the preparation yourself or hire a funeral director's services, you will want to decide how you want the body disposed. Although there are as many ways to honor the dead as there are individuals who have died, there are essentially only two ways in which a body is ultimately disposed—**burial** or **cremation.**

Even a body that has been donated to medical science will eventually be cremated or, in some cases, buried. And although your initial decision will be between these two options, there are several variations on each. The manner in which the body is buried or the cremains disposed of will vary depending on the wishes the deceased expressed prior to death, if any, and those of his or her family.

The Burial

Burial is the most common method of disposition in the U.S. Although cremation is growing in popularity, approximately 75 percent of Americans choose burial for themselves and their loved ones. It is one of the more expensive methods of disposition. In addition to any funeral services and funeral home fees with the burial, there is the cost of the cemetery plot, the casket, the vault, the headstone and opening and closing the grave to add to the bill.

If you choose to bury the body there are essentially three types of burial to choose from:

- **interment** or **earth burial**;

- **entombment in a crypt** or **a mausoleum** (aboveground burial); or

- **burial at sea**.

Burial requirements differ from state to state and county to county. The state may regulate a time period in which a body must be disposed of. Every state requires a physician or coroner to sign a death certificate attesting to the cause of death prior to burial. You will also need a permit to inter or a burial or cremation permit. If you are making arrangements through a funeral home, the funeral director will arrange to get these documents for you. If you are making the arrangements yourself, see your local registrar's office.

You may want to keep the time of year in mind when making your plans for body disposition. In some parts of the country, if the ground is frozen an earth burial may have to wait until warmer weather. In such instances, the body will need to be stored in a tomb or other holding facility until a grave can be dug. You may have to pay extra for this storage.

Opening and Closing the Grave

Essentially, digging a space in the cemetery for the casket and the vault, placing the casket within the vault and covering it with earth (usually done with machines)—can cost up to $2,000 or more if the work is done on a weekend or holiday. And that's excluding any gratuity for those who do the work. The cost of opening and closing a mausoleum or columbarium space may also give you sticker shock. Ask about these costs before assuming they are included in the cost of the space you are buying.

Why is opening and closing the grave so expensive?

Opening and closing fees can include 50 or more separate services provided by the cemetery. Typically, the opening and closing fee includes administration and permanent record keeping (determining ownership, obtaining permission and the completion of other documentation that may be required, entering the interment particulars in the interment register, maintaining all legal files); opening and closing the grave (locating the grave and laying out the boundaries, excavating and filling the interment space); installation and removal of the lowering device; placement and removal of artificial grass dressing and coco-matting at the grave site, leveling, tamping, re-grading and sodding the grave site and leveling and re-sodding the grave if the earth settles. —International Cemetery and Funeral Association Web site at *www.icfa.org*.

Immediate (or Direct) Burial

If you choose to bury your loved one, you may elect **immediate** (or **direct burial**). This is one of the least expensive options for burial

because it allows you to forgo any **embalming** or **viewing** of the body—elements in the more costly full-service funeral option. If you are working with a funeral director he will transport the body and make arrangements with the cemetery to take the body to the gravesite or to the mausoleum crypt. You can also call the cemetery directly if you wish to save money and take a more active role in making the arrangements.

A casket is not required for this type of burial. But just as with cremation, some form of container will be necessary for the handling of the body. A vault or grave liner may also be required by the cemetery—these usually run in the $300 to $1,000 range.

If you choose immediate burial, and wish to have some type of service—be it large or small—you have the option of a graveside service or committal service for which there will be an additional charge. If money is an issue, you can always have a memorial service without the body present, for little or no expense, depending on the location.

Burial Plots/Cemeteries

If you plan to inter the deceased's remains and he or she did not have a reserved cemetery space, you will need to obtain one. Just as when selecting a funeral home, you may want to inquire about religious and cultural affiliations when selecting a cemetery.

There are several different types of cemeteries, including:

- municipal or town-owned;

- religious or church-owned;

- private or family-owned

- national or state-run; or

- commercial for-profit cemeteries—many of which are run by the conglomerates.

Costs vary for each type of cemetery, depending on a number of factors, including: location; popularity; and age of cemetery.

Who owns and runs the cemetery may also make a difference in the cost to be buried there.

Cemeteries in churchyards are usually available only to members of the congregation. Religious cemeteries are usually reserved for only those members of the faith, although spouses of another faith may be allowed. Ask if this is permitted. In some cases, it's not. For example: Harry Houdini is buried in a Jewish cemetery, but his wife who was Catholic was not allowed to be buried with him, even though that was their intention. Things have changed since Houdini's time but not everywhere. If you want the deceased to be buried next to someone of another faith, you may want to verify—ahead of time—any restrictions the cemetery has.

Cemetery lots can be expensive and vary in cost from one area of the country to another, ranging roughly from $150 to more than $5,000, with those in urban areas being more expensive. In some municipal areas, plots can easily cost $20,000 or more. You may want to contact cemeteries outside of your city or town to see if costs are cheaper. Or, contact a funeral consumers group in your area and ask them for advice on more affordable cemeteries.

Prices for plots will also vary greatly within a cemetery based on location. Those with a scenic view—under a tree, near a rose garden, on a hilltop—will cost more than those that may be more difficult to access—next to a fence or sandwiched between other graves. Think of it as theater seating—front row balcony will always cost more than an obstructed view.

How Much Do Graves Cost?

Grave prices can vary, but are usually set based on their geographical location. Typically, graves in urban centers are more expensive than in rural centers. This is because of the replacement value of

land. In addition, within the cemetery, grave prices can vary by the section in which the grave is located. For example, graves in proximity to a central "feature" such as a sculpture or resting bench—may be more expensive than in non-feature sections. The number of interments permitted in a grave (i.e., a couple or mother and child) may also affect the price, as may the size of the grave. Graves that allow for a monument are also more expensive due to the space required for the monument.

Shop around for the right cemetery and the right plot. Visit several cemeteries before you make a purchase. Buying a plot you've never seen is a bad idea. When you visit the cemetery, take inventory of how well the grounds are maintained. Ask yourself the following:

- Does the cemetery allow for the type of burial marker you would like?

- Are you required to have a vault?

- What if this conflicts with your religious beliefs?

- Is this the type of place you will feel comfortable visiting?

- Are you able to get to the cemetery and the plot easily for visiting with your loved one?

If you let your funeral director make the arrangements, tell him what your concerns are—easy access (say you are in a wheelchair), a scenic view, cost—whatever they may be. Don't be intimidated or made to feel like you're being a penny pincher. Funeral and burial costs increase at a rate faster than inflation. There is no reason for it other than greed. The fact that the public will bear the price is out of ignorance and intimidation more than a willing desire to accept a "fair" market price. The only way to fight back and keep from getting bowled over is by being a well-informed consumer and making the choices that are right for you and your family.

Remember: All other-than-dishonorably-discharged veterans and their spouses and dependent children are entitled to free burial in a national cemetery and a grave marker. This includes opening and closing the grave, grave liner and setting the marker. U.S. vets greatly under utilize these benefits. For more information visit the Department of Veterans Affairs Web site at *www.cem.va.gov*.

For-Profit Cemeteries

Jessica Mitford in her famous exposé of the death industry, *The American Way of Death*, makes several interesting points about cemeteries. First, she points out that historically, cemeteries—usually on church or municipal land—have enjoyed a **tax-free status** being that they make use of cheap land and serve the public good. Charges for burial were once nominal and cemeteries were not meant to be the money-making ventures that they are today.

Today, however, there are many commercially-owned cemeteries that benefit from the tax-free status. They also benefit from the constant reinvestment of **perpetual care endowment** and of **pre-payment funds**. And, no matter what happens in the world of medicine, they benefit from the fact that people will continue to die. So with all this working in the financial favor for cemeteries why does the cost for burial continue to soar?

The answer is that some very clever "businesspeople" have set up non-profit corporations to run cemeteries. These non-profits pay no income tax on the sale of graves. The businesspeople keep most of the profit as the management company and the cemetery make just enough to keep its non-profit status. The more graves sold the more money the businessmen can keep. A cemetery can divide an acre of land to fit between 2,500 and 3,200 plots (counting some as double-depth, two caskets per space for couples, and some smaller infant-size plots, three to an adult-size grave). A land developer would be lucky to carve six

lots out of the same acre. And, the funeral management company can charge $2,000 to $8,000 or more (for the scenic views) per plot. That's a modest $5,000,000 an acre tax-free!

The sky is literally the limit when it comes to the profit potential for a mausoleum, which allows for 10 or more bodies to be stacked one drawer above the next as high as the cemetery cares to build. You can see why the push to sell pre-need lots is so prevalent. The conglomerates in states where owning both a cemetery and a funeral home is considered illegal have opted to keep the cemeteries over the funeral homes for obvious reasons.

Cemeteries are not regulated by the FTC's Funeral Rule (see Chapter 1) unless they also sell funeral goods and services. Be sure to ask about various price options for the items and services you want to purchase. Find out what the cemetery's requirements and restrictions are vis à vis:

- grave liners;

- monuments;

- decorations;

- additional charges for weekend interments;

- temporary grave markers; and

- fees for outside monument dealers to deliver and install the monument.

Don't assume anything is included. If this seems like too much for you to do with everything else that is going on, assign a relative or friend to help you negotiate with the cemetery. If you are using a funeral director he can do it for you—for a fee.

Grave Liners or Vaults

Depending on the cemetery, you may be required to purchase a **grave liner** or **vault**—at a cost of several hundred dollars—to keep

the grave from sinking in when the grave settles and the natural decomposition of its contents takes place.

A *grave liner* is made of concrete slabs placed around the sides of the grave by machine. The casket is then lowered into the grave at burial and another slab is placed on top. A grave liner covers only the top and sides of the casket. A *vault*, which is more substantial (expensive) than a liner, consists of a solid piece of steel-reinforced concrete, with a tight fitting lid, which surrounds the casket.

Grave liners or vaults are not required by law, but may be required by the policy of the individual cemetery. According to the Federal Trade Commission, it is illegal for funeral directors or cemetery personnel to tell you that law requires a liner or vault or that it will keep dirt or water from penetrating the casket indefinitely. For more on this see the FTC's pamphlet, *Funerals: A Consumer's Guide.*

In spite of what you may be led to believe by the funeral director or even by the names of these products—such as Duravault and Protector vault—neither a grave liner nor a vault is meant to protect the casket indefinitely. The purpose of either is to help the cemetery maintain its level grounds (graves sink when the casket and the body naturally decompose) and make mowing safer and easier, thus keeping maintenance costs low.

A funeral director is required by law to give you a description and list of prices for each of the vaults and grave liners he or she has available *before* showing them to you. Some do not sell grave liners but carry only the more expensive vaults. If you don't see what you want or the prices appear to be too high—leave. There's no point in staying and listening to the hard sell tactics of this funeral home when there are plenty of others out there who can meet your needs at a price you can handle.

In most states, both funeral homes and cemeteries sell these products. But, you may be able to get the less expensive grave liner from the cemetery.

In most cases, you will be able to get a grave liner or vault much more cheaply directly from the manufacturer, dealer or wholesaler. However, if you are shopping after the death has already occurred, you may not have the time to order and wait for these products to arrive. Contact the dealer and find out if the merchandise can be delivered within 48 hours. A cemetery cannot restrict you from purchasing these items elsewhere.

> Check with your state laws when it comes to the purchase of a vault. A few states stipulate that only a funeral director may sell caskets and vaults. In others states, cemeteries are prohibited from selling vaults.

Cremation vaults are also available and may be required by some cemeteries. Prices for these can range from $50 to more than $600.

Some cemeteries do not require vaults (Arlington National cemetery, for example). Others are against them (Jewish and Muslim cemeteries) because they interfere with decomposition and the natural return of the body to the earth. If you are environmentally conscious, this might be important to you. If it is, shop around for a cemetery that does not require a vault or grave liner. Not only will you save money, you'll also help the environment. (The casket is in direct contact with the earth and will decompose faster and more naturally than being enclosed in concrete.)

Perpetual and Endowment Care

Another cost associated with earth burial in a cemetery is **perpetual** or **endowment care**—the ongoing maintenance and groundskeeping. This fee may be separate or included in the purchase price of the plot. Other cemeteries make it a percentage of the price of the plot—10, 15 or 20 percent. Again, these prices vary but can add more than $1,000 to the cost of the plot. Be sure to ask about the cost

of perpetual care at the time of purchase, and read your contract carefully. You don't want to be hit with this added expense after your loved one is in the ground.

What guarantee do you have that the endowment care fees will be used appropriately? According to the ICFA Web site (*www.icfa.org*), while not guaranteed, endowment care funds are conservatively managed. Income from the fund can only be spent on care and maintenance of the cemetery. Laws in most states for consumer protection govern endowment care funds.

Purchasing a Casket

If you plan to bury the deceased in a cemetery, you'll most likely need a casket. (Although, in some cases, for direct burials you may be able to get away with some other type of appropriate container, such as a grave liner or vault.) Caskets are typically the most expensive item you'll buy for the funeral—and account for one-third to one-half of the total cost. They vary widely in style, construction and cost. They can be made of almost any type of material from plastic, fiberboard and cloth to hardwood, copper and bronze. They can cost anywhere from $100 to $25,000 or more. The average casket typically costs around $2,000.

Why do caskets cost so much? Prior to FTC regulation, the price of a casket was the total cost of the funeral. The price was marked up five to seven times the wholesale price in order to cover the other goods and services the undertaker provided such as picking up the body, filing the paper work, embalming, the funeral, etc. Once the Funeral Rule (see Chapter 6) went into effect in 1984, goods and services had to be itemized, but many funeral homes never reduced the casket prices to compensate for the other items that were now being charged separately.

Today, you have many options when it comes to the purchase of a casket. You can buy a casket from a funeral home, order one online or even build your own.

> By law, the funeral director must accept any suitable casket you provide from outside his facility. And, he cannot charge you an extra handling fee for doing so.

One funeral home I visited told me that I would be charged $400 for any casket I purchased elsewhere and that they couldn't guarantee the quality of a casket delivered from another party when it arrived. I was told that the seal would likely break, which would mean that the casket could not be closed. "What do you do when that happens?" I asked. "We offer to sell the family one of ours." How thoughtful.

Legally, the funeral home is obligated to use any coffin you prefer without any extra charge or reprisals, as long as it can hold the body for transportation. (There may be size restrictions on a coffin that is to be cremated with the body. It must fit into the retort. Ask for details on restrictions if you want to have the casket cremated.)

You can also build your own casket. To some, this may seem primitive. To others, it may be a fitting and personal gesture of love that makes perfect sense. Decorate the casket any way you like or have family and friends sign and write farewells on it for the deceased.

> Buying a casket online or from a wholesaler will save you a good deal of money on a casket—maybe even the same caskets the funeral home has to offer. Funeral homes have been known to mark up the price on caskets considerably—some times as much as 250 to 500 percent or more.

In most cases, dealers can ship the casket to a funeral home within 24 hours. If, however, you have any problems with the merchandise once you receive it, you will have to resolve them with the dealer or manufacturer. The funeral home won't be willing to help you—unless, of course, you want to buy one of their caskets to replace it.

> Caskets that cost $150 wholesale might be sold for nearly $600 or more. Some of the caskets marked $1,500 or $2,500 cost less than $500 wholesale. —Funeral Consumers Alliance

By law, the funeral director is required to show you a list of all the caskets he sells—including a description of each and its price—*before* showing any caskets to you. You may find at this point in your dealing with the benevolent and counseling funeral director that his salesman side emerges.

One of many so-called "tricks of the trade" is to show a range of three caskets at the upper end of your price range. Say your range is around $1,000. The funeral director might show you a casket that costs $1,899 (which is actually closer to $2,000), that may be lovely for its purpose but is out of your range. He may then show you one that is of noticeably lesser quality for, say $950. The third one, the one he really wants you to buy, is $1550, which, for "a mere $550 more" than your original target price, will seem well worth it in contrast to your other two choices based on price and quality. It seems like a fair deal. If this occurs, you've fallen for the trap. This is what they want you to think and it happens all the time.

One high-end mortuary/cemetery chain plays this game. It offers three package levels to choose from: the Harmony; the Traditional; or the Heritage. No matter which casket you choose at the Harmony level, it'll cost you $1,350; in the Traditional all caskets are $2,150; in the Heritage they're $2,850. The mid level is probably called the Traditional for a reason. Most people will make a beeline for it because, after all, it's the traditional. It's not too cheap and it's not too extravagant—it's just right. (Of course, they have the Prestige level for $4,375 and the Elegance level for $9,850 or you can break the bank for The Royal casket at $25,000.)

According to the FTC, industry studies show that the average casket shopper buys one of the first three models shown, generally the middle-priced of the three. Funeral directors will first show you the higher-end models. If you haven't seen some of the lower-priced models on the price list, ask to see them. Don't be surprised if they're not prominently displayed or not displayed at all. You may even have a hard time trying to get them to show you these models.

Some major mortuaries and conglomerates don't even offer low-cost models. Others may simply hand you a catalog and hope that you plan to take care of the matter immediately—on the premises—with a higher-end model.

A few states require the display of a minimum number of caskets. One funeral home I visited didn't have whole caskets on display, just a cut cross section of the corners of those available in each of its three packages. Walking into a room full of coffins may be the last straw for an already weary widow(er), but being asked to spend a good deal of money on something you can't even see in its entirety also seems like a lot to ask.

You may feel rushed and stressed by the situation and not in the best mood to look at coffin after coffin. Funeral directors know this— that may be another reason why the "show 'em three" game works so well.

Don't be embarrassed to cut to the chase and ask to see the less expensive caskets. Don't be put off if they are not on display or are way in the back as if to indicate that no one ever buys them.

The funeral director may even use language that might lead you to believe these caskets are only for the indigent and that your loved one deserves better. Remind the salesman that your love for the deceased couldn't possibly be expressed in terms of dollars and cents and therefore it makes no sense to draw such analogies.

The purpose of a casket is to have a means to transport the body to and from the service and to the place of burial or cremation. That's it—period. The only time the casket will be seen is if you have a viewing. (See Chapter 5 for more on viewings.) Don't let a funeral director tell you that a certain casket is not suitable for viewing. That's *your* call—not his. He is merely trying to get you to buy something more expensive. If you are having a memorial service—without the casket present—no one will see the casket anyway.

Protective Schmective

If you are not easily swayed into buying an expensive casket merely based on cosmetics, the funeral director may try to sell you based on the "protective" qualities of the caskets. Protective caskets have a rubber gasket designed to seal the coffin and protect its contents from water, earth and insects. Regardless, the fact is that no casket can preserve the remains indefinitely and it is against the law for a funeral home to claim otherwise. Nature will take its course, as it should, and dust will eventually return to dust in spite of an 18-gauge bronze coffin and a concrete and steel burial vault.

In most cases, the "sealer" casket only serves to interfere with the natural decomposition of the body by keeping air from the contents and thus causing them to putrefy. This may also cause the casket to rust from the inside out. In fact, some caskets have been sealed so tightly that gases built up inside, causing them to explode. Others have held air so tightly that the sealer vaults float away during a flood. This may seem insensitive to mention but no more so than having the wool pulled over your eyes by a salesman at a time of crisis.

A casket is not required for cremation, but some facilities will require that a cremation container be purchased or provided. These containers are usually of cardboard and can run for less than $50. They are cremated with the individual. If your loved one is to be cremated and you would like to have a viewing and a funeral, you can

rent a casket for these services from the funeral home at a cheaper rate than buying one. If, however, you want to buy a coffin for the deceased to be cremated in, you will have to choose from those models that are suitable for combustion—pressboard, wood or cloth.

Headstones and Grave Markers

You are not required to purchase a marker or a headstone. Again, arrangements can be made through your funeral director, the cemetery or with an independent monument maker, if you want one. A cemetery cannot tell you that you have to purchase a headstone, marker or monument from them. To do so is against federal regulations. If you use a vendor outside of the cemetery, it may save you money on the price of the headstone, however, the cemetery may charge a fee for having the stone delivered. And, the cemetery may insist on installing the stone and charge you for that as well.

Regardless, there is no need to rush into this purchase. A temporary marker will be set on the grave for identification until a permanent one replaces it. In the Jewish tradition, the marker is not placed until the one-year anniversary after the death. Some people never replace it.

> The type of cemetery you've chosen may also dictate the type of marker allowed, so ask the cemetery when you're doing research on where you want to have the burial.

Traditional cemeteries allow you to mark the grave with an aboveground granite, marble or bronze marker that is the size and shape of your choosing. A "memorial park" however, may have a policy of permitting only uniform stones or plaques that are level to the ground. This lets the park keep the appearance of a wide open space and also makes it very easy to mow the grass, which keeps mainte-

nance costs low for the cemetery. The cemetery may also dictate the type of flowers or vases or other adornments you can use at the gravesite, so be sure to ask about these ahead of time.

You will also be charged for delivery, installation and the base— which could be made of granite to match the marker or cement. If you don't ask they may assume you want the more expensive option. Or if you don't know what your options are, they could charge you for the granite and give you the cement. You will want to ask about these things before you make your purchase.

Be prudent in your dealings with the cemetery. The FTC's Funeral Rule—which tries to impose fair dealing from the funeral industry (discussed in Chapter 6)—carries no weight on cemeteries, unless a cemetery also provides funeral goods and services.

It is up to you to ask the right questions, get the information you need about pricing, service and goods available before making your decision to work with the cemetery. Once again, it is important to know your rights, have a relatively clear idea of what you want and what you are willing to pay, before you begin to negotiate or walk in the door. Haggling over prices at a time when you are coping with the loss of a loved one may not seem appropriate. But consider those on the other side of the deal who are willing to take advantage of you in such a state. They are the ones who are inappropriate.

Home Burial

You can bury your loved one's body on private property if local law permits. Each state and local area has regulations and zoning ordinances for private property burial. A body must be buried a certain distance from a water supply or power lines. The grave must be at a certain depth and in soil with the appropriate composition. Check with the health department, regulatory board and/or the medical examiner in your area regarding specifications and permits.

You may also want to consider how long you expect the land to be in the family. You will not want to have to think about moving your loved one's body in a few year's time. Land values change rapidly and what may be a rural area today may be quite populated five years from now. New owners may want to develop the land. And, future owners may deny you access to the site although in many states a gravesite becomes a permanent easement. Because it becomes a permanent easement, it devalues the land. If you want to sell the land for a higher value, you may not want to bury the deceased on the land.

If, however, the deceased will be buried in an established cemetery and you would like to take a more hands-on role in the burial, ask cemetery personnel if you and family or friends may participate in the excavation of the grave. Most cemeteries will insist—for safety reasons—that they handle the excavation of the grave and the installation of the grave liner or vault. However, they may understand the family's desire to participate and allow members to help with the closing of the grave.

Entombment

Some people prefer burial above ground in a tomb rather than being placed underground in a grave. Today's modern burial crypts are called **mausoleums**. These aboveground structures are usually made of marble or stone and can be as tall as 20 stories high. They are essentially a honeycomb of vaults where casketed remains are stacked in shelves one on top of the other and side by side. Mausoleums can hold hundreds of bodies; some have been built to even hold thousands.

The crypts open out to either a central room or have an opening to the outside. A plaque is placed over the vault door where the casket has been placed with the deceased's name, date of birth and death and a small epitaph (if space allows). A small vase may be attached to the outside to allow for the placement of a flower or two.

Most mausoleums are found on cemetery grounds. While space for earth burials grows sparse, mausoleums continue to grow. Space above ground is unlimited, allowing cemeteries to build their mausoleums higher and higher to accommodate more tombs.

Interment of a body in a mausoleum is called *immurement*. The word *mausoleum* reportedly comes from King Mausolos of Caria in Asia Minor, who built a 140-foot temple-like tomb for his wife in about 350 B.C. The Taj Mahal in India and the Great Pyramids of Egypt are some of the most well known and historic tombs. In more recent history, leaders like Vladimir Lenin in Moscow's Red Square, Mao Tse Tung in Bejing's T'in-anmen Square and Ulysses S. Grant in New York City have tombs built in their honor.

If you purchase a mausoleum vault, understand that there is a distinct difference in cost depending on the level at which the casket is placed in the mausoleum. The following terms refer to the various levels, based on where they align with where you are standing in the mausoleum—eye, heart and heaven. Heart is the most expensive level because you don't have to bend or stretch to read the inscription. Cost for space in a mausoleum can be about $1,500 and up depending on the level you choose. (Prices for mausoleum vaults at cemeteries I visited in Los Angeles ranged between $2,500 and $10,000.)There is also a cost of a few hundred dollars for opening and closing the vault door, inscribing the nameplate and maintenance (this can range anywhere from $300 to $1,000).

At one cemetery I visited, in order to secure a plot for direct burial of my dying (fictional) Aunt Rhonda, I was told that plots were very expensive and hard to come by but I was in luck since they had plenty of room in their "pre-construct" mausoleum. I would save big bucks because I would not have to buy an outer burial container and pay a setting fee for that container. The price of this great opportunity was broken down in writing for me as follows:

- Right of interment $2,500 (Interesting expression. Do they mean basic services fee?);

- Interment Service Fee $495 (Opening and closing the vault door);

- Memorial $350 (Small plaque on vault with her name); and

- Department of Consumer Affairs interment fee $8.50 (A charge allowed by the California Cemetery and Funeral bureau since 1997. Although, no one I spoke with there could tell me what it was for.)

The grand total: $3353.50. This price, of course, did not include the casket, death certificate, permits or anything else I would need for a direct burial. It also didn't include the cost I would incur for having to store Aunt Rhonda until the "pre-construct" was finished or the cost for moving her when it was ready. These costs would surely make up for any savings I would have realized had I gone with the mausoleum versus an earth burial—which is what I wanted.

The cemetery insisted that I write a check in the amount of $150 before I left. This $150 was to "reserve" a spot in the pre-construct, even though I had only gone to the mortuary to inquire about prices for direct burial. The cemetery employee hadn't been listening to what I wanted, which was earth burial and a committal service. This woman had an agenda: to fill a quota and sell spaces in the soon-to-be-constructed mausoleum.

In a last ditch attempt to get my business, the saleswoman warned me as I was leaving that if Aunt Rhonda had the nerve to pass away in the night and I came back tomorrow, the same so-called "deal" would not be available to me. Had I been bereaved and exhausted, I may have given in to her demands and poor Aunt Rhonda would have been put in a mausoleum against her wishes only to be moved several months—and hundreds of dollars—later.

Both earth burial and immurement provide survivors with a physical place to visit and memorialize the deceased. Burial at sea however, does not provide a place for visitation and remembrance, unless you consider the entire ocean as the memorial.

Burial at Sea

When most people think of or hear "burial at sea," they assume that you're referring to a scattering of the deceased's ashes. Burial at sea however, can also refer to a full body ocean burial. Full body ocean burial is an unusual choice for disposition. It is very expensive, roughly two to three times what it would cost for earth burial, and requires additional permits and authorization, which can take time to secure. However, once the proper legal documentation has been obtained, burial at sea can be performed by anyone who complies with the regulations and can navigate a boat that can accommodate such a cargo.

Regional authorities, as well as U.S. Navy and Coast Guard regulations dictate where, when, how, and even if, a body can be deposited in the ocean. There are a few stipulations of course. The body must be embalmed—to last for at least 60 days—and placed in a non-sealing metal casket, bound with bands of nylon and bearing 150 pounds of additional weight. Two-inch holes (20 total) must be drilled in the top, bottom, and at each end. All necessary measures are taken to ensure that the remains sink to the bottom rapidly and permanently.

A burial at sea also requires you to notify the Environmental Protection Agency (EPA). You have 30 days from the time of the burial to report it to the EPA's Regional Administrator in charge of the region from which the vessel carrying the remains departed. The EPA has established environmental rules for burial of human remains that are not cremated. The rules state that the burial shall take place no closer than three nautical miles from land and in water no less than

100 fathoms (600 feet) deep. To reach this depth may require a long voyage (hence the reason for the prolonged embalming) in an appropriate vessel and adequate number of crew members—all of which affect the cost.

According to the EPA, flowers used in a ceremony must consist of materials that decompose easily in the marine environment.

If you are planning full body burial at sea after a traditional funeral, your costs will be substantial. The cost of full-body burial at sea ranges depending upon the following:

- location;

- time of year;

- type of service;

- type of vessel;

- number of crew members needed;

- fuel costs; and

- **number of permits that may need to be secured.**

> The cost for renting a boat in the summer months in certain vacation ports may be more expensive because most vessels will be used for recreation.

There may be expensive docking charges in some large cities or popular ports that will also be tacked on to any charges you have to pay for the disposition. If you and family or friends will be accompanying the remains this will also greatly affect your cost. Law dictates that specific types of vessels be chartered—the larger the group, the larger the vessel and the more crew required.

Burial in a National Cemetery

Veterans are entitled to the following: burial in a national cemetery; a government headstone or grave marker (regardless of the cemetery); a burial flag; and a Presidential Memorial Certificate. But spouses and dependent children of veterans are also entitled to a plot and marker (only in a national cemetery). There is no guarantee that spouses will be interred side-by-side. However, in some cases, one grave site is provided for the burial of all eligible family members and a single headstone or marker is provided. When both spouses are veterans, two grave sites and two headstones or markers may be provided if requested. A spouse and dependents of an eligible veteran are entitled to burial in a national cemetery even if the veteran is not buried there. A spouse who remarries a non-veteran and whose marriage ends in death or divorce may claim burial rights from the prior marriage, as well.

> Cremated remains are buried or inurned in national cemeteries in the same manner and with the same honors as casketed remains. — Veterans Affairs

Generally, there is no charge for the following:

- opening or closing the grave;

- perpetual care;

- a vault or grave liner for casketed remains; or

- setting the marker in a national cemetery.

Depending on the circumstances, a family will be responsible for all other expenses—including transportation to the cemetery.

> The VA will assume responsibility for burial when the body of a veteran with no next-of-kin is unclaimed from a VA facility and his or her estate is without funds.

153

The Department of Veterans Affairs' National Cemetery Administration maintains 120 national cemeteries in 39 states. A list of VA national cemeteries is provided online at *www.cem.va.gov.*

Although there isn't a VA national cemetery in every state, many states have established state veterans' cemeteries. Eligibility is similar to VA national cemeteries, but may include residency requirements. Contact the state Veterans Affairs office for eligibility requirements. State veterans' cemeteries are run solely by the states.

The Arlington National Cemetery is operated by the Department of the Army and eligibility for burial is more limited than in other national cemeteries. For information on burial in Arlington, visit *www.mdw.army.mil/fs-a01.htm* or contact the Superintendent, Arlington National Cemetery, Arlington, VA 22211, or call (703) 695-3250.

No special forms are required when requesting burial in a VA national cemetery. Plots in VA national cemeteries cannot be reserved in advance. Simply contact the national cemetery in which burial is desired at the time of need. Or ask your funeral director to do so.

Burials are not conducted on the weekends. But, according to Veterans Affairs, you can call seven days a week to schedule an interment Monday through Friday. Keep in mind: Viewing facilities are not available and funeral services cannot be held at VA national cemeteries; however, a final committal service may be performed. For safety reasons, these committal services are held in committal shelters located away from the grave site. Burial will take place following the committal service.

When contacting the cemetery, you will want to have the following information concerning the deceased available to share with the cemetery to confirm eligibility:

- Full name and military rank;

- Branch of service;

- Social Security number;

- Service number;

- VA claim number, if applicable;

- Date and place of birth;

- Date and place of death;

- Date of retirement or last separation from active duty; and

- Copies of any military separation documents, such as the Department of Defense Form 214 (DD-214). The discharge documents must specify active military duty and show that release from active duty was under other-than-dishonorable conditions.

Department of Veterans Affairs (VA) national cemetery directors have the primary responsibility for verifying eligibility for burial in VA national cemeteries. A determination of eligibility is usually made in response to a request for burial in a VA national cemetery.

According to the directors, persons eligible for burial in a VA national cemetery, include the following:

- **Veterans and Members of the Armed Forces (Army, Navy, Air Force, Marine Corps, Coast Guard).**

(1) Any member of the Armed Forces of the United States who dies on active duty.

(2) Any veteran who was discharged under conditions other than dishonorable, with certain exceptions.

(3) Any citizen of the United States who, during any war in which the United States has been or may hereafter be engaged, served in the Armed Forces of any Government allied with the United States during that war, whose last active service was terminated honorably by death or otherwise, and who was a citizen of the United States at the time of entry into such service and at the time of death.

- Members of Reserve Components and Reserve Officers' Training Corps.

- Commissioned Officers, National Oceanic and Atmospheric Administration.

- A Commissioned Officer of the Regular or Reserve Corps of the Public Health Service.

- **World War II Merchant Mariners.**

- **Spouses and Dependents.**

(1) The spouse or unremarried surviving spouse of an eligible person, even if that person is not buried or memorialized in a national cemetery.

(2) The surviving spouse of an eligible decedent who remarries an ineligible individual and whose remarriage is void, terminated by the ineligible individual's death, or dissolved by annulment or divorce is eligible for burial in a national cemetery. The surviving spouse of an eligible decedent who remarries an eligible person retains his or her eligibility for burial in a national cemetery.

(3) The minor children of an eligible person. A minor child is a person who is unmarried and: (a) Who is under the age of 21 years; or, (b) Who is under 23 years of age and pursuing a course of instruction at an approved educational institution.

(4) An unmarried adult child of an eligible person if the child is physically or mentally disabled and incapable of self-support before reaching the age of 21 years. Proper supportive documentation must be provided.

Headstones and Markers

The VA will furnish—at no charge—a headstone or grave marker for any eligible veteran buried in any cemetery in the world. Headstones and markers are also available for spouses and dependents buried in military, state or national cemeteries (not for those buried in private cemeteries).

However, the style of the marker must be consistent with the cemetery's requirements. Niche markers are also available to mark columbaria, which is used for inurnment of cremated remains.

When burial is in a national or state veterans' cemetery, the headstone or marker should be ordered by the cemetery officials based on the inscription information provided by the veteran's family. When burial is in a private cemetery, the headstone or marker must be ordered by the family or a representative—such as funeral director, cemetery official or veterans counselor—from the VA. The VA will ship the headstone free of charge, but will not pay for its placement.

VA provided headstones must be inscribed with the following information in the following order:

- Name of the deceased;

- Branch of service; and

- Year of birth and death.

The headstone may also include an emblem of religious belief (Holy Cross, Star of David, etc.), and if space permits, military grade, rank, war service, military awards, military organizations, civilian or veterans affiliations. Additional items—such as nick-names and terms of endearment—may be added at the family's expense, and must be approved by the VA.

To request a government headstone or marker you must submit *VA Form 40-1330, Application for Standard Government Headstone or Marker for Installation in a Private or State Veterans' Cemetery*, along with a copy of the veteran's military discharge documents, (DD-214) to:

Memorial Programs Service (402E), Department of Veterans Affairs, 810 Vermont Avenue, NW Washington, D.C. 20420-0001. To obtain the form, go to *www.cem.va.gov/factsheets.htm* or call (202) 275-1494.

> On December 27, 2001, President George W. Bush signed the Veterans Education and Benefits Expansion Act of 2001. This law allows the Department of Veterans Affairs (VA) to furnish an appropriate headstone or marker for the graves of eligible veterans buried in private cemeteries, whose deaths occur(ed) on or after September 11, 2001, regardless of whether the grave is already marked with a non-government marker. —The Office of the Inspector General Semiannual Report to Congress, October 1, 2001 to March 31, 2002

The VA also provides memorial headstones and markers—bearing an *In Memory of* inscription—for eligible individuals or groups of veterans whose remains are:

- not recovered or identified;

- are buried at sea;

- donated to science; or

- whose cremated remains have been scattered.

Memorial headstones and markers may also be provided in national, military post, base or state veterans cemeteries to eligible spouses whose remains are unavailable for interment.

The stone must be placed in a cemetery (national, state, local or private). The VA will ship the headstone free of cost but does not pay for plot or placement in a local, private or state cemetery.

Cemetery staff in national, military post, and military base cemeteries are responsible for setting the headstone or marker at no cost to the family. Some state veterans' cemeteries may charge a nominal fee for setting the headstone or marker. Arrangements and expenses for

setting a headstone or marker in a private cemetery are the family's responsibility.

> Upright headstones are the standard for most national cemeteries; however, some have flat marker sections, as well. Be sure to discuss these options with the cemetery director prior to choosing a site for burial.

Burial at Sea for Vets

Burial (or the scattering of cremains) at sea is also available to veterans and their dependents, through the U.S. Navy or Coast Guard free of charge, with certain restrictions.

Because sea burials are performed at the convenience of the military, family and friends may not witness sea burial. And as stated earlier, the body must be embalmed—to last for at least 60 days. (Presumably because the burial is performed at the convenience of the military, which could mean storing the body for some time.)

> For more information about the Burial at Sea program or for Navy regulations for burial at sea, contact the United States Navy Mortuary Affairs office toll-free at (888) 647-6676. Or, contact the Department of the Navy www.donhr.navy.mil.

Cremation

Pottery from the Neolithic period provides evidence that cremation may have begun around 4,500 to 3,000 B.C. in Europe and the Near East. The practice spread to the British Isles in around 2500 to 1000 B.C. For ancient Greeks, like Homer, and Romans, like Julius Caesar, cremation was the predominant method of disposition. Early Christians considered it pagan and Jews preferred entombment. When Emperor Constantine spread Christianity throughout the Holy Roman Empire around 400 A.D., earth burial replaced cremation and

remained the accepted mode of disposition throughout Europe for more than 1,500 years.

Modern cremation began when Professor Brunetti of Italy exhibited a dependable cremation chamber at the 1873 Vienna Exposition. Sir Henry Thompson, Queen Victoria's surgeon, founded the Cremation Society of England in 1874. In the U.S., Dr. Julius LeMoyne built the first crematory in Pennsylvania in 1876. In 1913, the Cremation Association of America was formed with 52 crematories in North America and over 10,000 cremations that year. In 1975, the name was changed to the Cremation Association of North America to include membership in Canada. As of 2001, there were 1,700 crematories and 650,776 cremations, roughly 27 percent of all deaths in the United States.

Slightly more than a quarter of Americans choose cremation for final disposition. For some states the statistics are much higher— roughly 45 to 62 percent in California and Hawaii, respectively. These numbers have increased dramatically in the past two decades and continue to escalate. In fact, the Cremation Association of North America (CANA) predicts that by 2010, close to 36 percent of all Americans will choose cremation. In other parts of the world, such as Britain and Japan, the practice is the most common form of disposition.

CANA attributes the growing popularity of cremation in the U.S. to a number of emerging trends including: the loosening of religious restrictions and ties to tradition, as well as environmental concerns and an increased desire to employ a simpler, less emotional and more convenient mode of disposition.

Some people opt for cremation simply because they like the idea that the body can become one with nature more quickly when the cremated remains are scattered or buried, than when they are sealed in a casket or concrete vault. For them, cremation symbolizes the return of ashes to ashes and dust to dust. For the environmentally conscious, it's more about not filling the ground with materials that won't erode, naturally—like metal coffins and concrete vaults—than anything else.

One funeral director I spoke with said that at first he resisted the shift toward cremation, but admits, "the cost of traditional funerals are just getting too high, we are pricing ourselves right out of the business." With the "if you can't beat 'em, join 'em" philosophy he opened one of the first crematories in his area to meet the growing demand of his community.

But, for many people the option of cremation does come down to price. Cremation is one of the most cost-effective options for final disposition. With **direct cremation** you don't need to pay for:

- a **casket**;

- **embalming**;

- **viewing**;

- a **hearse**;

- a **vault**; or

- a **funeral**.

Although selecting cremation does not mean you have to forgo these things altogether. If you want to have them, by all means, have them.

No Body No Service?

If you're worried that cremation will cause you to forfeit having a service, you've been ill-advised. Some crematories have chapels where you can have a service prior to the cremation with the casket (or container) present. Flowers, prayers and music may also be part of the service. The service is similar to the funeral without the funeral home.

You can keep the arrangements simple, such as having a memorial service—after the cremation—at your church or a location other than the funeral home. Following the service, scatter the remains yourself or take them home. This will help keep costs low. Or you can opt to have a full funeral at a funeral home just like you would with a

traditional burial. However, if you have a traditional funeral with an open casket and viewing, followed by cremation and then have your loved one's remains buried, brace yourself for the cost. You'll probably spend even more than you would with a traditional funeral. If you wish to have an open casket funeral before cremation, you might be able to save a few dollars by renting a casket from the funeral home rather than buying one.

> Some experts claim that cremation followed by a simple memorial service allows the survivors to honor the memory of the person who has died rather than focus on the dead body. Direct cremation allows survivors to concentrate on the spiritual life—not the loss of the physical one.

To make arrangements for cremation, you can work directly with a crematory, a direct disposition memorial society or through a funeral home. (Some funeral homes have their own cremation facilities on the premises; others will contract the cremation out to a crematory for an added fee.)

Do I Need a Casket for Cremation?

No. The law does not require a casket for cremation, which would allow you to save on the disposition. A simple container that allows the staff to handle the body easily and respectfully is all the crematory requires and can be purchased for about $100 or less. If you are working with a funeral director, by law he cannot tell you that you are required to buy a casket for direct cremation. He must also disclose in writing your right to buy a plain wooden box or alternative container for direct cremation. And he must make a plain wooden box or an alternative container available to you—although you could provide your own. (You can build your own or order one online or from a retailer).

Jewelry should be removed before the body is transferred to the crematory. Unless, of course, the deceased's wishes instruct otherwise. The cremation process will destroy such items and retrieval will be impossible. Pace makers and other medical devices need to be removed by the attending physician, the medical examiner, or the funeral director prior to cremation to prevent explosion.

Due to the finality of cremation—and because it eliminates the ability to determine a cause of death—the legal transit documents, a cremation permit and authorization to cremate are required by the crematory before it will accept a body for cremation. Some crematories may also expect payment upon receipt of the body. Certain states also require a waiting period of up to 48 hours prior to cremation (Texas, Massachusetts, Florida and Indiana to name a few). In such instances, state law may require refrigeration or embalming after 24 hours. If the deceased did not sign a **cremation authorization** prior to death, the next-of-kin must give authorization to cremate the body. This must be obtained in writing and may be obtained via fax, telegram or overnight mail if the next-of-kin lives out of town.

"Next-of-kin" laws vary by state but the order usually is as follows: surviving spouse, all adult children, parents, all adult siblings, then guardian. If the spouse is alive and gives permission for cremation, no other authorization is required. If there is no surviving spouse, the authorization must come from all the adult children and so on down the list. If the next-of-kin do not agree with one another about the cremation or if the next-of-kin is not available, the crematory will not proceed with cremation.

Identifying the Body for Cremation

You may be asked by the funeral home or crematory to come and identify the body before cremation. By the time the body—accompa-

nied by all the required permits and authorization forms—reaches the funeral home or crematory it should be quite clear whose body it is. This is reputedly a tactic funeral homes use to increase their revenue by:

- enticing families to buy a nicer casket (once they see grandma in a cardboard box);

- charging for storage of the body (if the family can't come immediately to ID the body);

- charging for this ID viewing (although the family didn't request it); and

- charging for preparing the body for such a viewing.

The state of Louisiana passed a resolution to make such ID viewing a prerequisite to cremation. In every other state you have a right to refuse such a viewing. But, be warned, the funeral home may threaten to charge you for storage of the body until you comply with ID viewing.

Ironically, in some instances when families have tried to make arrangements with the crematory directly, circumventing the funeral director, and delivered the body themselves to the crematory, the crematory refused to take the body from the family without the funeral director. If the family delivers the body (with the proper permits), they are identifying it, and giving their authorization for cremation. But the industry wants us to play by their rules, even if they conflict with our rights as survivors and next-of-kin.

Many crematories require that the body be placed in a rigid, leak-proof, container made of wood, cardboard or other combustible material to allow for easy handling. The container is then placed in the cremation chamber—called a **retort**—where the temperature reaches approximately 1,800°. After about two to three hours, the body is

reduced to about seven or eight pounds of bone fragments. The chamber must cool down before the cremains—**cremated remains**—can be removed. Care is taken to remove every particle; however, it is impossible for the crematory to retrieve every minute particle. (Likewise, there may be minute residue from the previous cremation in the retort when your loved one is placed inside.)

Any metal—from the casket or dental work, etc.—is removed using an electromagnet and disposed of. The cremated remains are then pulverized into fine particles and are placed in plastic bags in a container of plastic, cardboard or metal provided by the crematory or in an urn purchased by the family. The entire process takes approximately three hours. But you may not get the cremains returned to you for a few days.

Urns and Containers

Although you may receive the cremains from the crematory or funeral director in a container marked "temporary," you do not need to put them in a different container. The term *temporary* is used to give you the impression that you have to buy a different container—preferably from them. You don't—ever. This is only another tactic to make a quick dollar.

A **cremation urn** is a container designed to hold cremains. On average, urns cost between $75 and $500, but, depending upon the materials they are made of can cost much more. The urns at one of the chain funeral homes I visited ranged from $250 to $2,500. Urns can be made of wood, glass, crystal and stone and come in any shape or design. Remember: If you want an urn, you don't have to buy a cremation urn from a funeral home or crematory. You can save a great deal of money by buying one directly from a wholesaler, over the Internet or by making your own.

If you plan to provide your own container, make sure that it is big enough—about 200 cubic inches for an adult—to store all of the

cremains. Bring it with you when making cremation arrangements so that the crematory or funeral director can tell you if it is the appropriate size. Don't be talked into an expensive urn if that is not what you had in mind. You can always transfer the remains into another container once you bring them home.

Final Disposition of Cremains

With cremation, you will have even more options for final disposition and memorialization than with body burial. Once you receive the cremated remains of the deceased you have an endless number of options to choose from.

> Cremains can be stored indefinitely, so there is no rush to decide on a final resting place. You may want to hold on to them until distant family members are able to join you for the memorial or committal service.

You can put the ashes in an urn or other container (or leave them in the original container) and keep them at home. Or, place the urn in a niche in a *columbarium*—a structure containing recessed memorial niches for cremated remains. There will be a cost for the niche as well as for opening and closing it. Some people have an inurement ceremony in place of—or in addition to—a memorial or funeral service. The niches are faced with glass, bronze or marble and may bear an inscription. The columbarium may be part of a mausoleum, church or cemetery wall. Not all cemeteries have mausoleums or columbaria. You'll need to call to find one that does.

There are few restrictions on the burial of cremains. You can bury them in your garden or back yard. You can also bury the cremains just as you would a casket in a cemetery. You don't need to buy an urn or special container to do this. The cremains can be buried in the container the crematory places them in.

Depending on the cemetery, you may have to buy a **cremation vault** in which to place the remains. The vault would serve the same purpose as a burial vault—keeping the earth from caving in as the contents decay, thereby making lawn maintenance easier and safer for the gardener. (One funeral director swears he heard a story about a gardener who was killed when a grave collapsed and the riding mower fell in on him.)

There may be a separate section of the cemetery for urn burials, sometimes called an **urn garden**. Just as with a grave, a memorial plaque or grave marker would be placed to mark the spot. One such plot may be sufficient for the cremains of two or more people—no matter what the cemetery staff tells you.

> If you want to bury your loved one next to another person, say your parents want to be together, you can have the cremains buried on top of the casketed remains, or in the space next to him or her. However, depending on the cemetery's policy, you may need to purchase a full-size plot next to the casket and pay the full price. The cost of burying an urn can be expensive and includes opening and closing the plot, a liner (if required) and a memorial marker.

Some cemeteries have scattering gardens, where you can have your loved one's remains scattered. A memorial plaque with his or her name may be placed on a wall surrounding the garden. There will, of course be a charge for this. Having the remains placed in a niche, interred or scattered on a cemetery's grounds ensures that you and other survivors will have a place to visit and remember them.

Of course you can always scatter the cremains of your loved one in almost any location that was special to him or her—such as a favorite garden, forest, mountain or the ocean—as long as state and local laws permit. If the location is on private property, you must get permission first. You may also want to keep in mind that the land may some day be sold or developed—a meadow becomes a condo development, a

mountainside a ski area—making it difficult for you to visit. Even your own back yard may some day be sold and you may not want to leave your loved one behind in the garden. These are things to consider when deciding where to scatter the deceased's remains.

> If you are scattering the remains yourself, be careful not to breathe in the particles, since there may be health risks.

You can have cremains scattered from a plane or boat almost anywhere. You can launch them into space (only about a lipstick size container of the ashes is used.) My father-in-law remembers his friends at the 9th hole of his golf course where commemorative plaques of those who have had their ashes scattered there are displayed on the green. Or there are a countless number of options for keeping a part of your loved one with you, including the following:

- jewelry made to contain some of the cremains (*gemhut.com*, *urnseller.com*, *casketstore.net*);

- a pen or key chain made to contain some of the cremains (*funeralfinearturns.com*);

- diamonds made from part of the cremains (*lifegems.com*);

- art made of the cremains to hang on your wall (*memorialart.com*); or

- have the cremains turned into a glaze and poured over an urn rather than (or in addition to) being placed in it. The urns and containers are vary in style and quality (*funeralfinearturns.com*).

Few states have limited restrictions on the disposition of cremains. California is the most restrictive, limiting disposition to interment, inurement, being kept at home, storing in a house of worship or religious shrine, scattering at sea, in a cemetery scattering garden or in

areas of the state where no local prohibition exists and with written permission of the property owner or governing agency. The cremated remains must be removed from the container and scattered so that they are not distinguishable to the public. Cremated remains may not be transported without a permit from the county health department. That said, there are no cremains police checking to be sure families follow these rules to the letter.

In fact, no one is policing the crematories, either. One direct cremation provider suffered from a scandal two decades ago for storing remains in an airplane hanger rather than disposing of them as he had been paid to do. More recently in Noble Georgia, a crematory operator was charged with 266 counts of theft and deception for not cremating the bodies of those he was contracted to. A total of 339 bodies were found on the property's 16 acres; one was found in the hearse that had been up on blocks for more than two years. Bodies were scattered in the woods among rusted old cars and trash. Bodies were stacked and thrown in piles. Steel vaults were packed with human remains.

Tri-State Crematory owner Ray Brent Marsh is believed to have hidden hundreds of bodies in 16 acres close to his home—instead of cremating them.

Marsh hid bodies in the woods, outbuildings and vaults near the crematory and there was some speculation that bodies had been dumped in the septic tank and a nearby lake. Three mass graves were discovered at the back of Marsh's property. Bodies were covered in mud and had missing limbs.

Marsh, who took over the family-owned business that received bodies from funeral homes in Georgia, Alabama and Tennessee in 1996, claimed that the furnace had broken, but experts believed some of the remains had been there for at least two decades—maybe even more. Officials, however, speculated that he was trying to save the $25 it would cost to cremate each body. But investigators also found caskets, dug up and opened, as well.

Even more shocking: Relatives of the dead learned that instead of the cremains of their loved ones, they were given urns filled with wood chips, charcoal and cement.

How could this crime have gone undetected for so long?

In 1995, the state Funeral Services Board investigated Tri-State Crematory for not having a funeral licence but the charges eventually were dropped because the crematory dealt only with funeral homes, and not the public. And, because it didn't deal with the public, it was not subject to state inspections, either.

According to one lawyer representing many of the families who suffered from the abuse and desecration of the remains of their loved ones, the Tri-State Crematory tragedy is exactly why so many feel that the civil justice system is critical in regulating these entities.

The state offered to pay the costs of identifying the bodies and Georgia Governor Roy Barnes also promised to inspect the funeral homes that sent bodies to the crematory. But how can this help families from falling victim to another Tri-State Crematory incident? It can't.

The solution: Tighten the laws on the cremation and cemetery industry.

Cremation Societies

There are also a number of **memorial societies** that can handle the immediate removal and cremation of your loved one's body and can arrange to have your loved one's cremains scattered over the ocean or some other location, be it by boat, helicopter or plane. Although these organizations call themselves "societies" (e.g., the Neptune Society), they are *for-profit* companies. Don't confuse them with the non-profit "funeral and memorial societies" that help consumers find low cost and fair disposition and memorial options. Be sure to compare costs, get estimates and beware of uninsured or unlicensed pilots or boat owners who dabble in scattering ashes.

If you are not sure what to do with the cremated remains of your loved one, you can keep them with you until you decide. A memorial or committal service can be planned at any time, even months or years after the death. If you want to hold on to the remains until yours can

be buried, joined or scattered with his or hers, you can. There is no rush to decide.

Just as the EPA regulates full body burials at sea, it regulates that the scattering of cremated remains shall take place no closer than three nautical miles from land. There are no depth limitations to consider when scattering remains.

You may want to keep in mind that scattering cremains and burial at sea do not provide a personal physical memorial to visit the way that a headstone, grave or niche does. This may or may not be important to you, but it is something to consider. The ocean, park or mountain where your loved one's remains rest may be enough of a memorial for you. Or, create a memorial of your own. You can commemorate and memorialize the deceased in a number of ways, including one of the following:

- plant a tree and mix the cremains with soil;

- carve a sculpture;

- start a scholarship in his or her name;

- name a boat after him or her;

- name a child after him or her;

- raise money for the disease that took him or her;

- write him or her a poem, song or book; or

- place a bench with an inscription in your garden.

Memorialization possibilities are endless. Some cemeteries will allow you to purchase a memorial of some type on the cemetery grounds—even if the remains are scattered somewhere outside the cemetery—so survivors will always have a place to visit.

Remembering the deceased is an important part of working through grief and allowing the healing process to begin. Your loved

one will always be an important part of your life. Having a permanent memorial might help you to focus your thoughts and feelings and eventually bring closure.

Most religions now permit cremation, including the Roman Catholic Church. However, the Greek Orthodox Church, Moslems, Bahai's, conservative and orthodox Jews and well as some Protestant, fundamentalist and evangelical sects do not allow cremation.

Conclusion

Culturally, we have been programmed to think about the funeral service first. It is important to have some sort of ceremony for the living to acknowledge and say their goodbyes to the dead. However, from a practical and financial stand point it makes more sense to plan for the disposition first. If the deceased wanted to be cremated, figure out the cost of a simple cremation. Do the same if he or she wanted a burial. Find out how much it will cost for the plot, the grave marker, the opening/closing the grave, the vault or grave liner and any other goods or services you will need to make the burial he or she asked for a reality. Then use what funds remain to calculate how best to commemorate his or her life. If the bulk of your budget is spent on the burial, perhaps there won't be enough for a full-fledged funeral with viewing and a simple memorial without the body present will suffice.

Keep in mind: The funeral home and the cemetery are two separate entities (although the conglomerates are trying to marry the two wherever possible) and the money that you make available to the funeral home will be spent on the funeral—not the actual burial.

The funeral director wants his chunk of change and the cemetery superintendent will want his, so they don't always work well together.

In a sense, they are competing for pieces of the same pie. Who will you buy your vault from—the cemetery or the funeral home? What about the grave marker? Each may have different arrangements with other funeral associated vendors, like florists and soloists. Each will want you to give the bulk of the business to him.

There are many decisions to make with regards to final disposition. Use the following as a checklist for making these decisions:

Final Disposition Checklist

☐ Use a funeral director or do it yourself.

☐ Cremation or burial.

☐ Embalm the body or not.

☐ Buy a casket, rent one or build one.

☐ Select a cemetery or get permission to use private property.

☐ Purchase a plot, crypt or niche.

☐ Purchase a vault or grave liner or find a cemetery that does not require any.

☐ Order a gravestone, plaque or marker.

☐ Scatter cremains or keep them.

Disposition Options Chart	
Burial	**Cremation**
Interment—earth burial	Bury cremains in the ground in a regular sized plot or smaller cremation plot
Entombment—in a mausoleum (above ground burial)	Place cremains in a niche within a columbarium (above ground burial)
Burial at sea	Scatter cremains (at sea or elsewhere)
	Keep cremains at home

5 Planning a Funeral or Memorial Service

Once the manner and means of how your loved one's remains will be disposed of have been decided, the next decision will be how you and your family want to commemorate his or her life.

The most important thing to keep in mind when planning a funeral or memorial service is that it is **for the living** not the dead. It provides a forum to express grief amid the comfort of family, friends and community. The service commemorating the life of your loved one is, in fact, for you.

Throughout the world and throughout history, rituals surrounding death have always existed partly to pay tribute to the dead and celebrate a life well lived, but more importantly, to allow the living to say goodbye, find support and comfort in one another and begin the long process of healing. Services, rituals and ceremonies help us to accept the death and at the same time remember the deceased in a meaningful way.

Grief has many stages—denial, depression, anger, guilt and finally acceptance—and takes some longer than others to overcome. We all have different ways of expressing our love and pain. Funeral and memorial services provide a setting that can help us begin to put the pieces of our lives back together. Many grief counselors believe that some type of ceremony is necessary in order to accept the death and for the healing process to begin.

If the deceased left specific details about the type of commemorative ceremony he or she wanted, you'll have a guide to work from and can present these details to your funeral director or to those who are helping with the planning. Do your best to follow those wishes but don't be disappointed if there are certain aspects that must be changed due to scheduling conflicts, availability and cost or time constraints. Your loved one would have understood and would have appreciated the efforts you have made on his or her behalf. Do what you feel is most appropriate. Ask for help and try not to overextend yourself emotionally, physically or financially.

Types of Services

If your loved one did not leave specific instructions regarding the type of ceremony he or she wanted, you have essentially three types of services to choose from:

- **Funeral.** A funeral service is a service with the body present. The casket may be opened or closed;

- **Memorial.** A memorial service is a service held in honor of the deceased without the body present. This service can be held in lieu of a funeral or in addition to one; or

- **Committal service.** A committal service is a service held beside the grave, mausoleum, columbarium niche at the time the deceased is committed to his or her final resting place. In the case of cremation, the service can be held wherever the cremains are scattered or buried or in the crematory chapel prior to cremation. This service can be had in place of or in addition to a funeral or memorial service.

Each type of service has a wide range of options for content, presentation and style. You may choose one, two or even all three options.

A Funeral Service

A funeral service is usually conducted by an appropriate member of the clergy or a funeral director in a place of worship or a funeral home. Funerals tend to be fairly solemn formal affairs that follow a format preset by the clergy or funeral director, with your input, of course. They often include the following:

- a **religious component**;

- **homily** (a religious discourse delivered to a congregation);

- **prayer**;

- **readings**;

- **music** (soloist, organist, choir or taped recording); and

- a **eulogy** (that pays homage to the deceased—presented by a family member or friend).

The funeral director or clergy will ask you if there are any special prayers, hymns or other elements you want to include. Feel free to say what you think and to stress what you feel the deceased would have appreciated.

If you prefer a less formal service that allows for more participation from the survivors and friends, then say so. The tone need not be solemn. You may want to take the focus of the service off of the death and the loss and place more emphasis on the life of the deceased. Share joyful memories. Your clergy and funeral director may even have suggestions for doing so. Both will have planned and participated in several funerals and can tell you what others have done. This does not mean that you have to follow the crowd. It's your event, make it what you want it to be. You should feel comfortable, comforted and consoled.

> What has become known as the "traditional American funeral," featuring a viewing of the embalmed body in an expensive metal casket adorned with flowers, followed by a formal funeral service and limousine motorcade to the cemetery—has little cultural or religious significance.

Often survivors who suddenly find themselves having to plan a service are caught like a deer in headlights and follow blindly the "traditions" the funeral director sets before them. Contrary to popular belief, you can go with whatever you want or the deceased would have wanted. More importantly, you don't need to go along with the pre-established format. This ceremony is for you and your family. It is about your loved one—a unique individual. Make the service as much a part of who he or she was as any other gathering you would have had in his or her honor when he or she was alive. Forget about what the funeral director tells you.

A traditional "full-service" funeral is generally the most expensive option. This is why the industry shoves it down our throats. In addition to the funeral home's non-declinable, basic service fee (usually $1,000 or more), basic costs include: embalming, dressing and cosmetizing the body; rental of the funeral home for viewing and service; use of vehicles to transport the body and the family if they don't use their own; the cost of a casket, among other things.

Families who want—and can afford—to spend a good deal of money on a funeral should. However, there are more affordable alternatives available to you that can express the family's love, grief, guilt, emotion and devotion in more personal and significant ways. Most religious services stress humility in death. A simple service allows mourners to focus attention on the spiritual life of the beloved rather than on trappings of the material one.

Pallbearers

If you plan to have a funeral, you may also need to select **pall-bearers**—usually six members of the family or friends—to "carry" the casket from the funeral home to the hearse when transporting the casket to the church or the cemetery. If you are using the services of a funeral director, chances are the casket will be set on a rolling bier that mechanically raises and lowers the casket for easy transference in and out of the vehicle. There may still be some lifting involved so you may want to select individuals who can physically handle such a task. Maybe the "20-something" grandchildren versus the "70-something" brothers. Being a pallbearer is a privilege, one that should be given to those close to the deceased who will appreciate the honor. Both men and women can be selected for this honor.

To View or Not to View

There is some debate among funeral industry professionals, psychologists and grief therapists about the importance of viewing the body before disposition. For immediate family—spouse, children or siblings and parents of the deceased—seeing and touching the body may help them to better accept the death and move forward in the natural grief process.

Some feel that there is relatively little need for the bereaved, much less the public, to "view" the body dressed up and restored to a "life-like" state in order to accept the reality of death. In fact, some grief experts believe that the process of embalming, cosmetic restorations and display of a loved one in the "slumber room" only creates an illusion that the person is asleep and keeps the survivors in denial about the death.

An informal viewing can take place at the hospital or the nursing home at or shortly after the time of death. If your loved one has been ill and his or her death anticipated, you and your family may have already said your goodbyes. If the death occurred at home or while

you were present at the hospital or nursing home, you may have had time to hug and hold your loved one's body and say a final goodbye to his or her physical being. Ask the nursing staff to remove any respirators or apparatus from the body so that you can touch and hold the body in a more natural state if you want to.

If you were not able to spend time with the deceased's body at the hospital or nursing home before he or she was taken to the funeral home and you feel that it would be important for you and close family or friends to say goodbye to the body before disposition, you may be able to arrange an informal **private family viewing** at the funeral home instead of a viewing at the actual funeral service. There may or may not be a charge for this. Either way, the funeral home may limit the time allowed for such a viewing (to about 15 minutes on average). So, if the funeral home has agreed to a private family viewing, ensure that family members know when and where to go—and that they are on time for the viewing.

During this viewing, the body may not yet be in a casket, providing you with the opportunity to touch the loved one and say goodbye to the physical body. (You can't do this if the body is in the casket.) A viewing might be important if family members who are coming from some distance wish to see the body and say goodbye. Again, this is for a small family viewing—it isn't open to the public. Embalming is not legally required for such a private viewing, (unless of course, due to the time period elapsed since death, state law requires it).

A representative from the National Funeral Directors Association told me that the association has no particular stand on the subject of viewing, be it formal or informal. She did say that funeral directors are making more of an effort to be accommodating to families who may want something other than what has been traditionally offered. In fact, she told me that one funeral director recently arranged a special viewing with the body laid out on velvet atop marble. This "memory picture" was far more comforting to the family than having had the body lying in a casket.

> Seeing your loved one "restored" in a casket on display at a public viewing or at the funeral tends to draw more attention to the dead body than to the living memory of the deceased and for most, creates a sense of unease.

There is no religious foundation that supports the *public* viewing of a dead body. Most clergymen advocate a **closed casket service**. One catholic priest explained, "The casket should be closed in the church. The focus of the funeral mass is on the spirit, not the body."

In many religious funeral services, the casket is closed and covered with a ceremonial drape—called a *pall*—that helps draw attention from the physical body and focus the ceremony on the spiritual life of the deceased. It is also used to symbolize humility in death (that in death we are all equal). In such instances, embalming the body and selecting an elaborate casket would be a waste of money.

Embalming

To be delicate about it, embalming is a physically invasive process that entails injecting the body with chemicals that simultaneously drain the blood it replaces. The embalming fluids help to slow decay of the body for temporary preservation. It's a service sold by funeral directors in order to restore the appearance of the deceased to create what they call a life-like, dignified "memory picture" of the loved one.

> Embalming is never required for the first 24 hours after death. In many states, it's not required by law at all under any circumstances. However, most funeral homes will require embalming if the body is to be presented at a public viewing or in an open casket funeral service. Refrigeration is almost always an alternative to embalming if there will be a delay before final disposition.

Funeral-type embalming (versus medical embalming) preserves the body for only a few days—just long enough for an open casket

funeral and viewing. After which the body will start to decompose, just as it would naturally without this procedure. If you are led to believe that embalming can preserve your loved one for more than a few days, you have been misled—by a long-shot.

According to the Federal Trade Commission Funeral Rule, a funeral home is required to get permission from the family before embalming a body. Handing the body over to a funeral director is not consent. It may be assumed that this service was what the family wanted and therefore be performed immediately upon receipt of the body at the funeral home. If you do not want your loved one embalmed say so there's no turning back.

If a funeral director tells you that law requires embalming, he's lying and you should report him to the FTC, FCA or the state's funeral and cemetery bureau. He must disclose in writing that embalming is not required by law unless the body is being transported via common carrier or there will be a delay in disposition, which requires the funeral home to hold the body for more than 24 hours (provided that no refrigeration nor a hermetically sealed container are available).

Embalming must not conflict with religious beliefs or medical examination. Orthodox Jews and Muslim religions consider embalming a desecration of the body. And it has *no* roots in Christian religion. Jews require that the body be buried before sundown so there usually isn't any issue with having to store the body for more than 24 hours.

According to the NFDA, in 2001, the national average for embalming was around $588. You are not required to have embalming if you select arrangements such as direct cremation or immediate burial. If a funeral home charges for embalming when you request these services, they must explain why in writing.

> *Embalming gives funeral homes a sales opportunity to increase consumer spending (by as much as $3,000 or more) for additional body preparation, a more expensive casket with a more expensive outer burial container and a more elaborate series of ceremonies.* —Funeral Consumers Alliance

The U.S. is the only country where embalming is a common practice. (However, the giant funeral conglomerates have turned the Japanese, Australians and the English onto the practice, as well.) If the citizens of other countries have been able to grieve effectively for their dead without the open casket viewing experience, why can't we?

One former British citizen told me, "When I went to my first American funeral I nearly got sick when I saw my girlfriend's grandmother laid out in her Sunday best in a coffin covered with flowers. It was an unexpected shock. It's an image I, unfortunately, can't forget."

The FTC allows funeral homes to set a policy requiring embalming for public viewing. Most funeral homes will require embalming for such a viewing.

Dressing and Make-Up

You will also be charged for preparation of the body, which includes washing and dressing the body, washing and arranging the hair, cosmetically restoring the body and placing it into the casket.

You shouldn't be surprised to learn that special funeral cosmetics are used. There are also a host of burial footwear and clothing suppliers if what your loved one has to wear doesn't seem suitable for such an occasion. Special hosiery, suits and dresses that drape over the bodies are designed so the funeral director and his staff don't have to wrestle the clothes onto the body. There is also a line of funeral undergarments.

> You will save a great deal of money if you bring your loved one's clothes to the funeral parlor rather than having the funeral director sell you a new set of clothes for the deceased.

A funeral director from Florida told me about one woman whose husband died while picking fruit in the panhandle. She wanted to

ship his body home to his family in Alabama. She had the funeral director dress her husband in new denim overalls before shipping his body to the family. When she returned to pay her bill she was furious, "Why didn't you tell me it was illegal to bury a man in overalls?" she demanded. The funeral director in Florida called the funeral director in Alabama and threatened to have his license revoked for lying to this poor woman (the family had put him up to it) if he didn't grant her a full refund on the funeral. He did.

Some funeral homes won't allow open-casket viewings or services if a body is not embalmed. This is not entirely frivolous or unreasonable, according to one funeral director, because it is difficult to create an acceptable presentation of unembalmed remains. Family and friends attending a funeral or viewing will expect to find remains embalmed when they attend such a service. Embalming solves many problems, including controlling odor and keeping features set. Most funeral homes—even if they don't require it—will recommend embalming if you plan on an open casket funeral, particularly if you plan to have the viewing in a church or anywhere other than the funeral home.

Visitations

Often the words **viewing** and **visitation** are used interchangeably, or one funeral home may use the word visitation for what another calls a viewing. In general, a *visitation* is an informal gathering of family and friends who come together to visit with and show support for the survivors, to share their feelings and to remember the loved one. The casket is either closed or not present. A visitation without the casket present can be scheduled anywhere, anytime—such as your home or a restaurant.

Following the service it is customary for those attending to want to visit informally with the family and friends gathered, to give their condolences and show their support. Keep this in mind when selecting the venue and scheduling the time for the service. If there is not

adequate time or space for visiting with guests following the service, you may want to move the gathering to a more conducive location.

It is often expected that after a funeral or committal service there will be a reception of some kind at the family's home or other location to allow for visiting. Be sure to let those invited to attend the service know about the time and location of the reception. This can also be mentioned in a service program and in the obituary.

A Committal Service

Committal services are usually brief with a clergy member or funeral director presiding and only close family and friends in attendance. This service takes place at the graveside and may include prayers and music.

Bag pipes were played at my grandmother's committal ceremony. Her family was from Scotland and it was a very moving tribute. Another person I knew was laid to rest in a church cemetery to the sound of the church bells. It's up to you to tell the clergy or funeral director about your loved one, the type of person they were and what they would have wanted.

At a committal service, family members may be encouraged to ceremoniously start filling in the grave. Traditionally, mourners would scoop a bit of dirt with the shovel or throw a handful of dirt in the grave. But now some funeral directors in further attempts to provide goods and services have created the "earth dispenser"—virtually a giant salt shaker that allows the next-of-kin to gently shake earth into the grave without soiling their hands. Of course, you may buy a commemorative earth dispenser with the deceased's name engraved on it as a memento of the service. Frankly, it seems like just another funeral good to add to the long list of expenses and one that separates you from the reality of the death. The religious symbolism of "earth to earth" is all but lost when a salt shaker is used.

A committal service is especially nice if you have selected a scenic burial spot. Remember: If where your loved one will rest is most important, spend the money on selecting a scenic resting place and compensate by having a simple, less costly service.

> A committal service costs less than a funeral since there is no need for embalming, viewing or renting the funeral home for services. You can also save on charges for storing the body if you choose to have the burial as soon as possible.

There will be other costs, however, such as a set-up fee for the service, which may include the cost of:

- chairs;

- an astro-turf mat around the otherwise muddy grave; and

- a tent or awning to protect mourners against weather.

There will be the unavoidable basic services fee, which will cost you the same regardless of the service or disposition option you select.

Having a funeral or a committal service is not an "either/or" situation. You could have a service like this after the funeral or in place of one. You could have a funeral one day and the committal service the next. If you have a committal service without a funeral, you may want to have a memorial service some time after the burial. If you have a funeral or memorial service before the burial, it does not preclude you from also having a graveside or committal service at the time of burial.

A Memorial Service

A memorial service can take place any time almost anywhere. A memorial service serves much the same function as a funeral does but tends to have a more uplifting tone. Without the body present, the focus is more easily shifted from death and loss to the living memory of the husband, wife, brother, father, etc., you knew and loved. The

setting is usually less formal than a funeral home—a church, a meadow, someone's home, a meeting hall, etc.

Although you can have a memorial in a funeral home, you may find that another location is more appropriate. Besides, other locations can usually be reserved for free, or far less than a funeral home.

A memorial service can have a set program of music, readings and prayer with one individual, such as a friend, presiding, like a funeral. Or more often, it can be set up to provide a forum for family members and friends to gather and share their thoughts, feelings and memories about the deceased. Include funny stories or things about the person that have been faults or weaknesses. This will only serve to show how much he or she was a real person and was truly loved. People should be encouraged to speak at the service and the service should be somewhat flexible in its length to allow everyone who wants to speak the opportunity to do so.

You may want to bring objects that remind you of the person or set the tone for the gathering, including:

- photographs of the deceased, family members or pets;

- his or her golf clubs, tennis racket, motorcycle helmet, baseball glove, etc.;

- mementos from memorable trips he or she had taken; or

- art work that he or she enjoyed or created.

Other suggestions: Play music he or she listened to or have everyone in attendance wear the deceased's favorite color.

One memorial service I went to featured a mini-biographical video of the deceased's life. The video featured old home movies, photos and interviews with family and friends. It was a moving, uplifting tribute and his grandchildren were each given a copy to keep as a living memorial (*www.livingmemories.tv*).

If the deceased lived in two places or lived in one place but had family and friends in his or her "home town," you may wan to have one service where he or she lived and a memorial service in the other location a month or so later. Memorial services can take place anytime and anywhere.

If your loved one has been cremated you may want to wait to have a service when and where you plan to scatter the ashes (if you do). This might be more meaningful to all and allow those in attendance to feel more connected to the deceased than they would if the service were in an unfamiliar funeral home that had no connection to the deceased's life or family.

Religious Services

Near death many find comfort in religion. Some renew a faith that was dormant when life was full and busy and health was good. If the deceased was sick for some time he or she may have had the opportunity to discuss his or her funeral plans with clergy. He or she may have shared other things with the clergy that may be appropriate to include in the service—hopes for his or her grandchildren, gratitude for a life well lived, forgiveness, etc.

Even if your clergy did not know your loved one, he or she can still provide meaningful insight that may help you plan a service to commemorate the life of the deceased. He or she can inform you of the death rituals of your faith (or that of your loved one) if you are not familiar with them and explain their significance. What's more, your clergy can comfort and console you. Most are compassionate listeners and used to guiding others through difficult times.

Any of the above detailed services can be a religious service. That is, you can have a service with or without the body present, before, during or after committal. You may want to include religious elements without having a completely religious service.

The death of a loved one tends to bring about a return to religious beliefs on the part of survivors. (Or, sometimes they are angry about the death and turn away from faith completely). Whether or not the deceased may have held strong religious beliefs, it may be comforting for you to ask your clergy to help in planning a "religious" aspect of the service that may provide comfort to you without disregarding the deceased's beliefs. For example, a catholic priest presided over the funeral of a family member of mine in a cathedral, but because the surviving spouse was not catholic there was no formal "mass"—sharing of communion.

A funeral director has no religious title, however as more and more people shift away from participation in a standardized religion the funeral director has stepped in and taken the helm presiding over ceremonies that once where strictly directed by clerics and rooted in religious faith. Although some funeral directors may have an affinity with a particular religious group or establishment, they in no way represent a church, temple or synagogue.

The "chapels" that funeral homes or crematories operate are "for-profit" establishments and should not be confused with a church or house of worship. You shouldn't be charged for the use of your church or synagogue or other place of worship for a funeral service. (There will be an honorarium for the cleric or an offering for the mass.) However, you will be charged for the use of the funeral home's chapel or other facility.

If, on the other hand, you don't want a service—don't have one. Sometimes, no service is appropriate. A friend recently called for my advice. He had an elderly uncle who had been an abusive alcoholic for most of his life, he was estranged from his children and his wife, and now it fell to my friend, his nephew, to make his death arrangements. The family had little money and would be greatly pained to have to participate in or pay for any type of funeral service. I told him that the

most economical thing to do would be to call a crematory directly and have them remove the body for cremation. His aunt would have to sign a consent form as the next-of-kin. The cremains would be sent to the family. No funeral was necessary. The family could always hold a memorial service if they wanted to at any time in the future at no cost—perhaps when and where they eventually chose to dispose of the cremains.

Planning the Service

When planning a service, consider the wants and needs of the other survivors as well as your own. Now is the time to bring people together. Alienating someone close to the deceased, even accidentally, at this time may have repercussions for years to come.

Consult with family, friends and clergy. Keep in mind the values of the one who has passed and try to plan a service that reflects those values. Think about things your loved one may have said or done or written about that made him or her unique. Ask yourself the following questions:

- What and who was important to him or her?

- What were his or her goals, dreams and accomplishments?

- What hopes did he or she have for the generation he or she would be leaving behind?

- What was he or she most proud of?

- What was his or her philosophy on life?

- His or her religious beliefs?

As you reflect on the details of the deceased's life it will help you plan a meaningful service and also let go of the physical person and hold on to their living memory.

The more you allow friends and family to participate in the planning and share with the funeral director and the clergy, the more

personal and meaningful the service will become and the greater its healing power.

If your loved one was a vital part of your community, members of that community will also be affected by the death and may want to show their respect for the deceased or share their grief at a memorial service or funeral. Plan something that will allow for their inclusion. Then again, maybe your loved one was a more private person and would have wanted to have a small family gathering in his or her honor at a chapel or in a field of daisies. There really is no right or wrong choice when it comes to planning a service.

The Time of Service

Again, keep the needs of family and close friends in mind. Services are usually scheduled two or three days after death. However, if you are awaiting the arrival of distant family members or friends you may want to wait a few days more. This may be tricky if you are hoping to have an open casket viewing or funeral service, but remember, there are ways to work around this—even if you have to shell out a few more dollars. The body will need to be embalmed and/or possibly refrigerated for the duration. The funeral director will be the best one to advise you of your options in that case. In such an instance, you might be better off to have the body cremated or buried and then have a memorial service when the family arrives. In most cases, this is the more practical—and affordable thing to do.

Services that are planned on weekends or after work hours will allow for more mourners to attend. Although from a cost perspective, weekend services at the funeral home will cost more. Often cemeteries will charge considerably more for interment on a weekend than during the week (not to mention, the costs of storing the body for a few days). Other cemeteries may not allow burial on a Saturday or Sunday, because one of those days is kept free for families to visit at the graves of their loved ones.

> If the committal service will only be for the immediate family, who will in all likelihood be on funeral leave from their other obligations, you could go ahead and schedule the service during the week and save a lot on the cost of interment.

You will also want to be sure to schedule the service around the availability of your clergy and the place you've chosen. Churches usually have weddings on weekends and the one you belong to may not be available at the time you were hoping it would be. Your funeral director can check these things out for you or if you are not working with a funeral director you should make these calls yourself or have a close friend or family member do so. Be sure whoever handles this information writes everything down. You wouldn't want guests to show up at the wrong place or at the wrong time.

Writing the Obituary

Much of the important information about the service, time and location, is conveyed via the **obituary**—or death announcement—that will appear in your local newspaper. If the deceased lived in two places or if he or she had strong ties to another town, have the announcement sent to the newspaper in each town or city. (Have close family and friends call others to get the information about the time and place of the service and to invite those you wish to any reception after the ceremony.)

Prices for obituaries vary, depending on the newspaper, its circulation area (Los Angeles and New York city typically cost more) and the length of the notice. Some newspapers do not charge for printing a standard obituary notice. Others charge $200 or more. Of course, you do not have to have an announcement in the newspaper if you don't want to. Write up a notice and have it sent directly to friends or organizations whom you might not call in person. You could also

place an announcement in the newsletter of a fraternal organization that the deceased was a member of or in his or her alumni newsletter. Today, even an e-mail announcement is an option.

> The funeral director may offer to place the death notice for you. However, even if the notice is free he may charge you for his services for writing up the obituary, which seems reasonable. But, it's also a way to get the name, location and phone number of the funeral home ("services will be held at XYZ funeral home") into the newspaper, thus providing the funeral home with free advertising at your expense.

Write the obituary yourself and include more biographical information than would be featured in a standard announcement. Use the guidelines for writing a eulogy to help you determine what you most want people to know about the deceased. Or, if you don't feel you can write the obituary but would prefer to have someone who knew and loved the deceased—on a more personal level—ask a family member or close friend to assist. They can work with you to put together what you want. Deliver the information to the newspaper or fax it in. Some papers prefer that if your message is short, you call in the information.

Most obituaries include the following:

- Full name of the deceased (include maiden name, middle name and nickname);

- Age;

- Date and place of birth;

- Date and place of death;

- Cause of death;

- Date and place of marriage;

- Spouses name (include maiden name) date and place of birth, date and place of death if pre-deceased;

- Survivors—children, brothers and sisters, parents;

- Occupation, work history, accomplishments;

- Education—high school, college, advanced degrees;

- Military Service;

- Clubs and fraternal organizations;

- Hobbies, interests;

- Time and place of services, if open to the public; and

- Address of where to send flowers or charitable donations (in lieu of flowers).

Writing the Eulogy

Don't let the thought of giving a eulogy add additional weight to the emotional load you are already carrying. A *eulogy*, a speech commending the character of a person, does not have to be a formal speech—it's meant to be a snapshot of the deceased, something that you as the coworker, spouse, family member or friend, share with those attending to take away to add to their memories of the loved one. It may consist of reminiscences, stories or even jokes.

A eulogy should be as unique and memorable as the deceased—not something thrown together in the car on the way to the funeral or memorial service. If you're having trouble getting started, there are many references on this topic available at your local library and on the Internet.

So, what exactly do you include in a eulogy? You may want to start with the **basic biographical information** about the deceased, including:

- age;

- birthplace;

- marriage dates;

- spouse;

- children;

- grandchildren

- profession;

- hobbies; and

- placed lived, etc.

> Think about what you remember most about him or her—his
> laughter, her skill as a dancer, his involvement as a father,
> her contributions as a teacher, etc. Let family and friends
> share their memories with you to help create a full memory
> picture of the deceased and what he or she meant to you and
> others around him or her.

Talk about the various roles that he or she played throughout his or her life—reporter, traveler, coach, husband, son and father—in chronological order. Ask yourself the following:

- What were his or her hopes and dreams, greatest accomplishments?

- What was he or she passionate about?

- What do you think he or she would like to see change?

- What would he or she like to have stayed the same?

Make notes. Write notes on index cards in large letters. This way, if you start to cry or forget your glasses you will still be able to see your notes. Don't write full sentences, bullet each point to help you keep track of your ideas. Number the cards so you can keep them in order. Don't plan to deliver a formal speech if that's not the type of person you are. Most of us aren't. Use the bullets to give you a point of

reference, to remind you of what you want to share with those in attendance and speak normal and naturally. Practice in front of close friends and family if necessary.

If you don't feel you can do it, ask someone close to you to do it for you. The clergy or the funeral director can also do it, although it seems more personal if it comes from someone who knew the deceased well. Even if you intend to deliver the eulogy, have a back-up person on alert so that if you are unable to do so, they can be ready to take over for you.

> Keep in mind: You are speaking to family and friends. You don't have to impress them. They are people who care about you and the deceased. They are here to show their support for you. Don't let the stress of writing or delivering the eulogy add to your anxiety.

If you feel overwhelmed, hate writing, don't have enough time with all the other planning or simply don't feel comfortable with writing the eulogy, let a professional writer prepare the eulogy for you. There are many eulogy writing services advertised on the Internet and in the phone book. From as little as $10 to upwards of $250, a writer can provide you with a personalized and individual eulogy, incorporating stories and memories that you feel best capture the spirit of the your loved one.

Refreshments/Reception

You may or may not want to serve refreshments at the reception following the ceremony. Many cultures have the tradition of serving a meal after the service—usually at the family's home. This is something you can let your friends help you with. Suggest each person bring a dish for a potluck meal—or have a friend organize this for you. This way, you—or anyone else for that matter—won't end up doing all the work. If you'd like to have service attendees back to the

house, let some of your family and friends handle preparing and serving the food. They will be glad to have something important to do to help you at your time of need. Or, have the reception at a friend's home or other family member's house. Friends want to help. Let them clean up afterward or drive you home and stay with you after the service if you don't want to be alone.

You could also have a luncheon at a restaurant following the service. This can be expensive, but will save you and your family the hassle of cooking, serving and cleaning up.

At a memorial service you can serve refreshments if the venue permits. Think about coffee and cake, wine and cheese—it doesn't have to be a full meal. And, if you don't want to serve anything, you don't have to serve anything at all.

Additional Elements

As mentioned several times throughout this book, the disposition and commemorative service of your loved one can be as simple or as sophisticated as you choose. Electing to use the services of a funeral home or do all or most of the arranging yourself with the help of family and friends will also greatly affect your costs and your level of participation in these final acts of love.

Listed below are some additional components to a funeral or memorial service that you may want to consider. Most of these things are nice to have, but not necessary. If you are looking to cut costs these things are easy to eliminate or to make yourself or with the help of family and friends. If you give them a project or task it will make them feel useful.

Other elements of a funeral or memorial service to consider:

- **Printed programs**—for the service. These can be as simple or as detailed as you wish. They should feature the order of

the ceremony—speakers, prayers, songs—but can also include biographical information about the deceased, a thank you for those in attendance or an announcement about any receptions to follow the service. Providing the words to the prayers and songs may also be helpful to those in attendance. You can simply have the information typed up and have copies made or you can have a formal program printed on fine paper, just as you might for a wedding program. If you are having a very informal gathering, a program isn't necessary.

- **Memorial register or guest book**—for attendees of the funeral or memorial service to sign. This can be a simple, blank notebook or one especially designed for funerals. You may provide your own or buy one through the funeral home. However, if you purchase it though the funeral home, it will be added to your bill and may cost substantially more. A friend could make one and decorate it as a gift to the family. The guest book may be helpful for you to keep track of who attended the funeral. You may want to send acknowledgment cards.

- **Acknowledgment cards**—these are essentially "thank you" cards for those who attended the services or sent flowers or donations. You can use simple "thank you" cards or blank note paper. Again, it's up to you how simple or extravagant you want to make each element. A friend or family member can be assigned the responsibility for keeping track of who sent cards and flowers and who attended the service, so that all you have to do is sign the cards.

- **Prayer cards**—traditionally given out at Christian funerals to those attending the funeral. They include the name of the loved one, his or her date of birth and date of death, as well as a prayer.

- **Music**—played before, during or after the service can be in any form from tapped recordings to live performances by an organist, soloist, choir or brass band. Make sure the music is appropriate for the type of service you are planning. The funeral director can arrange for the type of music you want; however, he will charge you for making these arrangements—even if it is for taped music. If it's live, he'll charge you on top of what you will have to pay the musicians. If cost is an issue, you may want to ask friends to participate with this part of the service. Perhaps you have a niece or a sibling who is a beautiful singer or a cousin who plays the organ or violin. Or, if you are having hymns sung as part of the service, this may be all the music you need.

- **Flowers**—family and friends, especially those who are unable to attend the service, will want to offer their condolences by sending flowers to both you and your family. Ask them to send them to the funeral home or other location and use them to decorate at the service. This should provide you with all the flowers you need. You shouldn't feel that you have to buy more. The always-helpful funeral director will offer to order flowers for you. Some giant funeral factories have their own florists on hand and would love to have your business—for a pretty penny of course. Other funeral directors have established relationships with florists and may get a cut of the business they bring in and/or may mark up any goods or services they procure on your behalf from an outside vendor.

The funeral director may pay for flowers or other goods on your behalf with the understanding that he will be reimbursed later. Be sure to discuss any arrangement of this type with the funeral director and get something in writing before agreeing to it. If you don't, you may end up paying for something you don't want.

If there is a viewing at the funeral home and a funeral at a church or elsewhere, the funeral director will use a flower van to transport the flowers to the second venue or to the committal service. Of course there will be an extra charge for transportation. Be sure this is a service that you want to pay for. Ask how much it costs ahead of time. Customarily, after a funeral the flowers are donated to a hospital or nursing home.

Much to the chagrin of florists and funeral directors, as the population has become more economical, the trend has become more popular to ask family and friends inclined to send flowers to make donations to a charity chosen by the family in the deceased's name instead.

> "Cash advances" are fees charged by the funeral home for goods and services it buys from outside vendors on your behalf, including, among others: flowers, obituary notices, pallbearers, officiating clergy, organists and soloists. Some funeral providers charge you what they paid for the services themselves. Others, however, add a service fee to the cost of the items, marking up the price significantly. The Funeral Rule requires those who charge an extra fee to disclose that fact in writing, although it doesn't require them to specify the amount of the mark-up. Funeral providers are also required to tell you if there are refunds, discounts or rebates for the supplier on any cash advance item.

Other elements to consider:

- **Religious emblems**—to decorate the funeral home or place of service if other than in a house of worship. It may be important to you or your loved one to have a symbol of faith—such as a Holy Cross or a Star of David—displayed at the service. The funeral director can supply these for you but there will, naturally, be an extra charge for this. If you are having a memorial service somewhere other than the funeral home you can bring your own iconography from home or ask your clergy member to bring a symbol for display.

- **Family photos**—photo cards and photo boards of the family can add a personal touch to the service. The funeral home may offer to create these for you with your photos. Although, you can save money by simply making a display yourself. Ask a family member or friend to create a montage or to select some old photos of your loved one from your photo albums or frames to bring to the service. Let the funeral director know you are bringing these so that he can be sure to have a place to display them. If you want to have photo cards made you can have a family member or friend with a computer scanner and printer or color copier make these up for you.

Additional Expenditures

As you can see, between the disposition and the service, the costs for a funeral really adds up. By keeping it simple, letting friends and family contribute, and involving a funeral director as little as possible you will be able to keep costs down and create a more meaningful commemoration for the deceased. Here are just a few more things you might have to consider when making the final tally of your costs.

- **Honorarium**—for clergy performing the service. The rates for an honorarium vary depending on the location, size of the congregation, rank of the clergy member, (if the bishop attended rather than your local priest) and a number of other factors. The funeral director may handle this payment for you as part of the cash advance. If he doesn't already know, he can ask the office of the clergy the average rate for such an honorarium when he calls to check for availability in scheduling the service. If you are making the arrangements without a funeral director and are a little embarrassed to talk about money with the clergy attending

you in your time of need, have a friend call the church's administrative office to ask all the questions you need answered. It helps to know what is expected of you.

- **Mass offering**—If your ceremony includes a mass—usually at a church—then you will be expected to make an offering to the church, which is usually comparable (and in addition to) the clergy honorarium.

- **Gratuities**—for musicians, hired pallbearers, ushers, escorts, assistants, etc. The amount you spend will depend on how big a service you have and how many hired individuals you have involved. Whenever possible, let friends and family take on various roles of responsibility. They will not expect to be paid and will be glad to participate in any way they can. Remember: People feel better when they have a part to play. It helps individuals show their love to the deceased and respect for the family.

- **Transportation**—of the body to the funeral home from the place of death; from the funeral home to the church or other funeral location; and from the church or funeral home to the burial site. There will be additional charges of course for any limousines that are rented, not to mention the use of the hearse.

But Wait, There's More...

- **Eulogycast**—Some funeral homes are on the cutting edge of today's technology offering to Webcast your loved one's service over the Internet so that family and friends who could not attend in person can watch it on their computer. The service may be kept up on the Web site so that it can be viewed at anytime for up to a month or longer. The

home may also have an online registry book for those who want to add their names.

- **Biographies**—A few companies offer a modern way for families to remember their loved ones well past the memorial service via video biographies. Using old photos, interviews with loved ones and music, these undertaker/filmmakers create a short film about the loved one and his life. The video is played before, during or after the service. (If you do this for yourself "pre-need," you can also be in the biography you leave for posterity.)

 At the Hollywood Forever cemetery in California there are kiosks throughout the cemetery with touch screens that allow visitors to see the biographies of those who are buried there. In the future the cemetery is hoping to have touch screens built into the headstones.

- **Bereavement Services**—Seminars in coping with grief; teaching grief recovery to survivors. Grief is inescapable, although we each deal with it differently and go through the process at different speeds. If you feel you need help beyond that of family and friends, seek out a professional who is not necessarily associated with a particular funeral home. Ask about his or her credentials and experience. You want to speak with a professional who has not merely gone to a two-day training course at the expense of said mortuary.

 One funeral director, when asked why he did not offer grief counseling said, "I'm not being paid to grieve with the family. They have come to me to help them through a bad situation. I wouldn't be helping them if I couldn't keep a level head and take care of business."

The Survivor's Guide

The list on the following page features the options for disposition as well as the various options for services you might have before and after the disposition.

Disposition Service Checklist	
Burial	**Cremation**
Immediate burial with no service	Immediate cremation with no service
Immediate burial with committal (graveside service)	Immediate cremation followed committal (graveside service)
Immediate burial followed by memorial service	Immediate cremation followed by memorial service
Immediate burial with committal service followed by memorial service	Immediate cremation with committal service followed by memorial service
Viewing	Viewing
Funeral service with body present (closed-casket) followed by burial/entombment	Funeral service with body present present (closed-casket) followed by cremation
Funeral service with body present (open-casket—may require embalming) followed by committal service	Funeral with body present (open-casket—may require embalming) followed by cremation
Funeral service with body present (closed-casket) followed by committal service	Funeral service with body present (closed-casket) followed by cremation followed by committal service
Funeral service with body present (open-casket—may require embalming) followed by committal service	Funeral with body present (open-casket—may require embalming) followed by cremation followed by committal service
Visitation	Visitation
Memorial Service	Memorial Service

6 Taking Care of Business

Once you've called the people closest to you, gotten the planning of the funeral arrangements underway and made your decision about anatomical gifts, your next challenge is to tackle a heap of administrative tasks.

Searching for important documents, filing claims and meeting with an accountant, attorney and insurance agent may be the last thing you *feel* like doing right now. But all of these tasks are essential and they may help you focus and to find a much needed balance between practical matters and emotional turmoil.

Where to Begin

Set aside a place to work and ask a friend or family member to help you get organized. If you are feeling overwhelmed, ask him or her to help you acquire required claims and other forms and help you fill them out. He or she can order copies of essential certificates, make initial calls to find out how claims are filed and what documents and information are required from you in order to receive benefits. He or she can also help you investigate what benefits you may be due. A family member can call the Social Security Administration, the Veterans Administration, the deceased's former employers, union and/or fraternal organization for this information.

The object of this document search is simple: You need to review—literally—the paperwork related to everything you own. This *everything* includes:

- homes;

- cars;

- retirement monies and pension accounts;

- bank accounts;

- investment accounts;

- businesses; and

- collectibles.

If you hire a funeral director, he or she may offer to help you with some of these administrative tasks such as the filing for Social Security and veteran's burial benefits. Be careful. He may do this only if the benefits are to be applied to the cost of the funeral. Although allowing him to handle these claims saves you from having to file them, it could end up causing you more problems. The funeral director should deduct these benefits from the total cost of the funeral; however, this may not accurately be reflected on your bill.

When you get your bill it will seem reasonable but—when you consider that part of it should have been covered by these benefits—it will be higher than it should be. The funeral director will also charge you for his time for filing these documents. However, the funeral director may also have a better handle on how to get these things done fast and efficiently.

Much of what needs to be done will require pertinent information and documentation to come from you, so there's no getting around your involvement. Be sure you have all the right information. The wrong information (such as an incorrect digit in a Social Security number) can hold up your benefits and take time to get corrected.

Again, the first goal is to examine what the deceased owned...or partially owned. And what he or she *owed*. Family and friends may want to help and give you advice. Try not to make any immediate decisions, such as selling your house, moving or changing your stock portfolio. These things can wait. Don't add to the stress of the situation by taking on any more life altering decisions than is already necessary.

As time passes, you will begin to see things more clearly and be able to make your decisions on less of an emotional level. Be patient and ask others to do the same. You may want to calm them down by acknowledging that a decision has to be made (say, about the deceased's house) but that it will be made in good time.

> How much you have to do will depend on whether or not you are the executor of the deceased's estate. If someone else has been appointed executor either by the deceased through his or her will or by the probate court, you will not have as much administrative work to take care of yourself.

The executor will be responsible for handling the estate, which includes, among other things:

- assessing the assets and liabilities;

- filing taxes; and

- distributing what is left of the estate to the heirs as designated by the will or the laws of the state where the deceased lived.

If you are the spouse or next-of-kin, you should have a copy of the will or a letter of instruction naming the person chosen as executor. If you are not sure who the executor is, ask the attorney who drafted the will. If he is not the executor, he should be able to identify the nominated executor.

> If the deceased doesn't have a will, the probate court will appoint an executor to handle administration and settlement of the estate in accordance with the state's intestacy laws.

What is intestacy? *Black's Law Dictionary* defines it as "the state or condition of dying without having made a valid will, or without having disposed by will of a part of his property."

If married people hold joint title to assets, those assets pass automatically to the surviving spouse. But, if your spouse dies without a will, his individually-owned assets are subject to state intestacy laws. Depending on which state you live in, these laws normally divide the estate between a spouse and any children, using a predetermined percentage, based upon the number of children and marital status. If the deceased has no spouse or children, then the intestacy laws typically divide the assets among other relatives—and even the state.

Important Documents to Look For After Someone Close to You Dies

☐ Will;

☐ Birth certificates (of deceased and any dependent children);

☐ Marriage/divorce certificates;

☐ Insurance policies (including those that have not required premium payments in a while because the insurance may still be in effect);

☐ Titles to vehicles (cars, boats, motorcycles, RVs);

☐ Mortgage records;

☐ Deeds to real estate;

☐ Account information (checking, savings);

☐ Retirement fund information (including 401(k)s, IRAs, etc.);

- ☐ Stock certificates;

- ☐ Savings bonds;

- ☐ Veterans discharge papers;

- ☐ Social Security cards;

- ☐ Business records;

- ☐ Earnings statements for the past year;

- ☐ Copies of the last three year's income tax returns;

- ☐ Certified copies of the death certificate;

- ☐ Documentation that shows former employment;

- ☐ Documentation that shows membership in a credit union, fraternal organization, trade union or other association—that might entitle the deceased and his or her survivors to some type of death benefits.

If the deceased had mutual funds or brokerage accounts with the same company, you will have to reregister these accounts in your name (if you are the spouse and/or designated beneficiary), as well.

> Bank and brokerage accounts, securities certificates and mutual funds set up with **pay-on-death** or **transfer-on-death** provisions pass to designated beneficiaries and do not have to go through probate.

Locating the Will

If you are the next-of-kin and/or the executor you should know where the original will is located. If you don't, check with the probate court in the county where the deceased lived. The deceased may have filed the original there and you should be able to get a copy from the

court. Check with the deceased's lawyer. It may also be in a safe deposit box, in which case you'll need to petition the court for authorization to open the box immediately (unless you have joint access to the box).

If you have a copy but can't locate the original, you may need to produce witnesses to prove to the court that the original will was signed by the deceased.

The urgency in locating the will promptly has to do with the fact that it may contain time-sensitive provisions such as your loved one's desire to bequeath anatomical gifts, which can only be done at the time of death. Also, if there are children orphaned by the death, the designation of a guardian should be made as soon as possible.

Once found, the executor or the person acting as such, must submit the original will to the probate court. Filing the will does not initiate probate. Most states have laws that require the filing of the original will within 30 to 45 days after its discovery. Neglecting to do so can result in civil or criminal penalties. If probate administration is not necessary, the will simply remains on file with the court.

Safe Deposit Box

In some cases, you won't have to look too far to find the vital documents. The deceased may have kept the documents—and valuables—in a safe deposit box for security and peace of mind. Because safe deposit boxes are designed to provide security against access, there is an awful "catch-22" that exists with putting important papers such as the will, letter of instruction and other documents—marriage certificates and military discharge papers—in a safe deposit box. You may find that in order to access the box to get the will, the will must designate you the executor to access the box.

Putting the will in the safe deposit box is not a good idea. It is often found too late. In some states, a safe deposit box remains sealed until the estate is settled. If your name is not on the safe deposit box as a co-renter, you will need to obtain a court order to access the box. Your attorney can help you get the court order (impossible on a weekend or over a holiday). However, only papers relating to the estate may be removed from the box until after the will has been probated.

If you are the spouse, next-of-kin or executor, you should know where to find the key and location of your loved one's safe deposit box. The key will be flat and multi-notched and may be stored in a small envelope provided by the bank. The location of the box and key may have been listed in the letter of instruction or the will.

If you are not aware of a safe deposit box rented by the deceased, don't assume that one does not exist. Review bank records to see if a rental fee was paid for a box or contact the banks where the deceased held accounts or did business.

The safe deposit box may contain assets or documentary evidence of assets (deeds, certificates, etc.) or a will, letter of instruction, property inventory or other documents identifying assets.

Once you locate the box, access may be difficult even if you are an executor **with letters of authority** (see Chapter 7 for more on this). Some banks in accordance with state law "seal" the box until it can be opened by a representative of the state treasury department who inventories the contents for tax purposes. However, if you are a co-renter of the box you may be granted some access to the box in order to claim any items that you can prove are yours or were owned jointly. Items owned solely by the deceased must remain in the box until the beneficiaries are identified. The bank will let you know what is required to access the contents of the box.

> Don't open the safe deposit box by yourself even if you leased the box jointly with the deceased. If the other beneficiaries are available, have them accompany you and sign or initial a dated inventory of the box's contents. To do otherwise may make you a target of accusations with respect to its contents.

If you or another person leased the safe deposit box jointly, that does not mean that the contents of the box are jointly owned. Stocks and bonds registered jointly are the property of the surviving owner and should be delivered to the surviving owner once the contents of the box have been inventoried. Assets like cash, coins, jewelry or other valuables may be considered the sole property of the deceased and subject to probate—unless there are documents that prove they are jointly owned assets. Assets owned by the deceased should be protected against theft, loss or damage in a safe deposit box leased in the executor's name until they can be distributed to the beneficiaries in accordance to the will.

Watch Out for Swindlers

One funeral home urged me to order more than 100 copies of a death certificate through them (10 to 15 is more appropriate), but it depends upon the number of accounts you will have to access as well as the number of claims filed for benefits. I was quoted $10 per copy at the registrar but the funeral home wanted to charge me $13. If I had gone with his suggestion, that would have meant an additional $300 for the funeral home.

It would seem that nothing could be worse than taking advantage of someone overcome by grief and exhaustion following the death of a loved one, but it happens. In fact, the unscrupulous are famous for picking their targets out of the obituaries.

Don't fall prey to those out to take advantage of you in your overwhelmed condition. You may find yourself suddenly in control of a

large sum of money—due to insurance or inheritance—and feel unsure about how to handle it. Family and friends may make suggestions about investments. Brokers or mutual fund salesmen may start to call. Some of these folks may make a high-pressure pitch to help you with your finances and insist that you need to make changes now that your loved one is gone.

Don't give in to the pressure. Take the time to think about what makes sense for you and your new situation. Some financial advisers suggest a widow or widower reallocate their finances simply to collect the commission. Don't feel pressured to make any immediate financial decisions. Decisions made in haste could have long-term repercussions.

Some of the people who approach you may be outright swindlers. They may call you or show up at your door and tell you that the deceased owed one final payment due on a life insurance policy or an item for your home that your loved one never authorized. You make the payment and the item never materializes. They may send an expensive C.O.D. delivery that you pay only to find that the item was something inexpensive that the deceased never ordered.

Where to Look for Vital Information

Not sure where to find or whom to talk to about benefits, assets and other financial documents? The following is a list of people who can be of assistance with these matters:

- Employer/business partner/employees;

- Social or fraternal organization;

- Insurance agent (the deceased also may have insurance through a credit union, fraternal organization, trade union or other association);

- Social Security Administration;

- Veterans Administration—(if the deceased was a veteran);

- Bank and/or credit union;

- Credit card companies;

- Attorney; and

- Accountant.

If the deceased was employed at the time of death, you will want to inform his or her employer of the death. If you're not sure whom to talk to, ask to speak with someone in the human resources department or employee benefits department of the company. Whether you want to contact individual co-workers he or she was especially close to is up to you.

As an employee, the deceased may have been covered under company-sponsored life, health and/or accident insurance as well as a profit-sharing or pension plan. There may be a final paycheck due or money due from the following:

- sick leave pay;

- vacation pay;

- retirement benefits; or

- stock option plans.

> Wages and salary due can be transferred informally (without probate) to a surviving spouse or next-of-kin as long as you can produce a death certificate and sign an affidavit that identifies you as having a (priority) right to receive the funds, and as long as the amount does not exceed state-imposed maximum values. If it is a substantial amount, full probate administration is required.

If you are the surviving spouse, your family may be eligible for continued health insurance coverage under the company plan for up to 36 months. (For more information about this coverage, ask the

deceased's employer for information on the Consolidated Budget Reconciliation Act or COBRA.) You may have to pay a greater portion than when your spouse was working, but you will not have to worry about finding medical coverage right away. Again, talk to someone in the human resources department for more information on this coverage.

If the deceased was not yet retired, but had retirement plan benefits through his or her employer, you may roll his or her 401(k) into an individual retirement account (IRA). As the surviving spouse, you may be eligible for an annual benefit or monthly benefit which would begin at the time the deceased would have reached the age of retirement.

The human resources department should be able to give you the forms and information you need. Ask to see a copy of the company's **Summary Plan Description**, which will tell you what benefits you and the deceased are entitled to. If you encounter problems getting benefits you believe are due, consult your probate court, the state department of labor or your lawyer.

If the deceased was retired and receiving a pension from a former employer, you may be entitled to receive **survivor's benefits** from the plan, although benefits may be reduced. If your loved one was receiving retirement checks at the time of death, do not cash or deposit these checks, you may be required to return any checks received after his or her date of death. In the case of **direct deposit**, contact the bank or financial institution and they will work it out with the employer. Do not attempt to withdraw these funds or send a personal check as means of repayment—you may wind up paying twice. If necessary, the employer will bill you for any overpayment due. (Don't worry they'll always find you.)

If the deceased's death occurred at, during the course of or as a consequence or his or her employment, you may be due benefits through **workers' compensation**. This program provides a number

of benefits to the families of those who have died from work-related injury or illness.

Getting your claim paid by the employer, however, may prove difficult. Companies fear a rise in premiums by insurers if too many claims are filed, while others are afraid that safety code violations will be brought to light and fines will have to be paid and reparations made. If you feel that filing a workers' compensation claim is in order, do so. If the employer refuses to pay, contact a lawyer who specializes in such claims. (He or she may work on a contingent fee basis, which means you wouldn't have to pay unless you win your case.)

If the deceased worked for more than one employer over the course of his or her lifetime, contact all of his or her former employers—including federal, state or local governments— to find out if heirs are entitled to any pension, annuity or life insurance benefits through them.

Business Ventures

If the deceased owned his own business, was a partner in a business or held an interest in a limited liability company (LLC) or corporation, you will need to contact those affected by the death—including vendors, employees and his or her business partners. This should be done as soon as possible. Decisions will eventually be made about the management or closing of the business. If you wait too long, problems such as fulfilling contractual agreements with clients and vendors. Guidance for such decisions will come from the will, the partnership agreement or the corporate shareholders agreement.

If the business was a sole proprietorship or an LLC and the will does not specify that it be liquidated, the survivors may, if they wish, continue the business. It is up to the executor to decide if this is in the best interest of the estate. Funds from the sale of the business may be needed to pay creditors, taxes or other obligations. He or she may

have to petition the court on behalf of the family to permit continuation of the business.

If the deceased was part of a partnership, the **partnership agreement** will address the issue of death of one of the partners. Either the partnership will be dissolved, the deceased's interest purchased or the partnership will continue with survivors taking over the deceased's share.

If the deceased held stock in a closely held corporation, and he or she was not the sole stock holder, then the **shareholders agreement** will address the issue of disposition of his or her shares. Shares may be offered to first surviving shareholders. The will may bequeath the stock to designated beneficiaries. Or, if the stock has no market value, the corporation may be dissolved and the assets sold. The corporation's bylaws will cover the procedure for dissolution.

Social/Fraternal Organizations and Labor Union

If the deceased belonged to a labor union, professional association or fraternal organization you may want to check to see if it offers death benefits for members. Some benefits cover only funeral expenses but some may have other benefits for survivors as well.

Contact the member service department to ask if you are entitled to any benefits. You may need to file a claim. You also may want to let the organization know about the person's death so that it can put a death notice in its newsletter or bulletin.

Life Insurance

Call or have someone call the deceased's life insurance agent. The initial call to the agent need not be more than a courtesy call, allowing the agent time to get things started for filing your claim and to set an appointment with you for a later date. He can also tell you what you will need to bring with you to the meeting, such as a certified copy of the death certificate, etc.

If you don't know where the deceased's insurance documents are located, you might have to do a little digging. Look for documents that include policy numbers. The agent should be able to access all of the insurance policies the deceased had through his agency by name without having to have all of the policy numbers, but it doesn't hurt to have them with you. It will be helpful to have them on hand when you meet with him just to make things go faster and to insure you have uncovered all that you and your family may be entitled to.

> If you can't find policy documents, and you're not sure whom to call, you may be able to find the name of the insurance company and possibly the policy number in the deceased's check book under premiums paid. Pay stubs also may indicate any direct withdrawals to a life insurance company. Check with his or her employer for information on any company-sponsored group insurance.

Life insurance proceeds are usually paid directly to the named beneficiary. They are not included in the estate and therefore not subject to probate. However, they are subject to **estate tax**. (For more on this, see Chapter 7.) If the policy has a **designated beneficiary**, other than the estate, its proceeds need not be used to pay any of the deceased's debts. If the deceased named his or her estate as the beneficiary, proceeds will be included in the estate, subject to probate and taxation and used in the payment of debts.

Once you meet with your insurance representative, fill out your claim form and give him a copy of the death certificate. After filing the claim, he will send your claim in to the insurance company.

If the deceased's estate is named as the beneficiary, the executor must submit a copy of the letters of authority—granted by the court—along with the claim form.

If the insurance agent wants you to surrender your policy forms along with the claim, be sure to get copies as well as copies of the claim forms before handing them over.

Benefits are paid to the beneficiary(ies) named in the policy in either one lump sum or in fixed payments over time. If you are the beneficiary, you should receive a payment within a few weeks after making your claim, unless:

- the policy has been in effect for less than two years;

- the death occurred outside of the U.S.; or

- if a homicide is under investigation regarding the death.

Even in the case of suicide, if the policy was in effect for more than two years, you should receive the full amount. If it was less than two years, you may be entitled to receive a refund of the premiums paid.

Important: Some insurance companies may claim that an accidental death was a suicide in order to keep from paying the claim, or to stall payment while investigations into the death are pending. The burden of proof is on the insurer. In such instances an autopsy may be required to determine the exact cause of the death.

If funds for financing the funeral are tight, you may need the insurance money sooner rather than later. Tell the agent.

Slow Claims Payments

Sometimes life insurance claims are delayed unnecessarily. Take some precautions by sending your claim certified mail so that you have a receipt of when it was sent. (That is if the agent doesn't send it to the home office for you.) You may want to send it yourself to be sure it went and isn't held in limbo between the agent's office and the home office. Be sure to make your claim promptly. Some policies have a time limit after the death (typically 90 to 180 days).

Other things to watch out for:

- **The company may claim fraud on the original application because the insured "misrepresented" his medi-**

cal history. This is the last thing you need to be confronted with at this point. However, keep in mind that the burden of proof is on the insurance company. It must prove that the deceased intentionally omitted a medical condition that would have precluded his or her being covered by the policy. And, if the policy has been in effect for more than two years, the insurer cannot make a fraud claim.

- **The company may also claim that the policy lapsed because premiums were not paid.** It is up to the insurance company to prove that it notified the insured of the lapse. And some policies state that even if premiums are not paid a certain amount of coverage still exists.

If you feel that your insurance claim is not being handled in a timely or appropriate manner, you can file a claim with your state's insurance commission or regulatory agency. Information for locating the insurance board will be in the government listings in your phone book or can be accessed via the Internet.

If that course of action gets you nowhere, contact a lawyer. He may be able to write a simple letter that will motivate the insurance company anxious to avoid the courtroom. (Pay the lawyer for his time, but not on a contingency basis. You wouldn't want him to have one-third of your insurance proceeds for an hour's worth of letter writing, would you?)

Things to Think About . . .

- Premiums on any insurance policy must continue to be paid while a claim is being filed. If payments do not continue, the policy may become invalid.

- You should ask for the return of any "unearned" premiums. Premiums paid in advance, say for the whole year, but then death occurred before the year was up.

- You are also entitled to any dividends due.

- Many companies will pay interest from the date of death on the amount due to the beneficiary.

Other Insurance

If the deceased had **accident insurance** or **auto insurance** and died in an accident you may be entitled to proceeds from these policies for which you will also need to file. Filing takes time and in the case of an accident, an investigation may further complicate things and prolong your receipt of funds. Be patient but persistent with your insurance agent. These polices were set up to take some of the financial burden of the deceased's death off your shoulders. You are entitled to these funds and you shouldn't feel you have to beg or fight for them.

Health insurance should cover any health care expenses incurred by the deceased up until the time of death. The doctor, hospital or emergency facility may bill you directly. Be sure to check with your loved one's health insurance provider before paying any of the bills. Insurance should cover all or at least part of these expenses. Some medical facilities bill both the individual and the insurance company simultaneously. Wait to see what portion the insurance will pay before you send in a check.

Be sure the hospital or facility has the correct billing information. (If they have old information, they may be billing an insurer who refuses to pay because the insured is no longer on their plan.)

If the deceased had insurance provided through his or her employer, union or professional organization, and you are the named beneficiary, you'll need to contact each company about the death and file a claim for benefits. Remember: You should apply for benefits as soon as possible since it often takes time for claims to be processed.

Social Security Benefits

Almost anyone who works pays into Social Security, the federal government's pension program. These benefits are the major source of retirement income for Americans today.

The program was not intended to be any family's only income if the breadwinner dies, but if the deceased worked and earned enough "credits" under the Social Security program, the spouse or dependent child may be entitled to two kinds of benefits:

- A **death benefit** of $255 for burial expenses; and

- **Survivors' benefits** to support the deceased's spouse and dependent children.

The one-time lump sum death benefit is payable to the surviving spouse if he or she is living with the Social Security recipient at the time of death or if living apart, was eligible for Social Security benefits on the recipient's record for the month of death. If there is no surviving spouse, the payment is made to the deceased's dependent children.

If the deceased was in a nursing home or other facility at the time of death, the spouse (or dependent) may not be eligible for this benefit. Ask your local Social Security office for more information on this benefit.

If you are eligible, you can file your claim for this benefit over the phone, or complete the necessary forms at your local Social Security

office. Or your funeral director may complete the application and apply the payment directly to the funeral bill. For a list of Social Security Administration offices, visit the SSA's Web site at *www.ssa.gov.*

According to the SSA, if you ask a friend or family member to call Social Security, you need to be with them when they call so that Social Security will know that you want them to help. The Social Security representative will ask your permission to discuss your Social Security business with that person. If you send a friend or family member to a local office to conduct your Social Security business, send your written consent with them. Only with your written permission can the SSA discuss your personal information with them and provide the answers to your questions.

If your loved one paid into the Social Security program and earned enough "credits," a spouse (or divorced spouse), child or dependent parent may be entitled to Social Security survivor's benefits. Again, the number of credits needed depends on the age of your loved one when he or she died. The younger he or she was, the fewer credits needed for family members to be eligible for survivor's benefits.

Under a special rule, benefits can be paid to children and the widow or widower caring for the children, even though the deceased didn't have the number of credits needed. They can get benefits if the deceased had credit for one and one-half years of work in the three years just before death. Contact the SSA for more on this rule.

According to the Social Security Administration, family members eligible for survivor's benefits under Social Security include:

- Spouse age 65 or older—full benefits (if born before 1940), or reduced benefits as early as age 60. (The age for receiving full benefits gradually increases for persons born after 1939 and until age 67 for persons born in 1962 and later.);

- Disabled surviving spouse age 50 or older;

- Spouse any age who cares for dependent children under age 16 or disabled and receiving benefits;

- Unmarried children of the deceased under the age of 18 (or age 19 if attending school full-time);

- Children who were disabled before age 22, as long as they remain disabled;

- Dependent parent(s) age 62 or older; and

- A divorced spouse age 60 or older (50 if disabled) if the marriage lasted 10 years; or if caring for deceased's natural or legally adopted dependent children under age 16 or disabled and who also receive benefits; and who is not eligible for an equal or higher benefit on his or her own record; and who is not currently married, unless the remarriage occurred after age 60—or 50 for disabled widows. (In cases of remarriage after the age of 60, an ex-spouse will be eligible for a widow(er)'s benefit on the deceased's record or a dependent's benefit on the record of his or her new spouse, whichever is higher.)

How much your family can get from Social Security depends on the deceased's average lifetime earnings. That means the more he or she paid into Social Security, the higher your benefits will be. The amount you'll receive is a percentage of his or her Social Security benefit. According to the Social Security's *Survivors' Benefits* booklet, the percentage depends on your age and the type of benefit you are eligible for. For example:

- Spouses age 65 or older will receive 100 percent;

- Spouses age 60 to 64 will receive between 71 and 94 percent;

- Spouses (any age) with child under age 16 will receive 75 percent; and

- Dependent children will receive 75 percent.

Your benefits as the surviving spouse may be reduced if you also receive a pension from a job where Social Security taxes were not withheld. According to the SSA, the average 2003 monthly Social Security benefits for widow(er)s are as follows:

- Widow(er): $862.

- Young widow(er) with two children: $1,838.

To make a claim you will need the deceased's Social Security number. If you don't know the number nor have a copy of his or her Social Security card, you may be able to find it on copies of tax returns. When applying for survivor's benefits, the SSA recommends you bring the following list of items.

Survivor's Benefits Checklist

☐ Certified copy of death certificate;

☐ Deceased's Social Security card;

☐ Your Social Security card;

☐ Dependent children's Social Security cards;

☐ Certified copies of birth certificates;

☐ Marriage certificate (if you're a widow or widower);

☐ Divorce papers (if you're applying as a surviving divorced spouse);

☐ Deceased's most recent W-2 or 1099 forms or federal self-employment tax return for the most recent year; and

☐ Contact information for your bank and your account number so benefits can be directly deposited.

> You should apply for survivors benefits promptly, benefits may not be retroactive. Call (800) 772-1213 to inquire about benefits and eligibility and to set up an appointment with your nearest Social Security office. Ask them to send you the *Survivors Benefits* booklet (Publication No. 05-10084), which explains Social Security survivor's benefits.

If the Deceased Was Receiving SS Benefits

If the deceased was receiving Social Security benefits at the time of death, you must notify the national Social Security office within the first few days following the death. Social Security pays benefits on a set schedule—and the deceased may have been mailed a payment shortly after death. In such instances, Social Security will expect benefits to be repaid.

You don't want to get caught in a situation where those funds have already been spent. If Social Security benefits were being deposited directly into the deceased's bank account, be sure to notify the bank of the death and request that any funds received for the month of death and later be returned to Social Security as soon as possible

> If the deceased was receiving checks from Social Security do not cash any checks received for the month in which the he or she died or thereafter. You must return these checks to the Social Security Administration as soon as possible.

If You're Receiving SS Benefits

If you are receiving Social Security benefits as a wife or husband on your spouse's record at the time of your spouse's death, your benefits will change following the death. Report the death to Social Security as soon as possible so that your payments can be adjusted to survivor's benefits. Benefits for any children will automatically be changed to survivor's benefits after the death is reported to Social Security.

> Once you have been receiving survivor's benefits on your spouse's record, you can switch to your own retirement benefits as early as age 62, assuming your retirement benefit rate is higher than your survivors' benefits. You can receive one benefit at a reduced rate and then switch to the other benefit at an unreduced rate when reaching full retirement age.

If you're getting benefits on your own record now, you'll need to file a form to get survivors benefits. Before filing for survivor's benefits you may want to find out—from the Social Security Administration—if you will receive more (or less) as a survivor. Regardless, you will receive the higher benefit—not a combination of the two.

You'll want to confirm the new amount of your checks with the SSA. It will take a month or two after notification for your checks to be adjusted to the new monthly benefit, so don't worry if the new amount is not immediately reflected on your check.

Social Security rules can be complicated and will vary depending on your particular situation, so talk to a local Social Security representative about the options available to you.

If You Work and Collect Survivor's Benefits

According to the Social Security *Survivors' Benefits* booklet, if you work while getting Social Security survivors benefits and are **full retirement age**, as defined by Social Security, the amount of your benefits may be reduced if your earnings exceed certain limits. In which case, you may elect to delay receipt of benefits to avoid the reduction. It's important to note that your earnings will reduce only your survivor's benefits, not the benefits of other family members.

To find out what the limits are this year and how earnings above those limits reduce your Social Security benefits, contact the SSA and request a copy of the *How Work Affects Your Benefits* booklet (Publication No. 05-10069).

> If you wait too long to call Social Security you may lose valuable benefits you are entitled to.

Military Service and SS Benefits

If the deceased served in the military on active duty or on inactive duty for training since 1957, he or she will have paid into Social Security. Inactive duty service in the Armed Forces Reserves and National Guard weekend drills has been covered by Social Security since 1988. If the deceased served in the military before 1957, he or she did not pay into Social Security directly, but his or her records may be credited with special earnings for Social Security purposes that count toward any benefits you may be entitled to receive.

The deceased may have been eligible for both Social Security benefits and military retirement. Generally, there is no offset of Social Security benefits because of military retirement. Social Security survivor's benefits may affect benefits payable under the optional Department of Defense Survivors Benefit Plan. You should check with the Department of Defense or your military retirement advisor for more information.

Veterans Benefits

The surviving spouse and dependent children of service members and eligible veterans may be entitled to a number of death benefits, including the following:

- a lump sum death benefit;

- monthly payments;

- educational assistance; and

- medical care.

Check with your regional Veterans' Administration (VA) office about your eligibility for the different types of survivor's benefits and the documents you will need to apply for these benefits. Although it may be convenient to let your funeral director file claims for you, he or she may charge you a fee for the time spent doing this, and he may only be willing to file for those funds appreciable to funeral reimbursement.

In general, just as with Social Security, there are essentially two types of benefits that the deceased, if a veteran, may be eligible for:

- **Death benefits.** These include: burial and funeral expenses, a plot-interment allowance, burial in a VA National Cemetery, headstone or marker, burial flag, Presidential memorial certificate; and

- **Survivor's benefits.** These include: dependency and indemnity compensation and death pension benefits.

A *burial allowance* is a partial reimbursement of an eligible veteran's burial and funeral expenses. When the cause of death is not service-related, the reimbursement is referred to as two payments:

- **burial and funeral expenses allowance**; and

- **a plot interment allowance.**

If the deceased was a veteran, discharged from the U.S. Military under conditions other than dishonorable, and died a non-service-related death on or after December 1, 2001, the Department of Veterans Affairs (VA) will pay up to $300 toward burial and funeral expenses and a $300 plot-interment allowance, if burial is in a cemetery other than a national cemetery. Burial in a national cemetery is free to veterans. If the death occurred in a VA hospital or while the deceased was receiving care from a VA-contracted nursing home, some or all of the costs for transporting the body may be reimbursed.

Veterans Affairs will also pay up to $2,000 toward burial expenses for a service-related death on or after September 11, 2001. If the vet-

eran is buried in a VA national cemetery, some or all of the cost of moving the body may be reimbursed. To qualify for these benefits, the deceased must meet one of the following conditions:

- Died of a service-related injury;

- Was receiving VA pension or compensation at time of death;

- Was entitled to receive VA pension or compensation but chose not to reduce his or her military retirement or disability pay; or

- Died in a VA hospital, in a nursing home under VA contract or in an approved state nursing home.

> You may be eligible for reimbursement from the VA if the deceased was eligible for the burial allowance discussed above, you paid for his or her funeral or burial and you have not been reimbursed by some other source such as another government agency. You or your funeral director can file a claim for reimbursement for burial and plot allowances with the VA office.

To confirm your loved one's eligibility for veterans burial benefits, call a Veteran's Benefits Counselor. To apply for burial benefits you must fill out VA Form 21-530, *Application for Burial Allowance.* You will need to attach proof of the veteran's military service, the Department of Defense Form 214 (DD 214), a death certificate and any copies of funeral and burial bills you have paid. For more information on eligibility and filing for these benefits call (800) 827-1000.

Locating Veterans Records

There are a number of VA benefits you as a survivor of a veteran may be entitled to; however, in order to apply for these benefits you will be required to make a number of calls and complete numerous claims forms. Try not to get frustrated. Ask someone to help you get

organized and keep a record of whom you talk to and in what office and capacity. The VA Web site recommends you compile the following documents before filing for benefits:

- the veteran's discharge certificate or DD 214;

- the veteran's VA claim's number or Social Security number;

- the veteran's death certificate;

- government life insurance policy number;

- a copy of all marriage certificates and divorce decrees (if any);

- a copy of each child's birth certificate (or adoption order); and

- veteran's birth certificate to determine parents' benefits (if any).

In order to file for any VA benefits you will need a copy of the deceased's military separation documents, such as the Department of Defense Form 214 (DD-214).

Remember: Make copies and keep the originals, as these documents, if requested, will not be mailed back to you. The discharge documents must specify active military duty and show that release from active duty was under **other-than-dishonorable conditions**.

The Department of Veterans Affairs (VA) does not retain veterans' military service records. Military service records are kept by the National Personnel Records Center (NPRC), which is under the jurisdiction of the National Archives and Records Administration.

Survivor Benefits

The VA has a number of benefits available to survivors of eligible servicemen and veterans including a death pension, dependents' education assistance and home loan guaranties.

According to the Veterans Affairs, the VA's Dependency and Indemnity Compensation (DIC) is a monthly benefit paid to:

- eligible survivors of a service member who died while on active duty;

- a veteran whose death was due to a service-related disease or injury; or

- a veteran whose death resulted from a non service-related injury or disease, and who was receiving or was entitled to receive, VA compensation for service-connected disability that was rated as totally disabling for at least 10 years immediately before death, or since the veteran's release from active duty and for at least five years immediately preceding or for at least one year before death if the veteran was a former prisoner of war who died after September 30, 1999.

According to the VA, the benefit is available to a surviving spouse if he or she:

- validly married the veteran before January 1, 1957; or

- was married to a service member who died on active duty; or

- married the veteran within 15 years of discharge from the period of military service in which the disease or injury that caused the veteran's death began or was aggravated; or

- was married to the veteran for at least one year; or

- had a child with the veteran; and

- cohabited with the veteran continuously until the veteran's death or, if separated, was not at fault for the separation; and

- is not currently remarried.

This benefit is also available to the surviving child if he or she is:

- unmarried; and

- under age 18, or between the ages of 18 and 23 and attending school; or

- is a disabled adult (under certain provisions)

DIC benefits may also be available to surviving parents based on need. For more information on this, visit the VA Web site at *www.va.gov.*

This benefit typically pays eligible surviving spouses $948 a month. In some cases, such as when there are dependent children, VA may pay more. Call toll-free at (800) 287-1000 for more information.

> Note: When the surviving spouse is eligible for payments under the military's Survivor Benefit Program (SBP), only the amount of SBP greater than DIC is payable. If DIC is greater than SBP, only DIC is payable. Concurrent payment of SBP and DIC to children or parents is not prohibited.

Since September 21, 1972, the Survivor Benefit Plan has been available for retired service personnel and commissioned officers of the Public Health Service. Eligible persons designate all or a part of retired pay as a basis for survivor's annuity. Surviving spouses of military retirees who did not participate in the plan and who died prior to September 21, 1973 are eligible for SBP-MIW (Survivor Benefit Plan Minimum Income Annuity). To be eligible, Veterans Affairs states that the surviving spouse must not be remarried, must be eligible for VA death pension, and must have income for VA purposes, excluding any SBP annuity, of less than the MIW-SBP annuity limitation.

To apply for DIC benefits you will need to fill out VA Form 21-534 *Application for Dependency and Indemnity Compensation, Death Pension and Accrued Benefits by a Surviving Spouse or Child*, and submit it to your local VA office. The forms are available through your local VA office.

Death Pension

The VA also makes available a Death Pension benefit paid to eligible dependents of deceased wartime veterans. This pension is based on need and is available to the spouse (if not remarried) and the children under age 18 or 23 if attending school or who are disabled before age 18.

There are special allowances under both the DIC and Death Pension if the spouse or parents are in a nursing home or are receiving in-home care.

According to the VA you may be eligible for the Death Pension benefit if:

- the deceased veteran was discharged from service under other-than-dishonorable conditions;

- he or she served 90 days or more of active duty with at least one day during a period of war time. However, anyone who enlisted after September 7, 1980 generally has to serve at least 24 months or the full period for which he or she was called or ordered to active duty in order to receive any benefits based on that period of service. With the advent of the Gulf War on August 2, 1990 (and still not ended by Congress to this day), veterans can now serve after September 7, 1980 during a period of wartime. When they do, they generally now must serve 24 months to be eligible for pension or any other benefits. But there are some exclusions; and

- you are the surviving spouse or unmarried child of the deceased veteran; and

- your income is below a yearly limit set by law.

INCOME LIMITS (EFFECTIVE DECEMBER 1, 2002)

If you are a... Your yearly income must
 be less than...

- Surviving spouse with no dependent children $ 6,497
- Surviving spouse with one dependent child $ 8,507
 (Add $1,653 to the limit for EACH additional child)
- Housebound surviving spouse with no dependents $ 7,942
- Housebound surviving spouse with one dependent $ 9,948
- Surviving spouse who needs aid and attendance
 with no dependents $10,387
- Surviving spouse who needs aid and attendance
 with one dependent $12,393
- Surviving child (no eligible parent) $ 1,653

Note: Some income is not counted toward the yearly limit (for example, welfare benefits, some wages earned by dependent children and Supplemental Security Income).

The VA pays the difference between your "countable" income and the yearly income limit, which describes your situation (see chart above). This difference is generally paid in 12 equal monthly payments rounded down to the nearest dollar. Call toll-free at (800) 827-1000 for more details or visit the VA Web site at *www.va.gov*.

To apply for the Death Pension benefit fill out VA Form 21-534, *Application for Dependency and Indemnity Compensation Or Death Pension by Surviving Spouse or Child* and attach copies of marriage and children's birth certificates and submit it to your local VA office.

VA Life Insurance

As a veteran (or service member) the deceased may have had **group life insurance** or **mortgage insurance** through the VA. Look for

evidence of such policies in your loved one's important papers. In order to file a claim, you will need the veteran's discharge certificate (DD 214), his or her VA claim's number or Social Security number, death certificate and the government life insurance policy number.

For more information on VA life insurance and how to file claims call (800) 669-8477 or visit the VA Web site at *www.va.gov.* You can also contact your regional VA office for more information, as well.

Monthly VA Payments

Just as with Social Security benefits, if the deceased was receiving monthly VA payments at the time of death, you will need to notify the VA of the death as soon as possible. Any checks received during the month of death and later must be returned to the Department of Veterans Affairs. Do not cash these checks. If they are direct deposited, notify the bank of the death and request that any funds received be returned to the VA as soon as possible. Don't write a separate check and send it in to the VA to cover funds already deposited, it will only confuse matters and you may wind up returning the money twice. They will bill you for any repayment necessary. Wait for the bill to arrive before sending payment and make copies of everything.

> Once you notify the VA of the death you can ask about the various benefits you and your family may be entitled to as the survivors of a veteran or service member. Ask for a copy of the *Federal Benefits for Veterans and Dependents* booklet, which outlines many of the benefits available to you. You can also visit the VA Web site at *www.va.gov* for valuable information or call the VA at (800) 827-1000.

Bank and/or Credit Union

Depending on the amount of money in your loved one's bank, brokerage or credit union accounts, you may be able to transfer any solely held accounts informally if you are the surviving spouse or next-

of-kin. They can be transferred by affidavit procedure or by a simpli-fied form of probate, as long as you have a certified copy of the death certificate. If, however, the amounts exceed the state-imposed maxi-mum values for probate assets, then full probate will be involved.

You will have easy access to the deceased's bank accounts if:

- you were listed jointly on the account;

- the account was set up as a **pay-on-death** (P.O.D.) ac-count and you are the named beneficiary (and you have a copy of the death certificate); or

- you have been appointed the executor of the estate and have **letters of authority** to present to the bank, along with a certified copy of the death certificate.

If none of these situations applies to you then you must wait until the appointed executor files with probate, closes the accounts, pays the estates taxes and debts and distributes what's left in accordance with the will. (For more on probate, see Chapter 7.)

A P.O.D. account ("Totten Trust") allows the owner to retain complete control of the funds in the account, but on death the balance automatically goes to the named beneficiary without any probate administration.

Five- or 10-year CDs set up as P.O.D. accounts may wave the early withdrawal penalty in the event of death.

To transfer title on a jointly held account to sole ownership, you'll need to file a new signature card with the bank. You may want to create a new joint account or set up a P.O.D. account so that when you die the account can avoid probate and be easily accessible to your survivors.

Jointly-held brokerage accounts can also be changed to sole own-ership. Call your broker. He will need a copy of the death certificate to do this. Any securities that are held in a transfer-on-death (T.O.D.)

account are immediately transferable to the beneficiary without probate administration. Solely-owned accounts may require the involvement (or appointment, if not done already) of an executor to collect, manage and ultimately distribute the assets therein.

Retirement accounts like IRA, SEP, Keogh and 401(k) should have a designated beneficiary and, like insurance policies, not be subject to probate. If no beneficiary has been designated, then the executor will need to handle them in the same manner as the solely held bank accounts.

The deceased may have set up a life insurance policy through his or her credit union, which would double his or her balance at the time of death. Another benefit a credit union may offer is a credit insurance policy that pays off any loans outstanding at the time of death. Be sure to check with the credit union to see if your loved one set up either type of policy.

Credit Card Companies

Contact the deceased's credit card company(ies) and inform them of the death. Cancel (and cut up) the cards and ask for a refund of the unused portion of the annual fee. If you destroy cards and don't call the companies they will continue to charge the annual fee to the card. Canceling cards also guards against any fraud, theft or loss. Call the companies to find out the specific process for canceling cards and then make your request in writing to legally insure your rights.

Don't be in a hurry to pay off balances. The deceased may have had credit card insurance—which pays off the balance at the time of death. Ask the customer service representative to look up the credit contract (if you can't find it) to see if such a policy is in place.

According to Hughes & Klein, authors of *The Executor's Handbook*, survivors are under no legal obligation to settle the deceased's debts regardless of their nature. Debts are paid from the deceased's solely-owned (probate) assets. Under certain circumstances (such as

there being no probate assets) the deceased's debts may be ignored. Every creditor makes provisions for a certain number of "bad debts," but it may be polite to let the creditor know that there are no assets with which to pay the debts.

> If the credit agreement was co-signed, the surviving co-signer is responsible for these account balances.

If the card was in the deceased's name but you were an authorized user, you will have to reapply for a card in your name based on your own credit. If you both had liability for the card or if the card was in your name and the deceased was an authorized user, you won't have to reapply. Simply call customer service (the number is usually listed on the back of the card) and ask how to take the deceased's name off the account.

Some credit card companies also offer a death benefit when a cardholder dies. American Express, for example, offers Automatic Flight Insurance, which, in brief, covers the cardholder, his or her spouse or domestic partner and dependent children under age 23 for up to $250,000 for any accidental death or dismemberment that occurs while riding in, boarding or alighting from an airplane—as long as the trip was purchased with the card. Other cards may offer similar or more comprehensive coverage. You won't know until you ask. Call the deceased's credit card companies to find out if they offer a similar program.

Conclusion

This chapter has covered the business and financial basics that you'll need to tend to in the days and weeks after someone close to you dies. Some people may find it cold or hard-hearted to focus on these financial matters so soon after a loved one has passed—but a

better way to think of it is as a sort of therapy. It's tending to the living impact of the person's passing. It can be a welcomed distraction from more personal concerns. And, lastly, it's a good memorial to keep the financial garden well-tended.

7 Settling the Estate

You've accomplished a lot when you've made the disposition and service arrangements and notified all of the relevant parties that your loved one has died. What's left? The longer-term arrangements.

The next hurdle you have to face: settling the estate of the deceased. This basically consists of paying his or her taxes and debts and distributing what is left of his or her cash and property to beneficiaries as stated in the will or as the law dictates. This may prove difficult and time consuming, depending on the complexity of the estate, whether the deceased left orphaned minor children and if his or her assets were solely-owned at the time of death. If the deceased left no minors and set up his or her finances and property in such a way as to transfer them without formal probate filing, you need only concern yourself with paying his or her taxes.

You may be alleviated from the majority of this responsibility if the deceased appointed someone, other than you, as executor. However, this person will greatly need your help in locating documents, identifying assets and creditors and locating heirs and beneficiaries.

A few facts regarding the settling of an estate:

- Only one third of all Americans die with a will.

- Those who die "intestate"—without a will—have their assets distributed in accordance with the intestacy laws of the state in which they lived.

- Whether or not there is a will the probate court will appoint a personal administrator to carry out the administration and distribution of the deceased's assets, if any.

The Executor

Whether the deceased died with a will or not—had just a few possessions or a vast estate—it will be necessary for:

- his or her assets to be inventoried;

- final taxes and debts to be paid; and

- the rest of the estate to be distributed to the designated beneficiaries.

The person responsible for these tasks is the **executor**. Also known as a **personal representative** or **administrator**, the *executor* is a friend, relative, bank or trust company appointed by the deceased in his or her will or by the probate court to carry out the terms of the will or if there was no will, the intestacy laws of the state. He or she need not be a lawyer nor have any special qualifications. However, he or she is responsible for the initiation and administration of the probate process—if necessary—and management of the estate until it is closed. This process may take anywhere from a few days to a few years, depending on the size and complexity of the estate. Most estates, however, are settled within a year to 18 months.

Some Important Definitions

- A **personal representative** of an estate is an executor, administrator or anyone who is in charge of the decedent's property.

- An **executor** is named in the decedent's will to administer the estate and distribute properties as the decedent has directed.

- An **administrator** (or administratrix) is usually appointed by the court if no will exists, if an executor was not named in the will or if the named executor cannot or will not serve. In general, and executor and an administrator perform the same duties and have the same responsibilities.[1]

Probate

Probate is a word that applies both to the process of settling a dead person's financial affairs...and the courts that handle legal issues related to the settlement. It's sometimes useful to think of probate as a legal holding cell—where assets and debts are accounted for, taxes are paid and what's left is distributed to the beneficiaries named in the will or if there was no will, to the heirs specified by state law.

The primary purpose of probate is to protect minor children and their property (probate court is called "orphans" court in some places). Formal probate is often costly and time-consuming. It is best avoided if possible. The probate legal process includes:

- **proving the authenticity of the will;**

- **appointing an executor or personal representative;**

- **appointing a guardian for minor children;**

- **identifying and inventorying property;**

- **paying debts and taxes;**

- **identifying and contacting heirs;** and

- **distributing the remainder according to the will or state law.**

[1] Internal Revenue Service; IRS Publication 559, *Survivors, Executors and Administrators.*

Important note: You may not want or need to formalize the appointment of the executor with the probate court immediately—as formal probate filing may be unnecessary. If the deceased set up his or her assets in a way, through joint ownership, trusts, insurance and pay-on-death arrangements that allows them to pass directly to those to whom they are intended, you can avoid the tedious and time-consuming probate process.

Whether an estate must undergo formal probate filing has less to do with its actual value than with who owns the assets at the time of death. Probate assets are those owned solely by the deceased at the time of death. Taxes for the deceased will still need to be filed by the person functioning as the executor, whether the appointment is formalized or not. Nevertheless, the formal appointment of an executor by the court does not obligate the estate to go through probate; however, it may wind up costing the estate and prove unnecessary if an inventory of assets reveals that nothing requires probate or that probate assets do not exceed the maximum value allowed. It may be wise to inventory the assets first to find out if probate is necessary before having the executor formally appointed by the court.

Unless someone else—with a legitimate claim—wants to be appointed executor or tries to block your appointment, the court should grant your request without delay. If a dispute does arise over your appointment as executor, the court may appoint someone else. Likewise, if you object to the executor nominated either by the will or by the court, you can file a formal petition of protest with the probate court.

On the other hand, if you are the nominated executor and do not wish to serve as such, you will still be expected to deliver any original will in your possession to the probate court along with your written declination of your appointment. The court will then appoint someone else. State law may require that the executor be a resident of the same state as the deceased.

> The executor is entitled to a fee for his or her services and reimbursement for all expenses incurred while settling the estate—legal and accounting fees, etc. State law sets the amount of the fee. It may be a percentage of the estate. The will may indicate an amount different from that stipulated by the state or it may say that no fee be paid at all to the executor. If the fee listed in the will is less than that stipulated by law, it can be ignored. The fee is taxable as income.

To protect the beneficiaries and the creditors of the estate against any negligence or malfeasance on the part of the executor, the will or the court may order the posting of a **surety bond**, which protects the estate from abuse. The cost of the bond is payable with estate funds and premiums are usually based on the value of the estate's assets. Bonds can be arranged through almost any insurance agent. The bond should be canceled as soon as the estate is settled

Letters of Authority

Once the court confirms the nomination and appointment of the executor, it will issue that person **letters of authority**, which grants him or her full authority to act on behalf of the deceased, providing access to solely-owned assets. As with copies of the death certificate, the executor will need a number of copies of these letters (usually consisting of one page) in order to allow him or her to access to each of the deceased's bank and brokerage accounts, CDs and safe deposit boxes and other probate assets.

In addition to the letters of authority, the court will instruct you and supervise your management of the estate. You are responsible for managing the estate and ensuring that assets are protected for the beneficiaries. As executor you are legally responsible for the estate and could be subject to personal liability.

Executor's Responsibilities

The basic job of the executor is to carry out the terms of the will, to see that the deceased's beneficiaries receive what he or she intended them to have and to be sure that any legitimate debts and taxes are paid. The responsibility is great and therefore it is an unselfish tribute one can make to the one who has died.

If you are the executor, use the following checklist as a guideline for settling the estate, including carrying out the terms of the will, paying beneficiaries and paying off any debts or taxes. I'll go over each in detail throughout this chapter.

Checklist for Executor

☐ Locate the will and letter of instruction.

☐ Note special instructions regarding anatomical gifts, funeral arrangements or care of minor children—take immediate and appropriate action.

☐ Admit will to probate court within 30 days (this does not in itself initiate probate).

☐ Petition court for confirmation of appointment as executor (acquire letters of authority).

☐ Identify and inventory probate assets.

☐ File inventory of probate assets with the court.

☐ Based on asset inventory, decide if formal probate filing is necessary or if the estate can be settled via small estate transfer procedures.

☐ Begin small estate transfer procedures (if possible).

☐ File petition for formal probate administration (if necessary).

☐ Contact probate attorney (if necessary).

☐ Contact heirs, beneficiaries and other interested parties.

☐ Open estate checking account (consolidate liquid assets).

☐ Publish "Notice of Petition to Administer Estate" in local paper.

☐ Publish "Notice of Death" in local paper.

☐ Send "Notice of Administration" to creditors.

☐ Obtain Tax Identification Number (for estate tax filing).

☐ Prepare and file final federal, state and local income tax returns (for deceased and estate, if necessary).

☐ File federal, state and local estate tax returns (if gross estate exceeds $1,000,000 for 2003).

☐ Settle creditor claims; pay debts and expenses.

☐ Notify heirs and beneficiaries of hearings.

☐ Distribute balance of probate assets to beneficiaries.

☐ File receipts and affidavit for final discharge.

☐ Close the estate.

Purpose of the Will

The most important function of the will is its designation of a guardian for minor or disabled children. If the deceased died and left his or her children orphaned, file the will as soon as possible with the court so that the court can officially appoint the guardian in accordance to the deceased's wishes. If he or she died without a will and left orphan children, the court will appoint a guardian, usually a blood relative. You can petition the court for the appointment of guardianship or contest the appointment the court makes if you have just cause and you feel that it is in the best interest of the children.

If the estate is substantial, the will may also name a conservator—a person, bank or trust company—to manage the inheritance of a minor child until the child reaches the age of maturity. The guardian and conservator (and executor) may or may not be the same person.

As most people know, the will is the vehicle through which the deceased bequeaths his or her probate assets to the beneficiaries of his or her choosing. He or she can give to family, friends, charities, schools, foundations or choose not to give to someone; he or she can disinherit one or more children.

If no will is in place at the time of death, a state-imposed will may give as much as three-quarters of the assets to the spouse. If there are no children or grandchildren, half may go to the deceased's parents. If the deceased has no living relatives, the assets will go to the state. (Domestic partners or children who have not been formally adopted will not be entitled to anything under most state laws.) See your local office of the Lambda Legal Defense Fund for more on this.

Of course, the will also names the executor.

The executor must submit the original will to the court. Most states have laws that require the filing of the original will within 30 to 45 days after its discovery. Neglecting to do so can result in civil or criminal penalties. Filing the will does not necessarily initiate probate. If probate administration is not necessary the will simply remains on file with the court.

If you are designated as the executor, once you have filed the will with the probate court, it will be entered into the public record and the court will make copies available to others. If the signature appears to be a forged or if the will does not comply with state law, the will may be contested. The will may also be contested in the following scenarios:

- if it is alleged that the person was mentally impaired at the time of signing;

- if the person thought he was signing something else; or

- if he or she was under undue influence when signing.

If the court rules that the will is invalid, the estate will be handled as if the deceased died intestate and the state's intestacy laws will dictate who gets what.

Handling Probate

Probate can be a long and tedious process, and should be avoided (or at least minimized) if possible. Whether an estate is subject to probate administration has little to do with its actual value; in fact multimillion-dollar estates are usually better managed to avoid probate than some estates of little value. Some people make the mistake of assuming that because they have so little they don't need a will or to manage their assets to allow for easy (probate-free) transfer to loved ones. Hence a man whose father had $5,000 in a bank account will need to file in probate court and his friend who inherits millions will not. This is something to keep in mind when planning your own estate.

That said, the majority of estates are settled with little or no involvement of the probate court. The value of the deceased's probate assets and whether or not he or she left any orphaned minors will determine whether the estate must undergo the full probate administration process. If the deceased's probate assets were few and he or she had no minor children, you may be able to avoid or minimize the probate process.

Inventorying Assets

As executor, one of your first duties in settling the estate will be to inventory your loved one's assets and categorize them as **probate assets** and **non-probate assets**. *Probate assets* are those that were owned

solely by the deceased at the time of death—such as furnishings, cloth-ing, jewelry, money, homes and cars. *Non-probate assets*, on the other hand, are those that pass to others through joint ownership or by beneficiary designation, such as with insurance. Whether or not the deceased had any probatable assets and their value will determine if formal probate filing with the court is even necessary.

Assets *Not* Subject to Probate Administration

- Jointly-held assets that pass to the surviving owner;

- Pay-on-death bank accounts (i.e., Totten Trusts) which pass to des-ignated beneficiaries;

- Transfer-on-death securities that pass to designated beneficiaries;

- Trust-held assets that pass to designated beneficiaries;

- Life insurance proceeds that pass to surviving beneficiaries; and

- IRA, SEP and 401(k) retirement accounts that pass to surviving beneficiaries.

All non-liquid assets—those that cannot be quickly and easily converted into cash, such as stocks, bank accounts—will require ap-praisal.

As executor, you are responsible for preserving these non-probate assets until they can be sold or distributed according to the will or, if no will, intestacy laws.

Retirement accounts and insurance are paid to designated benefi-ciaries. In addition, any assets held in a living trust are not probatable and remain under the control of the trustee or successor trustee, who must hold or distribute them according to the terms of the trust docu-ment.

Where to Look for Assets

As we've mentioned in previous chapters, in addition to a will, the deceased may have left a letter of instruction, which identifies each of his or her assets and liabilities and describes their location. This document will be very helpful to you as executor since even a will cannot list everything an individual owned or owed. However, even fewer people than those who write wills (only one-third of Americans) write letters of instruction.

If you find no such letter of instruction and you do not have intimate knowledge of every financial transaction the deceased may have made, you will need to begin a search to identify and assemble all assets and liabilities. Even with such a letter you must look carefully for assets that may have been overlooked or have been acquired after the most recent draft of the letter.

Other good places to begin looking for assets are through checkbooks, bank statements and cancelled checks. Through these documents you will find information on the following:

- **Insurance policies and dividends;**

- **Investments** (CDs, IRA, SEP or 401(k) accounts);

- **Charge accounts and loans;**

- **Stock dividend and bond interest payments;**

- **Mortgages/ Rents** (properties owned);

- **Taxes/ Tax refunds** (Property tax will identify owned properties);

- **Utility payments** (identifies properties not identified by mortgages or taxes);

- **Social Security, veterans and pension benefits;**

- **Hospital and medical expenses** (check with health care insurance for reimbursement);

- **Charitable contributions** (for filing final tax return); and

- **Safe deposit box or post office box** (location of box in order to inventory contents).

Mail also provides a good deal of information about a person's assets and liabilities—dividend and pension checks, bank and brokerage statements, utility and tax bills, insurance premiums, charge accounts—and should be sorted as such.

When the post office learns of a person's death, law says, it will hold the mail for 15 days and then return it to the sender.

If you are the executor, have the mail rerouted to your address by filing a change-of-address form with the post office and by providing the postmaster with a copy of your letters of authority. A family member can do the same by providing the postmaster with proper identification and a copy of the death certificate. If the postmaster gets two change-of-address forms from two survivors, the executor will have final authority.

Important: Social Security and VA benefit checks must be returned. Other government checks must be handled in accordance with instructions printed on the documentation that arrives with them or appears on the envelopes. Tax returns become part of the estate and need not be returned.

Mail addressed to joint owners should be forwarded to the surviving owner. Letters and personal mail can be answered by family or by means of a death announcement.

Since some funds or banks issue statements only once a year and some insurance premiums are payable annually or semi-annually it may be a good idea to monitor the mail for six months to a year or so as not to overlook any assets or liabilities. There is no need to delay settling the estate, since it is always possible to re-open probate to settle and distribute newly discovered assets.

Consolidating Assets

All of the deceased's solely held liquid assets—property that can be quickly and easily converted into cash—such as stocks and bank accounts, should be consolidated into one separate checking account (not one you already have). You, as executor can then use the money in this account to pay the deceased's taxes, pay off debts, reimburse your administrative expenses as the executor and pay court costs and any others you hire such as an attorney or accountant to help with settling the estate. The remainder goes to the beneficiaries. Liquid assets include the cash, solely owned bank balances, dividends, proceeds from the sale of estate assets and any other money that comes into the estate before the administration of probate finalized.

> As mentioned in Chapter 6, payroll checks and employee benefits can usually be paid directly to the spouse or next-of-kin. The employer may ask for a copy of the death certificate and have you sign an affidavit to authorize the transfer. If the employer balks at this, contact the probate court, your state department of labor or a lawyer.

Any securities held solely by the deceased at the time of death can be sold, by the executor, held for later distribution to beneficiaries or transferred to beneficiaries through small estate transfer procedures. If you do not liquidate these funds immediately in hopes of getting a higher yield, discuss this decision with the beneficiaries. If you don't, and the securities lose money, they may blame you. If the estate's assets include a large portion of stocks and bonds, consult an investment counselor at the expense of the estate.

Solely-owned accounts receivable payments in the form of royalties, residuals, promissory notes, etc., are probate assets transferable to beneficiaries designated in the will. If these assets are not designated to a beneficiary, the estate cannot be closed until the last payment is received—which may not be for several years.

Non-liquid assets will need to be appraised for inclusion in the inventory filing required by the court and to help you in determining the value before selling or distributing to the beneficiary. Personal property should either be sold or distributed to the entitled beneficiary as soon as possible to eliminate your responsibility and the estate's expense for storing and insuring it. You can petition the court for either an early distribution or an order to sell.

Real estate will require maintenance and repair as well as insurance, mortgage, taxes and utility bills until it can be sold or distributed to the beneficiaries. Use the funds in the "estate checking account" to pay these costs. Remember: It is your responsibility to "protect, maintain and secure the assets prior to closing the estate.

If the deceased owned or ran a business either as a sole proprietor, partnership or limited liability company (LLC), the will should tell you whether his or her intention was to continue the business by bequeathing it to someone, sell it or continue in business with the deceased's share being bought out by the surviving partners or shareholders. If the will gives you no guidance, you are within your authority as executor to liquidate the business. Consult the partnership or shareholders agreement to see how death of a partner or shareholder is to be handled.

The Place of Residence

The deceased's non-liquid assets such as his or her home (or other real estate) if jointly-owned will pass automatically to the surviving owner (in most cases the spouse). No probate court administration is necessary. However, you as the spouse, or surviving owner, will need to transfer title to sole ownership by filing a certified copy of the death certificate with the register of deeds in the county where you live. If the home is held in trust, the terms of the trust document will dictate whether the trustee is to sell the home, deed it to a beneficiary or hold it in the trust.

If the home was solely owned by the deceased, it must be entered into probate. As executor, it is your responsibility to pay the mortgage—and insurance on the home from estate funds—until the estate is settled. You are entitled to reimbursement for any maintenance you pay for the home. If you sell the home, you must pay all real estate related costs—appraisal, closing of sale, etc.—from the estate's funds (those you set up in a checking account).

> The contents of the home—if joint-owned—pass to the surviving owner except for items determined to be solely-owned by the deceased. If such an item is proven (by credit card or sales receipt) to be solely owned by the deceased, it is a probate asset and passes according to the will or state intestacy laws, if there is no will.

Protecting the Spouse

All states have a minimum **family protection allowance** that guarantees the spouse and dependent children receive at least some funds for support from the estate—even if they weren't named as designated beneficiaries. The spouse must petition the court soon after the death. The amount of the allowance is determined by the court. It may be large enough so that other bequests are reduced or eliminated. If the estate is sufficiently depleted by this allowance, debts including the funeral, court and probate administration costs—may go unpaid. In addition, the spouse may claim a **homestead right,** which allows the spouse and minor children to stay in the deceased's home for a specified period, even if the house has been bequeathed to someone else. In most states the spouse has the right to elect, within 30 days, whether to take the bequest in the will or the spouse's **statutory share**. This share may be greater or less than the amount stipulated in the will. In some states it's one-third or one-half the value of the probate estate. In some states the exact amount of the spouse's share depends on whether the couple has minor children and on how long the couple

was married. The spouse may elect the family allowance, the homestead right *and* either the statutory share or the willed bequest.

> Vehicles (cars, motorcycles, boats, RVs, etc.) that belonged solely to the deceased may be informally transferred in some states to a surviving spouse or next-of-kin without going through probate. Call or visit your local DMV for information on changing the title and registration of a vehicle. You may need to sign an affidavit and produce the vehicle's title and registration as well as a copy of the death certificate. If, however, the vehicles exceed the state-imposed maximum values (between $25,000 and $75,000) they may be considered probate assets subject to probate administration.

Is Probate Necessary?

Once you have identified, collected and appraised the deceased's assets, separated them into probate (solely owned) and non-probate (jointly-owned or passed to beneficiaries) categories you should be able to estimate whether probate administration is necessary or can be avoided. If a guardian or conservator must be appointed, the probate court must be involved and the sooner the better for the children involved because they can't be left alone until this is sorted out.

The value of the probate assets is a major factor in determining whether the estate must undergo full administration by the probate court or can be settled less formally through "summary" or "small estate" probate administration. Each state has different small estate transfer procedures. You will need to inquire with the probate court in the county where the deceased lived about eligibility requirements for this type of probate procedure—which may cut your probate process down to a few days rather than several months.

Eligibility for small estate transfers may depend on whether:

* the dollar value of the estate is within state limits—which varies widely; in California it's $100,000 whereas in New Hampshire it's $500;

- real estate is or is not involved—it's okay in some states not in others;

- creditors have been paid or do not object—in some states they are not required to be paid if the estate is less than the state set limit;

- the person claiming the estate is legally entitled to it—the will does not indicate someone else as beneficiary; and

- a specified number of days (usually 30 to 45) have elapsed since the death.

In some states, as long as the total value of the estate does not exceed the state limit, all you need to transfer all of the solely held accounts to your name is to fill out a **transfer affidavit.** The form should be available at all banks, credit unions, insurance companies or other financial institutions holding the deceased's assets. You simply sign the affidavit stating that you are the person legally entitled (as spouse or next-of-kin) to inherit the property, (cannot be used for real estate) and that there is no court-appointed executor for the estate. You also may be required to present a copy of the will to prove that you are the one who is entitled to the funds.

The affidavit procedure can be used to transfer bank accounts, insurance policies, securities and the contents of the safe deposit box.

If the deceased had real estate or if his or her assets exceed the maximum values allowed for transfer by affidavit, you can try another shortened from of probate administration called **summary probate administration.** You will essentially petition the probate court to issue an order granting you (as spouse or next-of-kin) the right to the property. You may be asked to provide an inventory of the assets and the court will notify all interested parties of a hearing, during which the court will rule whether you, or someone else, is entitled to the property.

Another form of summary probate: If after the spouse claims the family protection allowance (mentioned above), the value of the probate assets does not exceed the combined value of the funeral, final health care of the deceased and probate administration expenses, you may make a summary probate filing. You may close the estate by filing a sworn statement that the value of the estate did not exceed the cost of the family protection allowance, the funeral, health care and administration expenses; that the distribution of assets is complete; and that a copy of the final statement was sent to all beneficiaries and unpaid creditors. Under this summary filing, you need not pay creditors.

Initiating Probate

If after conducting an initial inventory you determine that probate filing will be necessary, you should initiate the probate process by filing the petition to begin probate proceedings at the probate court in the county in the state where the deceased lived. The executor should not file unless the estate requires probate administration.

You must file a detailed inventory of all probate assets with the court within 30 to 60 days after being appointed executor. The inventory must include fair market value of all of the items listed and any outstanding liens or mortgages.

If a guardian or conservator must be appointed for the protection of the deceased's minor children, or a lawsuit for wrongful death is pending then you must file formal probate proceedings with the court. Likewise, if after conducting the inventory the person's assets, you determine that the estate must undergo the formal probate process because the probate assets are valued above the maximums allowed for small estate settlement then you must officially file a petition to commence formal probate proceedings.

You, as executor, should file the petition but other interested parties such as an heir, beneficiary or creditor may also do so. The petition should be filed in the county of the state where the deceased lived. If

he split his time between a winter home and a summer home, the state where he "lived" will be determined by where he filed income tax, was registered to vote, had a driver's license and the address given in the will.

The petition—referred to as the **petition to administer estate, petition for commencement of proceedings** or **petition for probate of will**—is a form that can be found, filled out and filed at the probate court. Among other things, this petition includes:

1) Your name and relationship to the deceased;

2) The deceased's name, date of death, age and Social Security number;

3) His or her county and state of residence;

4) Names and addresses of his or her heirs (surviving spouse and minor children);

5) Date the will was drafted and names of its witnesses; and

6) The estimated value of the probate assets.

If you have not already done so, submit the original will to the court along with your request to be appointed executor of the estate. You will need to file a detailed inventory of all probate assets with the court within 30 to 60 days after being appointed executor. The inventory must include fair market value of all of the items listed and any outstanding liens or mortgages.

Ancillary Probate

If your loved one owned a summer home or other property elsewhere it may be necessary to file separate probate proceedings in the county of the state where the property is located in order to transfer the property to beneficiaries or heirs. (Unless the property was jointly-owned—in this case, it transfers to the survivor without probate.)

You will need to contact the probate court in the area where the home is located. There may also be separate inheritance or estate taxes payable to the state where the real estate is located.

Notifying Interested Parties

Following your filing the petition to commence probate, your request to be appointed executor and the will, the court will schedule a hearing at which, the judge will confirm your appointment and determine whether the will is legally valid and admissible into probate.

It is your responsibility to notify all interested persons—the deceased's beneficiaries, next-of-kin and creditors—by sending them a copy of the petition for commencement of probate, a copy of the will and a notice specifying the time, date and place of the hearing. Any one of these "interested persons" can file an objection to your appointment as executor or can contest the will. (Contesting the will is not easily done, seriously prolongs the probate process and costs the estate a great deal. Sometimes it is possible to reach a compromise settlement with the one contesting the will. If the will is thrown out as invalid, the estate will be probated as if there were no will.)

You should know or be able to assist the designated executor in locating all "interest persons." But if the deceased has family from a previous marriage or from which he or she is estranged or you feel that you may have forgotten someone who could later come forth with a legitimate claim, you may want to check with other family members, friends, his or her doctor or clergy. Consult birth certificates, marriage certificates, death certificates, military records, government (census) records, court (adoption or divorce) records. If the value of the estate is substantial, you may want to consult a genealogist or private investigator in tracking down any stray heirs who could come forth with a legitimate claim to assets and contest the will.

Hiring an Attorney

As I have mentioned in the various sections throughout this book, from time to time you may need the assistance of an attorney to help you in securing your rights and the benefits that you are entitled to. Having an attorney at your disposal to counsel you or write the occasional letter on your behalf can be very helpful and cut your waiting time and frustration nearly in half.

Although the deceased may have felt that you were capable of handling these arrangements, and you very well may be, you might not want to take on the full probate administration and management all on your own. You may also discover through an inventorying of the deceased's estate, you are unable to avoid probate—although you don't necessarily need an attorney to probate an estate—and you may find a benefit to having legal counsel. The assets of the estate may be large and complex and require more management than you are inclined to handle. What's more, the probate court system can be confusing not to mention tedious and frustrating and you may find that having someone familiar with property, estate, inheritance, tax and state laws is very helpful. Therefore, you may want to consult an attorney who specializes in probate law.

Ask friends and family for recommendations. Ask the clerk of the probate court. Ask your banker. You may even want to consult a lawyer referral service or your state or local bar association for lawyers who specialize in probate law.

> If you are a member of AARP you may be eligible for free or reduced fee legal services from lawyers who participate in the AARP Legal Services Network. For a list of participating lawyers, visit *www.aarp.org/lsn* or call (800) 424-3410 for more information and names of attorneys in your area.

Remember: Always meet with a few lawyers before selecting one. Most will meet with you briefly to get acquainted for no charge. Don't

let an aggressive attorney "choose" you as a client. You're the one doing the hiring and you should find someone you can talk with easily, who understands your needs and, if possible, one you feel you can trust.

When you meet with or call the lawyer, ask if he has probate experience, tell him what you need help with and be sure to discuss fees up front. Choose someone you feel comfortable talking with and make sure that he understands your needs. Although many estate attorneys prefer to work for a percentage of the estate, it may serve you—and the estate—better to try to negotiate an hourly fee.

> If you are organized and do some of the work yourself—notifying beneficiaries, filling out and filing forms—you will make better use of his or her time and save a good deal of money. Use the lawyer's services for big things, or purely for legal advice.

Be sure you find out how much he or she charges for the services you need. Typically, attorneys charge either a set fee to do a specific task (such as prepare a document), a percentage of the estate or an hourly rate. Get in writing a detailed statement of the services he or she will provide and the charge for each, including extra costs for filing, appraisers, mileage, copying court documents—*before* you hire him or her. Confirm the agreement in a formal contract that you can understand. A lot of people sign contracts without knowing what they say—and then get into trouble. If you don't understand a portion of the contract, ask the attorney to explain it to you before signing on the dotted line. In many states, the court dictates the amount—based on the size of the estate—that a lawyer can charge for probate administration. However, it may be less expensive if he or she charges by the hour. Negotiate to pay for only the actual time spent. Or arrange a flat fee for the job.

Experts warn that you should be sure you are not being charged the full rate for work done by a paralegal or a student.

The AARP advises that you consider the amount of time it will take to do the work, the difficulty of the legal issue and the lawyer's experience in figuring out whether a fee is reasonable. A less experienced lawyer may charge less but take longer, while an experienced lawyer may charge more, but resolve the matter more quickly. As with all other professional services, the cheapest fee may not be best. If you hire an attorney, you may be able to save on legal fees by using the attorney only in an advisory capacity and handling the rest yourself. Compile and organize all the records, files, forms and documentation he or she will need to settle the estate. Sometimes an experienced accountant can handle the entire process.

Paying Off Debts

As the person responsible for settling the estate, you will have to take stock of the deceased's liabilities as well as his or her assets. Although assets jointly owned become the property of the surviving owner, bills incurred jointly—through a joint charge account or credit card—remain the responsibility of *both* the estate as well as the surviving joint debtor.

Some bills must be paid when due—taxes, insurance, mortgage—otherwise the estate may be jeopardized. State law ranks creditors by priority. The order varies from state to state but usually includes the following at the top of the list:

1) Expenses associated with administering the estate, (lawyer fees, court costs, etc.);

2) Taxes;

3) Funeral expenses;

4) Medical expenses incurred immediately prior to death.

You need to pay those at the top of the list first, in full. If you pay a low-priority creditor before say, taxes or funeral expenses, you may

be held personally responsible for paying the higher ranked creditor later on if the estate runs out of funds. If there are insufficient probate assets to pay the lower ranked creditors, they get nothing.

Even if you are the surviving spouse, you are under no legal obligation to pay debts the deceased accrued on his or her own out of your money, insurance proceeds, jointly-owned assets or even funds from accounts made payable on death. If you pay any debt yourself, the estate should reimburse you. If, however, you co-signed the credit agreement, you are responsible for the remaining balance.

Creditors' claims can be ignored if there are no probate assets or if the estate is of so little value that it is not required to pay any of its creditors. Some states guarantee a "family allowance" for the spouse or minor children that is exempt from creditor claims. Estates settled by "small estate" transfer procedures are usually not required to pay creditor claims.

Notice of Administration

As executor, you are responsible for notifying the deceased's creditors, directly if you know who they are, or through a notice in the local newspaper. The notice should state that the will has been admitted into probate and that any claims against the estate must be submitted to the executor or the court within a given time period set by the state, (usually within three to four months). The court will tell you how long and how often the notice must run. The court will also ask for proof of publication.

The notice should include the following information:

- deceased's name;
- address;
- date of death;
- Social Security number;

- executor's name;

- executor's address; and

- address of the court.

Claims need not be paid if they are submitted after the deadline. No claim should be paid before the expiration of the claims deadline; however, once the deadline has passed you must pay claims promptly. Payment should be made by check from the estate's account. However, you may have to liquidate some assets—securities or real estate—in order to generate sufficient funds to pay allowed claims. In determining what to sell, it is wise to consult with the beneficiaries.

If you are unable to pay the creditors—because the estate has no funds it is a good idea to let them know—otherwise they may keep hounding you. Although this may seem embarrassing, don't worry about it. Most businesses make allowances for non-payment of debt.

The deceased may have had mortgage life insurance or credit card insurance that upon death would pay off the balance due. Ask the deceased's mortgage lending company, insurance company and credit card companies for more information about this insurance coverage.

If you feel that a claim is illegitimate or unfair, contact the creditor and try to reach a resolution or compromise. If you are unable to do so, file a formal objection with the court. Include your reason for the objection and send a registered copy to the creditor. The court may intervene on your behalf if it agrees with your objection.

Paying the Deceased's Taxes

One of the most important and perhaps daunting tasks you will have to face as the executor of the estate is filing the deceased's taxes. If you have not yet sought the help of professionals in the probate pro-

cess, now might be the time. If the value of the estate is high or probate is complicated, consult an accountant or tax lawyer who is familiar with the tax laws in the state and county where the deceased lived. As with hiring any lawyer, the more organized you are and the more information you can provide the accountant, the less time it will take him or her to do the work you need and the less it will cost the estate. Even if you hire professional help, you as executor are personally responsible for filing the returns and paying the taxes. If you use an accountant, you can't blame him or her for any delay in filing. The IRS won't buy it.

> Remember: Payment of taxes takes priority over any other debts. Taxes must be paid on time. Do not distribute assets to the beneficiaries before paying the taxes due or you will be held personally responsible for the taxes owed.

You may not have to pay all of these taxes. The type of taxes you will be required to file will depend on the deceased's income, the value of the overall estate as well as the estate and inheritance tax requirements of the state and county where the deceased lived and filed taxes.

When handling the deceased's taxes, you will need to file:

- personal federal, state and local income tax;

- federal, state and local estate tax; and

- federal, state and local income tax on the estate (if any).

You may also need to file:

- Life Insurance Statement (form 712);

- Gift tax (form 709); and

- Fiduciary income tax (form 1041).

Call the Internal Revenue Service (IRS) and ask for Publication 559, *Survivors, Executors and Administrators*, which outlines in detail

your responsibilities vis à vis tax filing as a survivor or executor of an estate. It also offers information about tax benefits for survivors. You can also get access to other information on their Web site at *www.irs.gov*.

> Special rules apply to members of the armed Forces who die in or as a result of active duty in a combat zone. The IRS also has special provisions for public safety workers killed in the line of duty and for victims of terrorist actions. For more information contact the IRS.

Personal Income Tax

To reiterate: The deceased's final federal, state and local **income tax** returns will need to be filed. The deceased's final income tax return should include all income earned in the year of death up until the date of death. These taxes are due on April 15th following the year of the death, just as they would be normally. Final tax returns for the deceased cannot be filed electronically. A paper tax return (Form 1040) must be filed in the IRS center for the place where the deceased lived.

If the deceased failed to file an income tax return for any years preceding death, you will need to file for those years, too. If, for example, he or she died in March of 2003 and had not yet filed in April for taxes due on 2002, you will have to complete the filing and pay the 2002 taxes as well. Even if the deceased had no taxable income for the year, you should file a return. A refund may be due if taxes were paid on wages, pension or annuities. In addition, medical and dental expenses, if paid within a year of the death, can be deducted from the deceased's final individual income tax return.

If you are the surviving spouse and it has been your custom to file a joint return, you may do so again for the year in which your loved one died. A spouse with dependent children may file jointly for an additional two years after the death. Or you can choose to file separately. There may be advantages to filing jointly. The surviving spouse

may offset income received after the deceased's death against deductions claimed by the deceased. What's more, the surviving spouse who files a joint return qualifies for special tax rates for the two years following the death. (Unless you remarry.)

Estate Income Tax

If the probate assets of the estate do not earn income during the probate administration process period, there is no need to file a federal income tax return on behalf of the estate.

But if the estate is large and takes time for probate administration, it is likely that the estate made money. If it made more than $600 between the time of the deceased's death and the time all assets are distributed, then you will need to file federal income tax for the estate.

In order to file on behalf of the estate, the executor must apply for an employer identification number (EIN) for the estate. Complete IRS form SS-4, *Application for an Employer Identification Number*, obtainable from the post office or Social Security office. It will take four weeks by mail or you can apply immediately by phone. The EIN functions like a Social Security number. You will need to enter it on tax returns, statements and documents you file on behalf of the estate. If interest or dividends are payable to the estate, the estate's EIN number must be provided to the payer and used on the Form 1099 to report the interest. It is your responsibility to give the EIN to those who file Form 1099 in connection with the estate. The estate income tax is reported on Form 1041.

You are required to file a Notice Concerning Fiduciary Relationship (IRS Form 56) if you are appointed to act in a fiduciary capacity for another. A *fiduciary* is a person acting for another person. An executor or personal representative is a fiduciary. You will need the EIN to file the Form 56. You will also need to notify the IRS when your responsibilities as fiduciary are completed.

Taxable income on the estate consists of all income received during the tax year and includes:

- dividends;

- interest;

- rents;

- royalties;

- gains from the sale of property;

- income from business;

- partnerships;

- trusts; or

- other sources.

There is no exemption for dependents or medical or funeral expenses. However, losses from the sale of property, net operating losses and some casualty and theft losses can be deducted if not also claimed on the federal estate tax return. The cost of administering the estate can be deducted from the gross estate, either on the estate's income tax return or on the federal estate tax return, but not on both. The estate's income tax return must be filed annually on either a calendar or fiscal-year basis. You may file at the IRS location nearest your home or workplace.

Federal Estate Tax

If the value of the deceased's taxable estate exceeds $1,000,000 for 2003, ($1,500,000 for 2004 and 2005) you must pay federal estate tax and file an estate tax return (Form 706).

The value of the estate is based not only on solely owned (probate) assets, but on *all* assets including those that are exempt from probate administration, such as:

- the deceased's share of jointly owned assets;

- life insurance, payable to the estate or to heirs;

- annuities paid to estate or heirs;

- benefits from retirement accounts and pension plans;

- assets held in a living trust;

- assets held in pay-on-death or transfer on death accounts;

- lifetime gifts made within three years of the death;

- gifts made at the time of the death; and

- the deceased's interest in community owned property.

You will need to itemize all the assets that comprise the gross estate including assessing fair market value for each. The value of the deceased's assets can be determined either as of the death or six months thereafter. Use whichever total reduces the amount of the tax.

There is an unlimited marital deduction from the gross estate, which may reduce the estate's value enough to eliminate having to pay the tax. All assets that pass directly to the surviving spouse from the deceased by—bequest, inheritance, joint-ownership, revocable living trust, pay-on-death and transfer-on-death accounts or as proceeds of life insurance—are exempt from the estate tax. Additional deductions include: funeral and burial expenses, administration expenses, debts owed at the time of death, mortgages, income taxes, property taxes, uninsured losses incurred during the estate settlement, charitable bequests and state death taxes. Once all allowable deductions have been subtracted from the gross estate, the result is the taxable estate.

A "tentative" estate tax is computed on a sliding scale based on the value of the taxable estate. Once the tentative tax has been calculated, the unified gift and estate tax credit—a credit of $345,800 in 2003, $555,800 in 2004—may be applied.

Note: A credit is allowed for any gift taxes previously paid on lifetime gifts made by the deceased of $11,000 (or $22,000 with the consent of the spouse). These credits may reduce or eliminate the estate tax completely.

If after the unlimited marital deduction has been taken and the unified gift and estate tax credit applied the value of the estate is still greater than $1,00,000 in 2003 ($1,500,000 in 2004), you must pay federal estate tax. Fill out and file Form 706 within nine months of the date of death. You also need to attach a copy of the will, the death certificate and state certification of payment of death taxes. U.S. residents may mail the form to the IRS Center in Cincinnati, Ohio 45999. If you fail to pay the tax when it is due, or misreport the value of the estate, you will be subject to severe penalties. If you cannot pay the tax because you have distributed assets to the beneficiaries, the beneficiaries will be personally liable for the tax.

State and Local Estate, Inheritance and Income Taxes

Consult an accountant, tax attorney or state and local tax laws to find out about filing estate income tax requirements for the state and local area where the deceased lived. Most states have either:

- an inheritance tax—payable by each beneficiary; or

- an estate tax—payable by the estate.

The tax may be applicable regardless of how small the estate is. Taxes are due to the state in which the deceased resided—not where the beneficiaries live. Certain beneficiaries may be exempt—spouse, children, grandchildren. The will may state that the tax be paid by the estate on behalf of the beneficiary. Regardless of how the tax is paid, it is the responsibility of the executor to be sure that it is paid.

It is important to note that tax laws and forms are revised and updated frequently. It may help to have the advice and counsel of a Certified Public Accountant (CPA) or tax attorney. Contact your local IRS office or access the IRS Web site at *www.irs.gov* for information. To order forms and publications to assist you with tax filing call (800) 829-3976.

Distributing the Assets and Closing the Estate

Once you have inventoried the assets, paid the taxes and debts including all probate administration costs, you can distribute the remaining assets to the beneficiaries. In order to do this, the court may require you to submit your plan for distribution of assets for approval. The court may share or ask you to share the plan with other interested parties. It may take 30 days or more before the court approves or rejects your plan for disbursement. If the court or other interested party files an objection, the court may make changes to your plan and you will be bound by the court order to distribute the assets accordingly.

When distributing the assets, use the estate's checking account (which you set up for all the liquid assets) to write checks to the entitled beneficiaries. Cancelled checks will prove distribution of assets to the court. When distributing other assets, you will need to get receipts signed by the beneficiaries, which will prove to the court that you have distributed the assets according to the will (or the state law). When distributing real estate or other personal property you may use a court order *assigning residue* that describes the property and specifies the beneficiary and deliver the order to the beneficiary. For titled items, like a car, fill out the transferor's portion of the certificate of title. Deliver the title to the beneficiary with copies of the death certificate and your letters of authority.

More Important Definitions

- **Ademption**. When a bequeathed asset is no longer in the estate. The beneficiary may have received the bequest during the deceased's lifetime, or if it was given or sold to someone else before the death the beneficiary gets nothing.

- **Abatement**. When there are not enough probate assets to satisfy all bequests in the will. If not addressed in the will, common law dictates the priority order in which bequests will be reduced or eliminated to make up the difference.

- **Lapse**. When the beneficiary dies after the testator but before the execution of the will, his or her bequest lapses. The will may have named a contingent beneficiary, or stipulate that the property may become part of the "residue and remainder" clause. Or if neither exists, it will be distributed according to the state's intestacy laws.

- **Uniform Simultaneous Death Act**. When there is no sufficient evidence that persons have died otherwise than simultaneously, the property of each person shall be disposed of as if he had survived.

Once you have distributed all of the assets, you must submit a final accounting to the court. Each state has different procedures for closing an estate, but in general you may close by filing a sworn statement or by petition.

Your sworn statement must state that you published a notice to creditors, distributed probate assets, that all beneficiaries and creditors are aware of the closing and that all beneficiaries have received an accounting of your administration. You cannot file a sworn statement unless you have served as executor for at least six months. Your discharge takes effect one year after you file the statement.

Closing by petition also requires that all interested parties be notified of the closing, including: beneficiaries, creditors and heirs. A

hearing is then held by the court during which the court will rule on the distribution of the assets, your fees and expenses and whether to discharge you as executor and close the estate.

Either way, once you have been discharged, you no longer have fiduciary authority over any new probate assets that may be discovered. If you are a survivor of the deceased you will have to obtain a court order to reopen the deceased's estate in order to transfer ownership and settle the estate if any other probate assets are in fact discovered. You may also petition the appointment of an executor (new or same) to handle the transfer of these newly discovered assets.

Conclusion: Your Own Will

The deceased's death has greatly altered your life, it has effected you emotionally and, on a practical level, financially. Once you have taken care of executing the deceased's estate and filing all the taxes associated with the death, you should take time to seriously consider the changes you need to make as a result of your new financial situation.

If you don't have a will, make one. Put together a letter of instruction for your friends and family. Share with them where important documents can be found and what your wishes are for your final arrangements. Consider what other changes you can make to your finances and property so that those close to you will have less to deal with when you die. In the next chapter, we will provide you with tools you can use to help you get started.

Using What You've Learned

If you have made it to this point in the book, you know how important it is to plan for your own end-of-life treatment, final arrangements and estate planning. As we have said, no one likes to think about his or her own death. However, each of us needs to get past our own fears to plan for the future—a future that extends beyond any single lifetime.

Regardless of what age you are now, if you have others who depend on you—a partner, children, parents, siblings, friends—then you owe it to them to think about what you would want them to have or do at the time of your death. Planning for its eventuality by setting up a will, designating a guardian for your children, buying life insurance, signing a donor card or selecting a charity to receive donations in lieu of flowers at your funeral will give you peace of mind now and your loved ones some comfort at a time when they are overcome with grief and overwhelmed with decisions.

The following is a checklist of things to think about and take care of today so that your family and friends will know what your final wishes are.

List of Things to Take Care of Now

- Create a living will.

- Designate a health care power of attorney and make sure that person knows about your desires for end-of-life care.

- Share your philosophy about end-of-life care with your family.

- Make arrangements to donate your organs, tissues or body.

- Sign and carry an organ donation authorization card.

- Share your wishes for organ or body donation with your family.

- Inventory your assets.

- Compose a Letter of Instruction.

- Set up your estate to avoid or minimize probate and estate and inheritance taxes.

- Buy life insurance.

- Draw up a will.

- Designate a guardian for your minor children and be sure the designee is willing to take on the emotional and financial responsibility.

- Designate a conservator to manage your children's inheritance.

- Appoint an executor and let that person know what his or her responsibilities are.

- Compile your "important documents" in a safe yet accessible place.

- Let your loved ones know where to find your important documents.

- Pre-plan (but not necessarily pre-pay) your funeral (final disposition/services).

We may have very little control over when we die but we do have some control over how we die. Modern medicine has come far to prolong the average life span of those of us fortunate enough to live in the Western world. And quality of life, however, may become an issue. As our population ages, dying with dignity is an important issue to a growing number of people. For many, just knowing that they have some control over how their last days will be spent brings great comfort.

Give some thought to how you want to spend your last days. Even if you are relatively young, you might experience an accident that could leave you unconscious and on life support. You will want to provide your traumatized spouse with some comfort by letting him or her know what you would want them to do on your behalf in such a tragic situation. Provide him or her with instructions for keeping you alive or letting you.

Today's medical science can keep the body alive for long periods of time even if the mind is gone and there is little or no hope of recovery. But, how long would you want your spouse to suffer without hope? Days, weeks, months? Ask yourself the following: *How long is enough for them to say goodbye? How long would you want your family to continue to pay for your life support? Is quality of life more important to you than a life prolonged artificially with no hope for improvement?*

There are no easy answers. Every situation is different. But as tough as these decisions are, they must be made and it helps to have a predetermined course of action and to share that information with your family.

Letter of Instruction

The letter of instruction has been defined and discussed in previous sections of this book. To reiterate in brief, it is an inventory of all your assets and liabilities. It should contain an up-to-date list of everything that you own and its location. Even if you feel that your spouse

knows the whereabouts of all your assets, he or she may not know all of your liabilities or he or she may die with you and your heirs will be at a loss when trying to settle your estate.

> Your will is a legal document that lists money, property and possessions that you want to bequeath to others. It should not list everything you own, as it will need to be amended each time you buy, sell or give away any property or possessions listed.

The letter of instruction is not a legal document but more like a map for those who may be left by your illness or death to navigate through your life.

Taking an occasional inventory of your assets and liabilities is a great way to take stock of your financial goals. You may realize that you need to buy more life insurance in order to protect your family in the event of your death. Or, you may realize that you can easily keep your estate from probate by shifting some property to joint ownership, that your estate will be subject to tax upon your death unless you make some lifetime gifts.

If you periodically inventory your assets and take stock of your estate as it grows throughout your life, you may find that setting up a trust or family annuity is beneficial.

> The letter of instruction should also express your wishes regarding a funeral service and final disposition. These are tough things to think about. But they may be tougher still when you are near death or when your family is left to figure them out without any directions from you. Don't think about these things as part of your death. Think of them as a means of helping your friends and family through a stressful time.

Make sure that if you have funeral and disposition preferences that you discuss them with your family and put them in the letter of instruction. (See charts on following pages.) Then be sure the letter of

instruction is in an easy to find place and that your loved ones know where to find it.

Unlike the will, which, if probated, becomes a document of public record that anyone can have assess to, the letter of instruction is a personal document and the place where you may want to include any personal statements to family members or friends. It is the place to tell family and friends anything and everything you may want them to know about you, your possessions and your life.

The letter of instruction is not a legally enforceable document so there are no legal constraints as to its form or content. Your survivors are not legally bound to follow the instructions it contains. It is merely meant to be a guide for them to follow. In some ways, this may be a consolation to you. You may have planned a very traditional funeral, which, if funeral costs continue to rise, your loved ones may not be able to afford. Because the letter of instruction does not bind them, they can use what funds they have to plan a beautiful and meaningful memorial ceremony that is not as expensive as the traditional funeral and still provide you with the burial that you wanted.

Life Insurance

If you are reading this book because your loved one recently died you may have good reason to reevaluate your insurance needs. For example, if your spouse was the head of the household and now you are, you will need to readjust your insurance portfolio to reflect your current situation and the needs of your family.

If the deceased was the beneficiary on your life insurance policy, then you will need to update the beneficiaries on your life insurance policy. If the designated beneficiaries die before you and you haven't made changes to your policies, the proceeds will be paid to your estate and be probatable and subject to estate and inheritance tax.

Your insurance agent should be able to advise you based on your age, the age of your children and your financial needs. If your children are young, have special needs or plan to attend college—their financial needs for the future will be greater than if your children are already grown and living on their own.

In addition to taking care of your family, life insurance provides another way to pass proceeds directly to beneficiaries without having to go through probate—that is, unless you have designated your own estate or its personal representative as the beneficiary. Life insurance proceeds are considered part of your taxable estate for federal estate tax purposes. However, you can get around this by transferring ownership of the policy while you are still alive to the beneficiary on the policy. You still pay the premiums but the new owner has the right to cancel the policy or change the beneficiary.

> A gift of life insurance is subject to the same federal gift tax if its value exceeds the $11,000 ($22,000 per couple) annual exclusion. Premiums on policies you have transferred also count as gifts but are not likely to exceed the $11,000/$22,000 annual exclusion. If the gift of an insurance policy is made within three years of your death, the IRS will consider the full death benefit as part of your taxable estate.

If you have set up a revocable living trust, you can name the trust as your **life insurance beneficiary**. That way, the proceeds pass through the trust to your beneficiaries and avoid both probate and state inheritance taxes. Federal estate tax will have to be paid unless the proceeds pass to your spouse who may claim the unlimited marital deduction.

You can also cover the cost of estate taxes by purchasing a life insurance policy intended to pay taxes. Talk to your life insurance agent and/or tax advisor to find out more about how this works.

Funeral Pre-Planning

To briefly review what we have discussed in earlier chapters the "funeral" essentially consists of two parts: the service and the disposition. When you can separate those two activities, you have a great many more options, both in kind and in cost. In Chapter 4, we discussed the options for disposition and in Chapter 5, we discussed many types of services you may want to consider. As was suggested earlier in the book, it may be more beneficial from a financial perspective to concentrate on the disposition first since if you elect earth burial or entombment it is likely to cost more than the service and is a less flexible necessity. Where you are laid to rest may be more important to you than the ceremony. If you want to be in a mausoleum on a hill overlooking the city you will have to do some shopping and some saving to make that happen. As a balance to that you might forego the big funeral and have a simpler ceremony in order to direct the better part of your or your family's funds toward the costly plot.

Don't buy a plot in advance unless you are sure that's where you want to be. It's hard to get a refund or to resell a plot you no longer want.

Once you have considered how and where you want your remains kept then you can consider the service, since the service can essentially be anywhere, any time and cost you nothing or close to nothing as long as you don't have it in the funeral home.

Use the checklist of options on the next page to help you make a decision and share your preferences with your family.

Decisions Regarding Final Disposition

☐ Use a funeral director or do it yourself;

☐ Cremation or burial;

☐ Embalm the body or not;

☐ Buy a casket, rent one or build one;

- ☐ Select a cemetery or get permission to use private property;

- ☐ Purchase a plot, crypt or niche;

- ☐ Purchase a vault or grave liner or find a cemetery that does not require any;

- ☐ Order a gravestone, plaque or marker; and

- ☐ Scatter cremains or keep them.

Disposition Options Chart

Burial	Cremation
Interment—earth burial	Bury cremains in the ground in a regular sized plot or smaller cremation plot
Entombment—in a mausoleum (aboveground burial)	Place cremains in a niche within a columbarium (aboveground burial)
Burial at sea	Scatter cremains (at sea, elsewhere)
	Keep cremains at home

Other things to consider when pre-planning your own funeral (include in your letter of instruction with your important documents):

- **Type of service**—Memorial, funeral, gravesite committal, etc.

- **The setting**—Formal/informal to reflect your personality. If it's a memorial service (without the body present) rather than a funeral, you are not limited to a location. If you love art have a service at an art museum, if you love the outdoors have a hillside gathering amidst the wildflowers, or a service on the beach at sunset.

- **Who should come**—Do you want a public announcement in the newspaper, a written mailing to certain friends or phone calls from family members? List people to call in your letter of instruction.

- **Who will lead the service**—Your clergy will be involved with any service in a church, temple, synagogue or mosque—the program determined by religion. You can ask clergy to lead a service held elsewhere. A close friend or family could be asked to lead or facilitate the service. Several may participate, but it's a good idea for one to be designated as coordinator to avoid awkward hesitations in the program.

- **The content of the service**—If are not planning a purely religious ceremony, you may want to pick a theme of remembrance. How do you most want to be remembered? For your civic activity? Your garden? Your art? For being a great mother?

- **Favorite readings**—Bible verses, poetry or something you've written yourself. Write something now. You can always revise it as the years go on. Having a note in your own handwriting will mean a lot to your survivors.

- **Music**—The service regardless will likely have a bit of music at least at the beginning and ending. If you have a preference, include it in your plans. You may want live musicians, family members to sing or your favorite CD played. Consider what you think your loved ones would appreciate and how you want to be remembered.

- **Photographs, memory books, videos**—Assemble a compilation of your favorite photos, clippings, awards or other special mementos for a memory book for family and friends to share at your memorial service. Provide clips of old home

movies. Some companies specialize in creating mini biographies commemorating a life.

- **Flowers**—If you feel that flowers are an important part of the service or feel that the money spent on them would be better going to a charity, share this with your friends and family. List any charities you have in mind, including contact information.

- **Refreshments**—You may not want to get into this much detail in the planning of your own funeral and disposition, but the more you plan now and share with your family, the easier the tasks will be for them. Request that friends and family bring food to share during a bereavement gathering at your family's home. Or, plan something more or less structured like a dinner at your favorite restaurant or a reception at the local lodge.

- **A memorial notice**—Nowadays it's likely that your friends and relatives are scattered far and wide. They may never see the obituary in a local paper. It would help to leave a list (or at least let your loved ones know where you keep your address book) so that they can send out a notice of your death if that's something you want them to do. Ask them to include your favorite charity for memorial donations.

Pre-planning your funeral arrangements provides an opportunity for open discussion of personal preferences, feelings, and in the event of death, your family will be comforted knowing that they are carrying out your wishes. This is especially important if you want a simple service, inexpensive disposition or no funeral at all.

Pre-planning allows you the time to comparison shop and make knowledgeable decisions.

Comparison shopping is important when choosing a funeral home. The costs of items such as caskets or "professional services" vary dramatically from funeral home to funeral home. Compare prices from at least three. It helps to know what you want—direct burial, cremation, open casket funeral—before you shop so that you can adequately compare goods and services.

Pre-Paying for Your Funeral

Although it is a great idea to plan ahead for your funeral and share your wishes with your family, it usually isn't a good idea to *pay* for your funeral ahead of time. If you have reached a certain age, or live in a retirement community, you're likely to have been bombarded by "pre-need" funeral advertising either through the mail, by phone or door to door solicitation. Although this has been the normal means of promotion and sales for cemeteries for generations, funeral sellers are also jumping on the money wagon.

> Although in many states only funeral directors may sell pre-need funeral packages, other states do not require pre-need salespeople to be morticians. Just about anyone connected with the funeral industry is promoting pre-need purchases including insurance companies, for-profit cremation societies and pre-need associations.

Industry leaders have armies of sales people, sometimes called "family service counselors" or some such, whose job is to sell, sell, sell. They work on commission and they are hungry and aggressive. Why not? The pre-need funeral industry has grown exponentially in the past two decades to become a multi-billion dollar industry.

A million pre-paid funeral contracts are being sold each year for billions of dollars. However, you get the same, or better security by placing these funds in a savings account or trust for funeral purposes so the funds remain under your control and can be transferred to an-

other location, changed or withdrawn from an institution without penalty and interest.

In some states door-to-door solicitation is prohibited. However, your mailbox and newspaper will still be full of materials explaining the advantage of prepaying for your funeral. Some funeral homes even sponsor pre-need seminars at nursing homes and senior centers.

> Pre-need salespeople will make the argument that it is better to purchase your funeral now and lock in today's prices because the costs for a traditional funeral continue to rise. The rate of funeral inflation has historically been between 5 and 7 percent a year for a traditional funeral. There is no reason for the costs to go up at such a rate other than greed on the part of the seller, and the fact that it is what the unknowing market will bear. However, the funeral insurance or pre-need funds that you buy through the funeral home rarely grow at a rate that keeps pace with inflation much less the accelerated rate of funeral inflation. You are better off with a savings account or CD.

The pre-need sales pitch is to lock in prices at today's rates. But in actuality, your survivors will be manipulated into paying more for, cash advance items like flowers, an organist, soloist, minister as well as the funeral director's fee for arranging such items.

Despite what people in the funeral industry tell you, and although it is a good idea to plan for a funeral in order to spare your loved ones the hassle of planning every detail at the last minute, it rarely makes sense to pre-pay for those arrangements. You are likely to pay more than you think you're paying. If the death benefits are less than the current retail price at the time of death, additional funds will be due.

According to the Federal Trade Commission, keep in mind that over time, prices may go up and businesses may close or change ownership. However, in some areas with increasing competition, prices may go down over time. It's a good idea to review and revise your decisions every few years, and to make sure your family is aware of your wishes.

The AARP, FCA and CFA have been trying to get new laws passed to protect the consumer.

Before you pre-pay for any funeral good or service, the FTC recommends that you get the answers to the following questions:

- What exactly are you paying for? Are you paying for merchandise only or funeral service as well?

- What happens to the money you pre-pay? (Each state has different requirements for handling funds for pre-need funerals.)

- Are the funds put in a trust? If they are, are they all put in a trust or only a percentage?

- What happens to the interest income on the money you prepaid and put into a trust account? Do you have to pay taxes on it or does the funeral home?

- What happens to your money if the funeral home you dealt with goes out of business or changes ownership?

- Can you cancel the contract, transfer the plan or get your money back if you change your mind, move or die while away from home?

- Can you cancel the plan at any time? If so, does the plan allow for a full refund with little or no penalty?

- Does the plan provide an annual report that tells you where your money is and how much is there? (This is critical in states where there is no guarantee fund to protect consumers in case of default.)

Other things to consider:
- If the funeral home is sold, you may not want to do business with the new owner and he may not honor your contract with the old owner.

- Be sure to obtain a guarantee *in writing* in which the funeral director agrees that the original price, plus interest, will pay for the designated funeral.

- Make sure that the agreement also stipulates that any leftover funds will be paid to your estate. Otherwise, the funeral director will probably keep them.

- Consult an attorney before signing anything.

Watch out for tricky terms in your pre-need contract such as "nontransferable" and "nonrefundable." Other terms to look out for: Plans that are *cancelable* by the plan or mortuary, will be canceled with no refund if you cannot make a payment on time; *non-cancelable* plans, on the other hand, mean the buyer or his estate will have to keep paying on the contract even if the funeral can never be used.

Funeral homes will insist on and attempt to sell you on the belief that if you have a pre-arranged funeral or burial agreement the interest (or growth if a life insurance policy) is retained by the funeral home/cemetery to offset the rising costs of those specified goods and services over time.

They may tell you that changes are generally possible. Be careful, when they tell you this, it often means that when changes are made, they affect the terms of guarantees that were created under the original agreement. And, in the event funds paid toward a funeral plan are excludable resources for purposes of receiving social services (SSI or Medicaid), changing the terms of that agreement could jeopardize your qualification for these benefits.

A small processing fee may be included with an early payment. This is not a penalty. In the long-run, there is usually a good amount of money to be saved by paying off early. Of course, funding agreements vary. Please be sure to check the terms of your (or your proposed) funding agreement for details.

Payment Options

As an alternative to pre-payment, you're better off putting the money into a specific interest-bearing bank account to pay for services at the time of need rather than paying in advance for services with the funeral provider.

A Pay on Death Account (or Totten Trust) is a special type of individual trust or account set aside for one's funeral to which you add the name of a beneficiary. The beneficiary can be a funeral director (not a good idea), friend or relative who is trusted to use the funds as you direct. The advantage is that the funds stay in your control and can be withdrawn in an emergency or transferred if you should move.

The trust is revocable during your lifetime, but, in most states, becomes irrevocable at the time of death.

You can deposit a sum of money equal to today's funeral costs in a savings account, certificate of deposit (CD) or money market account— payable to a beneficiary of your choice. The money will earn modest interest to keep pace with inflation. The beneficiary should be made aware now where the funds are and what they are for. You can always add to the account. Because these funds are in a P.O.D. (pay-on-death) account, they will be available immediately at the time of death without the delay of probate.

Accumulated interest (should) cover costs increased by inflation. However, annual interest is subject to income tax. Unless designated as "irrevocable," regulated trusts are subject to claim by the state if you receive social benefits. The advantage is that you'll be able to benefit from the interest it will accrue, and protect yourself if the funeral home goes out of business.

Your survivors may also pay for your funeral using the proceeds received as beneficiaries of your **life insurance, death benefits from veterans or Social Security**. Be sure to discuss this with the beneficiaries of the policy.

Conclusion

Few people like to think about death...and what it will mean for their loved ones. But the very fact that you *have* loved ones means that you care about them—and about the circumstances in which they live. Dealing with the death of your spouse or other close family member adds financial and administrative stress to the tumultuous emotions you're already feeling. Because you've lived through the events that led you to buy this book, you know how difficult death can be.

Perhaps the most important lesson that any survivor can learn is to plan well for your own passing. It's a process that combines profound matters with worldly ones.

I hope this book helps you with the worldly matters.

Appendix A

Funeral Consumer Groups
and
Memorial Societies

The following is list of non-profit funeral consumer groups and memorial societies recommended by the Funeral Consumers Alliance (*www.funerals.org*).

Alaska

- **Cook Inlet Memorial Society**, P.O. Box 102414, Anchorage 99510; (907) 562-4992.

Arizona

- **FCA of Central AZ**, P.O. Box 0423, Chandler, Phoenix 85244-0423; (480) 929-9659.

- **Memorial Society of Prescott**, P.O. Box 1090, Prescott 86302-1090; (928) 778-3000.

- **FCA of So. AZ**, P.O. Box 12661, Tucson 85732-2661; (520) 721-0230.

Arkansas

- **FCA of NW AR**, P.O. Box 3055, Fayetteville 72702-3055; (479) 521-6441.

California

- **Kern Memorial Society**, P.O. Box 1202, Bakersfield 93302-1202; (661) 366-7266, (661) 854-5689.

- **Redwood Funeral Society**, P.O. Box 501, Cotati 94931; (707) 568-7684.

- **Humboldt Funeral Society**, P.O. Box 856, Arcata 95518; (707) 822-8599.

- **Fresno Valley Memorial Society**, P.O. Box 101, Fresno 93707; (559) 268-2181.

- **Los Angeles Funeral Society**, P.O. Box 92313, Pasadena 91109; (626) 683-3752, (626) 683-3545.

- **Stanislaus Memorial Society**, P.O. Box 4252, Modesto 95352-4252; (209) 521-7690.

- **FCA of San Mateo & Santa Clara**, P.O. Box 60448, Palo Alto 94306-0448; (650) 321-2109, (888) 775-5553.

- **FCA of Northern CA**, P.O. Box 161688, Sacramento 95816-1688; (916) 451-4641, (800) 543-6133.

- **San Diego Memorial Society**, 4883 Ronson Ct., Ste. L, San Diego 92111-1812; (858) 874-7921.

- **Central Coast Mem. Soc.**, P.O. Box 679, San Luis Obispo 93406-0679; (805) 543-6133.

- **FCA of Channel Cities**, P.O. Box 1778, Ojai 93024-1778; (800) 520-PLAN, (805) 640-0109.

- **FCA of Monterey Bay**, Box 2900, Santa Cruz 95063-2900; (831) 661-0328.

Colorado

- **Funeral Consumer Society of CO**, 4101 E. Hampden Ave., Denver 80222; (888) 438-6431, (303) 759-2800.

Connecticut

- **FCA of CT**, P.O. Box 34, Bridgewater 06752; (800) 607-2801, (860) 355-4197.

District of Columbia

- **Mem. Soc. of Metro Washington**, 1500 Harvard St. NW, Washington 20009; (202) 234-7777.

Florida

- **FCA Brevard Co.**, P.O. Box 276, Cocoa 32923-0276; (321) 255-2100, (321) 242-1421.

- **Funeral Society of Mid-Florida**, P.O. Box 530392, DeBary 32753-0392; (386) 668-6822, (386) 789-1682.

- **FCA of SE Florida**, Ste. 144, 1626 SE 3rd Ct., Deerfield Beach 33441; (888) 288-9676, (954) 429-0280.

- **FCA of SW Florida**, P.O. Box 7756, Ft. Myers 33911-7756; (239) 573-0507.

- **FCA of N. Central Florida**, P.O. Box 14662, Gainesville 32604-4662; (352) 376-8703.

- **FCA of Orlando**, 830 Hammocks Rd., Ocoee 34761; (407) 294-1651.

- **FCA of Northwest Florida**, 5425 Dynasty Dr., Pensacola 32504; (850) 477-9085.

- **FCA of Sarasota-Manatee**, P.O. Box 15833, Sarasota 34277-5833; (941) 953-3740.

- **Suncoast-Tampa Mem. Soc.**, 719 Arlington Ave. N., St. Petersburg 33701; (727) 520-8922.

- **Funeral Cons. Assn. Leon Co.**, 1006 Buena Vista Dr., Tallahassee 32304; (850) 224-2082.

- Funeral Consumers Assn. Tampa Bay, 18902 Arbor Dr., Lutz, Tampa 33548-5051; (813) 948-1990.

Georgia

- Memorial Society of Georgia, 1911 Cliff Valley Way NE, Atlanta 30329; (800) 840-4339, (404) 634-2896.

- Middle Georgia Chapter, 5276 Zebulon Rd., Macon 31210; (800) 765-0107.

Hawaii

- Memorial Society/FCA of Hawaii, P.O. Box 11949, Honolulu 96828; (808) 638-5580.

Idaho

- FCA of Idaho, P.O. Box 1919, Boise 83701-1919; (208) 426-0032.

Illinois

- Chicago Memorial Association, P.O. Box 2923, Chicago 60690-2923; (773) 327-4604.

- FCA of Champaign County, 309 W. Green St., Urbana 61801; (800) 765-0107.

Indiana

- FCA of Bloomington, P.O. Box 7232, Bloomington 47407; (812) 335-6633.

- Indianapolis Memorial Society, 5805 E. 56th St., Indianapolis 46226; (317) 562-0116.

- FCA of NW Indiana, 1537 Janice Lane, Munster 46321; (219) 838-4829.

Kentucky

- **FCA of Louisville**, P.O. Box 5326, Louisville 40255-5326; (502) 454-4855.

Louisiana

- **FCA of Grtr. Baton Rouge**, 8470 Goodwood Ave., Baton Rouge 70806; (225) 926-2291.

Maine

- **FCA of Maine**, Box 3122, Auburn 04212-3122; (800) 218-9885, (207) 786-4323.

Maryland

- **FCA of Maryland**, 9601 Cedar Lane, Bethesda 20814; (301) 564-0006.

Massachusetts

- **FCA of Eastern Mass.**, 66 Marlborough St., Boston 02116; (888) 666-7990, (617) 859-7990.

- **FCA of Cape Cod**, P. O. Box 1375, East Orleans 02643-1375; (800) 976-9552, 508-862-2522.

- **FCA of SE Mass.**, 71 8th St., New Bedford 02740; (508) 996-0046.

- **FCA of Western Mass.**, P.O. Box 994 Greenfield 01302; (413) 774-2320.

Michigan

- **Mem. Advisory & Planning Soc.**, 2030 Chaucer Drive, Ann Arbor 48103; (734) 665-9516.

- **Funeral Consumer Info. Soc.**, P.O. Box 24054, Detroit 48224-4054; (313) 886-0998.

- **FCA of the Copper Country**, 1023 Fourth Street, Hancock 49930; (906) 482-8704.

Minnesota

- **Minn. Funeral & Memorial Society**, 717 Riverside Dr. SE, St. Cloud 56304; (320) 252-7540.

Missouri

- **FCA of Greater KC**, 4501 Walnut St., Kansas City 64111; (816) 561-6322.

Montana

- **FCA of Billings**, P.O. Box 1732, Billings 59103; (406) 259-7943.

- **Five Valleys Memorial Society**, 405 University Ave., Missoula 59801; (406) 728-2648.

Nevada

- **FCA of Nevada**, Box 8413, Univ. Sta., Reno 89507-8413; (775) 329-7705.

New Jersey

- **FCA of So. Jersey**, 401 Kings Highway N., Cherry Hill 08034; (856) 235-2783.

- **Raritan Valley Mem. Soc.**, 176 Tices Ln., East Brunswick 08816; (732) 572-1470.

- **Mem. Assoc. of Monmouth County**, 1475 W. Front St., Lincroft 07738; (732) 747-7950.

- **Morris Memorial Society**, P.O. Box 509, Madison 07940-0509; (973) 540-9140.

- **FCA of Essex Co.**, P.O. Box 1327, Montclair 07042-1327; (973) 783-1145.

- **Central Memorial Society**, 156 Forest, Paramus 07652; (201) 385-4153.

- **Memorial Society of Plainfield**, 724 Park Ave., Plainfield 07060; (908) 889-6289.

- **FCA of Princeton**, 50 Cherry Hill Dr., Princeton 08540; (609) 430-7250.

New Mexico

- **FCA of No. New Mexico**, P.O. Box 53464, Albuquerque 87153; (505) 296-5902.

New York

- **Mem. Soc. Hudson-Mohawk Region**, 405 Washington Ave., Albany 12206-2604; (518) 465-9664.

- **Greater Buffalo Memorial Society**, 695 Elmwood Ave., Buffalo 14222-1601; (616) 837-8636.

- **Ithaca Memorial Society**, P.O. Box 134, Ithaca 14851-0134; (607) 273-8316.

- **FCA of L.I./NYC**, P.O. Box 701, Greenlawn 11740-0701; (631) 544-0383.

- **FCA of Mohawk Valley**, P.O. Box 322., New Hartford 13413; (315) 339-4819.

- **Mid-Hudson Memorial Soc.**, 249 Hooker Ave., Poughkeepsie 12603; (845) 229-0241.

- **FCA of Greater Rochester**, 220 Winton Road South, Rochester 14610; (716) 461-1620.

- **Syracuse Memorial Society**, P.O. Box 67, De Witt 13214-0067; (315) 446-0557.

- **Funeral Cons. Info. Soc./Westchester**, 460 York Ct., Yorktown Heights 10598-3726; (914) 285-0585.

North Carolina

- **FCA of Western NC, P.O. Box 2601**, Asheville 28802-2601; (828) 669-2587.

- **FCA of the Triangle**, P.O. Box 1223, Chapel Hill 27514-1223; (919) 834-6898.

- **FCA of the Carolinas**, P.O. Box 26507, Charlotte 28221; (704) 596-1208.

- **Mem. Soc. of Coastal Carolina**, P.O. Box 4262, Wilmington 28406-4262; (910) 458-4136.

Ohio

- **FCA of Akron-Canton**, 3300 Morewood Road, Akron 44333; (330) 849-1030, (330) 836-4418.

- **FCA of Greater Cincinnati**, 536 Linton St., Cincinnati 45219; (513) 981-0307.

- **Cleveland Memorial Society**, 21600 Shaker Blvd., Shaker Heights 44122; (216) 751-5515.

- **FCA of Central Ohio**, P.O. Box 14835, Columbus 43214-4835; (614) 263-4632.

- **FCA NW Ohio**, 2210 Collingwood Blvd., Toledo 43620-1147; (419) 874-6666.

Oklahoma

- **FCA of the Southwest**, 1550 Knox Rd., Ardmore 73401; (800) 371-2221.

Oregon

- **FCA of Oregon**, P.O. Box 25578, Portland 97298; (888) 475-5520, (503) 647-5590.

Pennsylvania

- **Memorial Society of Erie**, Box 3495, Erie 16508-3495; (814) 456-4433.

- **Mem. Society of Grtr Harrisburg**, 1280 Clover Lane, Harrisburg 17113; (717) 564-8507.

- **FCA of Philadelphia**, 1906 Rittenhouse Sq., Philadelphia 19103-5793; (215) 545-9210.

- **Pittsburgh Memorial Society**, 543 Neville St., Pittsburgh 15213; (412) 621-4740.

- **Mem. Society of Central PA**, 780 Waupelani Dr. Ext., State College 16801; (814) 237-7605.

Rhode Island

- **Mem. Society of R.I.**, 119 Kenyon Ave., East Greenwich 02818; (401) 884-6763.

South Carolina

- **FCA of SC**, 2701 Heyward St., Columbia 29205; (803) 772-7054.

South Dakota

- **Funeral Cons. Info. Soc. of Dakotas**, 19168 Flat Creek Rd., Lemmon 57638; (605) 374-5336.

Tennessee

- **FCA of Chattanooga**, 3224 Navajo Dr., Chattanooga 37411; (423) 886-3480.

- **FCA of East Tennessee**, P.O. Box 10507, Knoxville 37939; (865) 483-4843.

- **FCA of Mid-South**, P.O. Box 770388, Memphis 38177; (901) 680-9149, (901) 685-2464.

- **FCA of Middle TN**, 1808 Woodmont Blvd., Nashville 37215; (888) 254-3872, (615) 907-3364.

Texas

- **FCA of the Southwest/FCA of No. Texas**, 2875 E. Parker Rd., Plano 75074; (972) 509-5686.

- **Austin Mem. & Burial Info. Soc.**, P.O. Box 4382, Austin 78765-4382; (512) 480-0555.

- **FCA of So. Texas**, 3125 Horne Rd., Corpus Christi 78415; (800) 371-2221.

- **FCA of Houston**, 5200 Fannin St., Houston 77004-5899; (888) 282-4267, (713) 526-4267.

- **FCA of San Antonio**, 7150 Interstate 10 West, San Antonio 78213; (210) 341-2213.

Utah

- **FCA of Utah**, 1823 S 250 E, Orem 84058-7840; (801) 226-4701.

Vermont

- **FCA of Vermont**, 1630 Clark Rd., East Montpelier 05651; (802) 476-4300.

Virginia

- **Memorial Society of No. Virginia**, 4444 Arlington Blvd., Arlington 22204; (703) 271-9240.

- **FCA of VA Blue Ridge**, P.O. Box 10082, Blacksburg 24060-0082; (540) 953-5589.

- **FCA of the Piedmont**, P.O. Box 152, Charlottesville 22902-0152; (434) 923-7679.

- **FCA of Tidewater**, P.O. Box 4621, Virginia Beach 23454-4621; (757) 428-5134.

Washington

- **People's Memorial Association**, 2366 Eastlake Ave. E., Areis Bldg. #409, Seattle 98102; (206) 325-0489.

- **Spokane Memorial Association**, P.O. Box 13613, Spokane 99213-3613; (509) 924-8400.

- **Funeral Assoc. Central Washington**, P.O. Box 379, Yakima 98907; (509) 248-4533.

West Virginia

- **FCA of Greenbrier Valley**, P.O. Box 1277, Lewisburg 24901; Morgantown & NE area: call MD (301) 564-0006.

Wisconsin

- **FCA of Fox Valley**, P.O. Box 1422, Appleton 54912-1422; (920) 734-2391.

- **FCA of Greater Milwaukee**, 13001 W. North Ave., Brookfield 53005; (262) 238-0507, (800) 491-8150.

Most of the FCA's affiliates are run by volunteers. Consequently, the phone numbers in this directory are subject to change. If you have difficulty contacting a society or the state in which you live is not listed here, please call the FCA office at (800) 765-0107.

Appendix B

Resources
and
Reference Material

The following is a list of resources and reference materials in no particular order to help you with planning the funeral of a family member or close friend, including everything from helpful books and publications to organizations, online resources and consumer groups.

Books

- Mitford, Jessica; *The American Way of Death Revisited*; 1998; Alfred A. Knopf, New York, NY.

- Leash, R. Maroni; *Death Notification: A Practical Guide*; 1994, Upper Access, Inc., Hinesburg, VT.

- Carlson, Lisa; *Caring for the Dead: Your Final Act of Love*; 1998, Upper Access, Inc., Hinesberg, VT.

- Morgan, Ernest; *Dealing Creatively with Death: A Manual of Death Education and Simple Burial*; 2001, Upper Access, Inc., Hinesberg, VT.

- Fatteh, Abdulah; *At Journey's End: The Complete Guide to Funerals and Funeral Planning*; 1999, Health Information Press, Los Angeles, CA.

- Hughes, Theodore E. and David Klein; *The Executor's Handbook: The Step-By-Step Guide To Settling and Estate For Personal Representatives, Administrators and Beneficiaries, Second Edition*; 2001, Checkmark Books (imprint of Fact On File), New York, NY.

- Hughes, Theodore E. and David Klein; *A Family Guide to Wills, Funerals & Probate: How To Protect Yourself and Your Survivors, Second Edition*; 2001, Checkmark Books (imprint of Fact On File), New York, NY.

- Shaw, Eva; *What to Do When a Loved One Dies: A Practical and Compassionate Guide to Dealing with Death on Life's Terms*; 1994, Dickens Press, Irvine, CA.

- Shaw, Ellen; *Step by Step: Your Guide to Making Practical Decisions When a Loved One Dies*; 2001, Aid Association for Lutherans Quality Life Resources, Appleton, WI.

- Rust, Mike; *Taking Care of Mom & Dad: The Money, Politics and Emotions that Come with Supporting Your Parents*; 2003, Silver Lake Publishing, Los Angeles, CA.

- Kübler-Ross, Elisabeth; *On Death and Dying: What the Dying Have to Teach Doctors, Nurses, Clergy, and Their Own Families*; 1997, Touchstone, New York, NY.

Other Publications

- *Complying with the Funeral Rule*; available from the Federal Trade Commission, *www.FTC.gov*.

- *Funerals: A Consumer Guide*; available from the Federal Trade Commission, *www.FTC.gov*.

- *Consumer Guide to Funeral & Cemetery Purchases*; available from the California Dept. of Consumer Affairs Cemetery & Funeral Bureau, *www.dca.ca.gov/cemetery*.

- *What Every Woman Should Know from Social Security Administration* (Publication No. 05-10127); available from the Social Security Administration, *www.ssa.gov*.

- *Survivors Benefits* (Publication No. 05-10084); available from the Social Security Administration, *www.ssa.gov*.

- *Social Security: Understanding the Benefits* (Publication No. 05-10024); available from the Social Security Administration, *www.ssa.gov*.

- *How Much Will My Funeral Cost?*; available from the Funeral Consumers Alliance, *www.funerals.org*.

- *Tax Facts for Seniors with a Change in Marital Status: Death, Divorce, Marriage...the Tax Rules You Thought You Knew May Change, IRS Publication 3864 (6-2002)*; available from the Internal Revenue Service, *www.irs.gov*.

- *Consumer Information Catalog*; *www.pueblo.gsa.gov*.

- *Prepaying Your Funeral?*, Vol. 2, No. 2; available from the AARP (formerly American Association of Retired Persons), Washington, D.C.

Resources for Funeral Planning Information

- **Funeral Consumers Alliance (FCA)**, a non-profit organization that advocates funeral consumer protection. Call (800) 765-0107 or visit their Web site at *www.funerals.org*.

- **National Funeral Directors Association**, a professional association of funeral directors. Call (800) 228-6332 or visit their Web site at *www.nfda.org*

- **National Funeral Directors and Morticians Association**, a national association of African-American funeral providers. Call (800) 434-0958 or visit their Web site at *www.nfdma.com*.

- **Final Passages**, an organization for family-run funerals. Call (707) 824-0268 or visit one of their Web sites at *www.naturaldeathcare.org* and *www.finalpassages.org*.

- **International Cemetery and Funeral Association**, a funeral service consumer assistance program. Call (800) 645-7700 or visit their Web site at: *www.icfa.org*.

- **Funeral Service Consumer Assistance Program**, a nonprofit organization whose goal is to educate about funerals and resolve funeral service disputes. Service representatives assist consumers in identifying needs, addressing complaints and resolving problems. Call (800) 662-7666 or visit their Web site at *www.funeralservicefoundation.org*.

- **Funeral Service Educational Foundation**, a nonprofit foundation dedicated to advancing professionalism in funeral service and to enhancing public knowledge and understanding through education and research. Call (877) 402-5900.

- **International Order of the Golden Rule (International Association of Independent Funeral Homes)**, is an international association of about 1,300 independently owned funeral homes. Call (800) 637-8030 or visit their Web site at *www.ogr.org*.

- **Jewish Funeral Directors of America, Inc**. Call (781) 477-9300 or visit their Web site at *www.jfda,org*.

- **National Selected Morticians,** an association of funeral directors who have agreed to follow a Code of Good Funeral Practice. You may request publications through NSM's affiliate, the Consumer Information Bureau, Inc. Call (800) 323-4219 or visit their Web site at *www.nsm.org*.

Resources for Cemetery Information

International Cemetery and Funeral Association; 1895 Preston White Drive, Suite 220, Reston, VA 20191. Call (800) 645-7700 or visit their Web site at *www.icfa.org*.

Cemetery Consumer Service Council (CCSC); P.O. Box 3574, Washington, D.C. 20007. Call (703) 379-6426.

Cemetery Consumer Service Council; P.O. Box 2028, Reston, VA 20195-0028. Call (703) 391-8407.

Arlington National Cemetery; Superintendent Arlington National Cemetery, Arlington, VA 22211. Call (703) 695-3250.

National Cemetery System; *www.cem.va.gov*.

North American Cemetery Regulators Association; 340 Maple Street, Des Moines, IA 50319-9966. Call (515) 281-4441 or e-mail them at *ncra@att.net*.

Resources for Cremation

Cremation Society of the South; 5754 Harrison Ave., Suite B, Austell, GA 30106. Call (770) 941-5352 or visit their Web site at *www.cremstion.org/georgia/georgia.html*.

Cremation Association of North America, an association of crematories, cemeteries and funeral homes that offer cremation; 401 North Michigan Avenue, Chicago, IL 60611. Call (312) 644-6610 or visit their Web site at *www.cremationassociation.org*.

Sea Services (for cremated remains). Call (888) 551-1277 or visit their Web site at *www.seaservices.com*.

Resources for Complaints

Funeral Ethics Organization; 87 Upper Access Rd., Hinesburg, VT 05461. Call (802) 482-3437 or 866-866-5411 or visit their Web site at *www.funeralethics.org*.

International Conference of Funeral Services Examing Boards; P.O. Drawer E, Huntsville, AR 72740. Call (501) 738-1915.

Federal Trade Commission (FTC); Washington, DC 20580. Call (877) 382-4357 or visit their Web site at *www.ftc.gov*.

Council of Better Business Bureaus, Inc.; 4200 Wilson Blvd., Suite 800, Arlington, VA 22203-1838. Visit their Web site at *www.bbb.org*.

International Cemetery and Funeral Association, a nonprofit association of cemeteries, funeral homes, crematories and monument retailers that offers mediation of consumer complaints through its Cemetery Consumer Service Council.; 1895 Preston White Drive, Suite 220, Reston, VA 20191. Call (800) 645-7700 or visit their Web site at *www.icfa.org*.

Resources for Anatomical Gifts

National Anatomical Service; 28 Eltingville Blvd., Staten Island, NY 10312. Call (800) 727-0700.

Coalition on Donation; 1100 Boulders Parkway, Suite 700, Richmond, VA 23225. Call (804) 3308620 or visit their Web site at *www.shareyourlife.org*.

American Association of Tissue Banks; 1350 Beverly Rd., Suite 220-A, McLean, VA 22101. Call (703) 827-9582 or (800) 635-2282 or visit their Web site at *www.aatb.org*.

Eye Bank Association of America; 1015 18th Street NW, Suite 1010, Washington D.C. 20036-5504. Call (202) 775-4999 or visit their Web site at *www.restoresight.org.*

Division of Transplantation, Health Resources and Services Administration, U.S. Department of Health and Human Services; 5600 Fishers Lane, Park Lawn Bldg. 4-81, Rockville, MD 20857. Call (888) 90-SHARE or (301) 443-7577 or visit their Web site at *www.organdonor.gov.*

American Association of Tissue Banks; 1350 Beverly Rd., Suite 220-A, McLean, VA 22101. Call (703) 827-9582.

Eye Bank Association of America; 1001 Connecticut Ave. NW, Washington, D.C. 20036-5504. Call (202) 775-4999.

The Living Bank; P.O. Box 6725, Houston, TX 77265. Call (800) 528-2971 or visit their Web site at *www.livingbank.org.*

United Network for Organ Sharing; P.O. Box 13770, Richmond, VA 23225. Call (804) 330-8500.

Department of Health and Human Services donation Web site; *www.organdonor.gov.*

Transweb, a non-profit educational Web site directory and collection of transplantation and donation related information. Visit their Web site at *www.transweb.org.*

The United Network for Organ Sharing (UNOS), an organization that maintains the U.S. organ transplant waiting list matching system and brings together members of the transplant community to facilitate development of organ allocation policy. Visit their Web site at *www.unos.org.*

Resources for Hospice Care

National Hospice and Palliative Care Organization (NHPCO); 1700 Diagonal Road, Suite 300, Alexandria, VA 22314. Call (800) 658-8898 or (703) 243-5900 or visit their Web site *www.nhpco.org*.

Partnership for Caring National Office
Washington D.C.; 1620 Eye Street NW, Suite 202, Washington, D.C. 20006. Call (202) 296-8071 or (800) 989-9455 or visit their Web site *partnershipforcaring.org*.

National Hospice Organization; 1901 N. Moore St., Suite 901, Arlington, VA 22209. Call (703) 243-5900 or (800) 658-8898.

Hospice Education Institute; 190 Westbrook Rd., Essex, CT 06426. Call (860) 767-2746 or (800) 331-1620.

Center to Improve Care of the Dying; George Washington University, 2175 K St. NW, Washington, D.C. 20037-1802. Call (202) 467-2222.

Children's Hospice International; 2202 Mt. Vernon Ave., Alexandria, VA 22301. Call (800) 242-4453.

Resources for Grief Support

Seasons: Suicide Bereavement; P.O. Box 187 Park City, UT 84060.

St. Mary's Grief Support Center; 407 East 3rd St., Duluth, MN 55805-4402. Call (218) 726-4402.

Teen Age Grief, Inc.; P.O. Box 4935, Panorama City, CA 91412-4935. Call (805) 252-5596.

Grief Recovery Institute; 8306 Wilshire Blvd, Suite 21-A, Beverly Hills, CA 90211. Call (213) 650 1234 or (800) 445-4808.

Children's Grief Center; P.O. Box 6324, Kent, WA 98031. Call (253) 631-0158.

Grief Education Institute; 4596 East Illiff Avenue, Denver, CO 80222. Call (303) 758-6048.

International Association of Widowed People; P.O. Box 3564, Springfield, IL 62708.

Compassionate Friends; P.O. Box 3696, Oak Brook, IL 60522-3696. Call (630) 990-0010 or visit their Web site *www.compassionatefriends.org*

Centering Corporation (for bereaved); 1531 N. Saddle Creek Rd., Omaha, NE 68104-5064. Call (402) 553-1200.

Kubler-Ross Center; South Route 616, Head Waters, VA 24442. Call (703) 396-3441.

St. Francis Center; 5417 Sherier Place, NW Washington, DC 20016. Call (202) 333-4880 or (202) 363-8500.

The Dougy Center for Grieving Children; 3909 S.E. 52nd Avenue or P.O. Box 86852, Portland, OR 97286. Call (503) 775-5683.

Resources for Survivors

AARP (formerly American Association of Retired Persons), a non-profit organization dedicated to helping older Americans; 601 E Street, NW, Washington, D.C. 20049. Call (800) 424-3410 or visit their Web site *www.aarp.org*.

Widowed Persons Service; AARP, 1909 K Street, NW, Washington, D.C. 20049.

National Victims Assistance Center; 307 West 7th Street, Suite 705, Fort Worth, TX 76102. Call (817) 877-3355.

Survivors of Suicide; P.O. Box 1353, Dayton, OH 45401-1932. Call (513) 297-9096 or (513) 297-4777.

Sudden Infant Death Syndrome Alliance; 1314 Bedford Avenue, Suite 210, Baltimore, MD 21208. Call (410) 653-8226 or (800) 221-7437 or visit their Web site *www.sidsalliance.org*.

National SHARE Office, Infant and Pregnancy Loss; St. Joseph Health Center, 300 First Capitol Drive, St. Charles, MO 63301-2893. Call (314) 947-6164.

Parents of Murdered Children; 100 East 8th Street, B-41, Cincinnati, OH 45202. Call (513) 721-5683.

Theos Foundation (for widows); 322 Blvd. of the Allies; Suite 105, Pittsburgh, PA 15222-1919. Call (412) 471-2229 or (312) 472-7782.

American Association of Suicidology; 4201 Connecticut Ave. NW, Suite 408, Washington, D.C. 20008. Call (202) 237-2280 or visit their Web site *www.suicidology.org*.

Emotions Anonymous; P.O. Box 4245, St. Paul, MN 55104. Call (651) 647-9712 or visit their Web site *www.mtn.org/EA*.

National Sudden Infant Death Syndrome Foundation (SIDS); 10500 Little Patuxent Parkway, Suite 420, Columbia, MD 21044. Call (800) 221-SIDS.

Estate Planning Resources

American College of Trust and Estate Counsel; 2716 Ocean Park Blvd., Suite 1080, Santa Monica, CA 90405. Call (310) 450-2033.

Jarvis & Mandell Integrated Planning Solutions; 1875 Century Park East, Suite 550, Los Angeles, CA 90067. Call 310-407-2829.

Commission on Legal Problems of the Elderly American Bar Association; 1800 M. Street, NW, Washington, D.C. 20036. Call (202) 331-2297.

Resources for Living Wills

Americans for Death with Dignity; P.O. Box 11001, Glendale, CA 91226.

Association for Death Education and Counseling; 638 Prospect Ave., Hartford, CT 06105. Call (860) 586-7503.

The Concern for Dying/Society for the Right to Die; 200 Varick Street, New York, NY 10014. Call (212) 366-5540.

National Hemlock Society; P.O. Box 11830, Eugene, OR 97440-4030. Call (503) 342-5748.

The Compassionate Friends; P.O. Box 3696, Oak Brook, IL 60522-3696. Call (603) 990-0010 or visit their Web site *www.compassionatefriends.org.*

National Association for Death Education and Counseling, Inc.; 2211 Arthur Avenue, Lakewood, OH 44107.

Miscellaneous Resources

Alzheimer's Association, Inc.; 919 N. Michigan Ave., Suite 1100, Chicago, IL 60611-1676. Call (312) 335-8700 or visit their Web site *www.alz.org.*

American Cancer Society; 1599 Clifton Rd. NE, Atlanta, GA 30329-4251. Call (800) 227-2345 or (404) 320-3333 or visit their Web site *www.cancer.org.*

American Heart Association; 1615 Stemmons Freeway, Dallas, TX 75207. Call (214) 748-7212.

American Lung Association; 1740 Broadway, New York, NY 10019. Call (212) 315-8700.

BioFab, LLC (caskets); P.O. Box 990556, Redding, CA 96099. E-mail them at *Biofab@ricestraw.com.*

Department of Veterans Affairs. Call (800) 827-1000 or visit their Web site *www.va.gov.*

Social Security Administration. Call (800) 772-1213 or visit their Web site *www.ssa.gov.*

Monument Builders of North America. Visit their Web site *www.monumentbuilders.org.*

Living Memories Biographies, an organization that produces personal biographies of everyday people for posterity. Visit their Web site *www.livingmemories.tv.*

Index